The Siege of the Arts

The SIEGE of the ARTS

COLLECTED WRITINGS 1994–2001

Robert Brustein

IVAN R. DEE
CHICAGO 2001

THE SIEGE OF THE ARTS. Copyright © 2001 by Robert Brustein.
All rights reserved, including the right to reproduce this book or portions
thereof in any form. For information, address: Ivan R. Dee, Publisher,
1332 North Halsted Street, Chicago 60622. Manufactured in the
United States of America and printed on acid-free paper.

Library of Congress Cataloging-in-Publication Data:
Brustein, Robert Sanford, 1927–
The siege of the arts : collected writings, 1994–2001 / Robert Brustein.
p. cm.
Includes index.
ISBN 1-56663-380-X (cloth : alk. paper) — ISBN 1-56663-381-8
(pbk. : alk. paper)
1. Theater—United States. 2. Theater—United States—Reviews. I. Title.

PN2232 .B74 2001
792'.0973—dc21 2001028934

For the children

Daniel, Jean, Peter, Tommy, and Max

Contents

III. PEOPLE AND PLACES

Acknowledgments

All the reviews and essays in this book were published in *The New Republic*, with the following exceptions:

"The Government versus the Arts" was a speech delivered at Dartmouth University and the American Academy in Berlin.

"The Philosophy of the Faculty" was a speech delivered to the National Association of Scholars.

"Jews and American Theatre" was a commencement address delivered at Hebrew College and later published in the *Jewish Daily Forward*.

"Memories of Libraries" was a speech delivered for the Living Lights Ceremony at the Boston Public Library.

"Himalaya Criticism" was a speech given to the American Theatre Critics Association and later published in *Theater*.

"A Little Touch of Harry" was spoken at Harry Kondoleon's memorial.

"David Mamet at Fifty" was the keynote address at the Mamet Society Conference in Las Vegas.

"Samuel Beckett and Alan Schneider" appeared originally in the *New York Times Book Review*.

"The Juvenescent Arthur Miller" was an introduction to the Massie Lecture at Harvard.

"Poker Face" and "Chekhov on Ice" were both originally performed at the Boston Playwrights Marathon.

To these organizations and periodicals, to Ivan Dee, and to my editors at *The New Republic* (Leon Wieseltier, James Wood, and Ruth Franklin), my friendship and gratitude.

R. B.

Cambridge, Massachusetts
June 2001

Introduction
The Three Horsemen
· # of the Anti-Culture ·

MOST OF THE ARTICLES AND REVIEWS in this book were writ-
ten for a particular occasion. Yet, directly or indirectly, most of them
somehow return to the same troublesome issue—why the serious
arts have such a hard time of it in this country. As a theatre critic and
theatre practitioner, I generally approach this question from the per-
spective of the legitimate stage, traditionally one of the most com-
promised forms of cultural expression. Some of these compromises I
love—the raunchiness of the clowns, the fleshiness of the actors, the
sensual musk of the occasion, the runaway emotionalism of the cli-
maxes—they keep the theatre lusty, vital, and engaged. But while the
blending of popular and high culture has often been a source of con-
siderable vigor and strength, that mix has also been responsible for
the theatre's greatest weakness: its vulnerability to the imperatives of
the box office.

In this regard the theatre's financial dependency is becoming an
unfortunate model for the arts as a whole. With the continuing
spread of corporate capitalism and the gobbling up of smaller arts
firms by huge conglomerates, commercial motives, once secondary
to questions of quality in serious publishing and music, have begun
to dominate those fields as well. Publishers used to try to dignify
their lists with unpopular books of distinction—now they rely en-
tirely on potential blockbusters, while serious music organizations,
especially symphony orchestras, are increasingly beginning to resem-
ble "Pops."

The problem is essentially a Marxian one—those who create the arts are becoming more and more alienated from the means of production. But accompanying the omnipresent financial constraints are certain political pressures that are influencing artistic quality and direction. For some years the arts have been colored by the conservative, radical, and liberal shades of the political spectrum alike.

To shift my metaphor, the siege of the arts is being conducted by three horsemen of the anti-culture, a group of vigilant night riders who circle from the right, left, and middle of the American castle, looking for a deviant artist. From the right gallops the horseman of moral correctness, determined to purify the arts according to preconceived standards of decency. From the left canters the horseman of political correctness, committed to laundering the arts of any perceived threat to racial, sexual, or ethnic sensitivities. And from the middle trots the horseman of aesthetic correctness, demanding that the arts conform to traditional and conventional rules of creative procedure. Besieged by every ideological camp, increasingly deprived of the funds with which to underwrite his professional pursuits, it is a wonder the artist has continued to function at all in such a hostile atmosphere.

Yet, despite these assaults, our serious culture has somehow managed to remain alive under the most stringent conditions. Indeed, it may even be possible that those three rampaging horsemen are growing a little chap-weary in their relentless ride across our cultural landscape. In regard to moral correctness, it cannot be denied that the 1998 Supreme Court decision endorsing content restrictions at the National Endowment for the Arts represented a serious blow to free artistic expression (this setback is discussed in my opening essay "The Government versus the Arts"). And that majority ruling of the conservative judges has recently been reinforced by New York Mayor Rudolph Giuliani's decision to deny public funds to the Brooklyn Museum on the basis of two exhibits he found sacrilegious. On the other hand, an even more recent (February 2001) Supreme Court decision set limits on government's ability to attach strings to public money, arousing hopes that the subsidized arts may one day be free again from government censorship.

Political correctness (glanced at in my essay "The Philosophy of

the Faculty") also seems to be loosening its repressive hold on the high arts, if not on the institutions where it has held the tightest grip, the educational system and the nonprofit theatre. Tireless agencies such as the American Civil Liberties Union and Harvey Silverglate's FIRE (Foundation for Individual Rights in Education, Inc.) have been monitoring the tendencies of universities to punish any deviations from strict sexual, moral, and racial codes. Novels such as Philip Roth's *The Human Stain* and Francine Prose's *The Blue Angel* (and J. M. Coetzee's *Disgrace*, which describes the same conditions in South Africa) have satirized the excesses promulgated by sexual harassment rules in the academy. Plays such as Jonathan Reynolds's *Stonewall Jackson's House* and Rebecca Gilman's *Spinning into Butter* have satirized the way white theatre directors and liberal academics buckle under real or imagined accusations by racial pressure groups. And a number of feminist, black, Latino, and gay writers have been permitting an element of surprise and unpredictability to enter work that has hitherto been rather rigid and ideological. I have often had opportunity to compare the vagaries of American culture to a crazy pendulum. It could be that this pendulum is now preparing to swing the other way.

Aesthetic correctness (which I engage in my essay "Himalaya Criticism") presents a knottier question, because the condition it reflects has a much longer history. Over the centuries the critic and the artist (or the academician and the professional, or the theorist and the practitioner) have confronted each other with a measure of suspicion and hostility. The artist may appeal to posterity, but it is the critic who controls contemporary opinion—that is why the academician has historically been able to impose his strict rules on creative expression, often wrenching it in the process. In a famous example, the Academie Française, demanding absolute conformity to the three unities, forced Corneille, in *Le Cid*, to squeeze the events of many years into a single day. Like the archetypal child and parent, the artist may have the capacity to break the rules and shock the family, but the critic has the power to punish him severely for it.

The American theatre today is in serious trouble, not because it lacks fine artists in every area of activity. Actually the numbers and quality of talent have rarely been higher or better. It is in trouble

partly because it lacks an informed, committed, and, yes, sympathetic criticism. I'm not talking of boosterism or cheerleading. I'm speaking of the kind of hard-minded encouragement that F. R. Leavis once gave to D. H. Lawrence, that Edmund Wilson supplied to F. Scott Fitzgerald, that George Jean Nathan offered to Eugene O'Neill—the kind of tough mentoring that helped these writers learn and grow.

But *The Siege of the Arts* concentrates not only on negative conditions—the arrogance of the opinionators, the decline in subsidy, the influence of ideology, the breakdown of taste, the loss of standards, the failure of arts education, the exaltation of amateurism. The book also tries to celebrate what I perceive to be the best that has been thought and written in this vulnerable form in recent years. Both as an artistic director involved with production and training, and as a theatre critic watching new developments in the field, I have been in a good position to observe the wide range of talent that the theatre currently offers. My book is intended both as a record of that artistic achievement and as a call to improve the conditions under which this art is being created. It is, in short, my small attempt to help lift the continuing siege of the arts.

The book is divided into three sections: (1) *Positions*, which amplifies on some of the aforesaid dangers to the arts from the opposing culture; (2) *Performances*, which reviews the progress of individual plays and productions; and (3) *People and Places*, which has a twofold purpose: to examine theatrical approaches in other geographical locations and to assess the work of some of those figures currently helping to improve our theatre. The two playlets in this final section—the one on Buster Keaton, the other on Anton Chekhov—are an effort to extend my admiration for these theatre artists into another form of literary discourse.

The Siege of the Arts

· I ·

Positions
and Polemics

· *The Government versus the Arts* ·

THE ISSUE of government support for the arts in America has always been etched in acid and shrouded in acrimony. What often begins as genuine enthusiasm for building a healthy American culture through public funding often degenerates into anger, suspiciousness, blocked programs, and canceled subsidies. An early example of this dispiriting pattern was a Roosevelt-led initiative called the Works Project Administration, which, in the depression years of the 1930s, supported a number of unemployed artists and needy arts organizations. The most notable of those was Hallie Flanagan Davis' Federal Theatre, with Orson Welles as its most famous alumnus. For all its auspicious beginnings and genuine achievements, the whole enterprise was soon shut down by a red-baiting Congress (events that were rather crudely chronicled in the movie *The Cradle Will Rock*) in the belief that some of the funded artists were Communists and some of the arts groups were revolutionary fronts.

Today congressional objections to federal funding are not so much political as moral. The National Endowment for the Arts (NEA), a federal agency founded in 1966, has been responsible for more than a hundred thousand grants to museums, symphonies, opera companies, dance companies, theatres, and individual artists. But because of a handful of controversial awards (forty in all, most famously a small grant to the Corcoran Gallery in partial support of Robert Mapplethorpe's homoerotic photographs), the militant Christian right has prodded a lockstep conservative Congress into calling for the extinction of this valuable agency.

Following a well-orchestrated letter-writing campaign by Don-

ald Wildmon and the American Family Association, the House of Representatives agreed in 1997 (by a single vote) to remove the NEA entirely from the face of the earth—though the slightly more sympathetic Senate managed, just barely, to prolong its existence as a sadly limping life-form. Still, this crippled and enfeebled agency has been living for the past three years on a puny subsistence of less than $100 million annually. Such a meager sum, distributed among state agencies and a dwindling number of arts groups, represents a drastic reduction from the NEA high of $176 million in 1995—pretty small pickings when compared with the infinitely more munificent arts funding in European countries and Canada.

Nevertheless this petty cash was to become the subject of one of the most acrimonious and contumelious debates in recent American politics, sometimes dominating entire issues of the *Congressional Record*. The plight of the NEA is now synonymous with the plight of the American artist in our time—"vilified, pilloried, misunderstood, and neglected," to use the words of former NEA chairwoman Jane Alexander. Perhaps the most egregious example of this humiliating treatment is the Senate-imposed decision that every individual or institution applying for government funds be required to conform to a prescribed moral code. Sponsored by Senator Jesse Helms of North Carolina, it asks the NEA to take into account what it calls "general standards of decency and respect for the diverse beliefs and values of the American public."

Behind the democratic phrasing of this statute lurks the homophobic revulsion and sexual loathing that has dogged this country ever since our Puritan forbears, having already closed up every theatre in London, sailed to these shores to implant in our collective brains their obsession with the profaneness of art. Rather than accept such strictures, Joseph Papp, late director of the New York Shakespeare Festival, angrily withdrew his theatre's NEA application, even though this meant the loss of a very important annual subsidy. Following a class-action suit initiated by Bella Lewitzky and others, a federal lower court in California threw out the decency test as a violation of free expression. And indeed it was. The court should have required Senator Helms to write the first amendment on the blackboard a hundred times.

Instead of letting the lower-court ruling stand, President Clinton's attorney general, Janet Reno, unaccountably appealed this case to the Supreme Court. Perhaps she was reflecting the indifference and thoughtlessness of an administration that has used the word "arts" as infrequently as the Reagan administration used the word "AIDS." Anyhow, instead of spanking Helms, the Supreme Court awarded him a gold star. In an 8 to 1 decision in June of 1998, the justices upheld the decency test for distributing arts grants through the National Endowment. This was the second bad decision the Court made in that year having to do with relations between private behavior and public morals. In the first, the Court ruled that the Paula Jones civil case against the president could proceed before Clinton left office, on the reasoning that it would not interfere with his presidency—a judicial miscalculation swiftly exposed by the events that unfolded. History will take a bit longer to demonstrate the folly of the Court's decision regarding the arts.

Some concurring justices, believing that the 1990 statute contained only "advisory language," excused their decision by saying the clause was essentially "toothless" anyway. Sandra Day O'Connor, for example, noted that the statute would violate the first amendment only if it actually imposed "a penalty on disfavored viewpoints," implying that artists could always resort to legal appeals if they felt their speech rights had been infringed. That may be an option, but does it really make sense to turn our artists into litigators in an already overcrowded court calendar?

Other justices, I believe, interpreted the Court's decision more accurately, if more ominously for the arts. Disputing O'Connor's sanguine view, Antonin Scalia said he would consider even an outright ban on federal financing of indecent art to be constitutional. Clarence Thomas agreed. Only Justice David H. Souter correctly recognized that such a statute, however interpreted or administered, was a form of content restriction, hence a clear instance of viewpoint discrimination, and should have been struck down.

None of the justices mentioned the really vexing question, which is how it ever came to be assumed that the public at large, much less moralistic politicians like Jesse Helms and (later) Rudolph Giuliani in the celebrated Brooklyn Museum of Art elephant dung

case, are the appropriate arbiters of morality in the arts. The whole notion of "general standards of decency and respect," otherwise known as "community standards," has never been sufficiently debated in this country, though this dubious concept has hitherto been denounced by many philosophers and artists, including John Stuart Mill, Friedrich Nietzsche, Henrik Ibsen, George Bernard Shaw, Kierkegaard, Unamuno, Santayana, and H. L. Mencken, among others. It was "community standards" that for years banned the works of D. H. Lawrence, Henry Miller, and, most notably, James Joyce, whose *Ulysses*, considered by many to be the greatest literary work of the century, was prohibited in the United States for ten years because it was considered a "dirty book." It was not until 1933, in a landmark decision, that United States District Judge John M. Woolsey ruled that while "somewhat emetic, nowhere does [*Ulysses*] tend to be an aphrodisiac," concluding that the book was therefore not obscene in the legal definition of the word, namely as "tending to stir the sex impulses or lead to sexually impure and lustful thoughts."

All right, Americans finally got to treat the emetic *Ulysses* as the literary equivalent of Ex-lax or milk of magnesia. But this judicial squeamishness about "sexually impure and lustful thoughts" would have legally prevented us from reading Rabelais, Aretino, or Boccaccio, among other authors more erotic than cathartic. In his classic essay "Pornography and Obscenity," D. H. Lawrence ridiculed a British home secretary who embraced a similar definition of obscenity. This official, scandalized by the idea of people reading what he considered to be improper literature, had sniffed: "And these two young people, who had been perfectly pure up till that time, after reading this book went out and had sexual intercourse together!!!"—to which Lawrence jubilantly retorted: "One up to them!"

Lawrence was hardly a proselytizer for promiscuity. He probably conformed to a stricter moral code than any of his detractors (expressing the curious opinion, for example, that masturbation was "the most dangerous sexual vice that society can be afflicted with"). But Lawrence also knew that behind the foam and fulminations of the Comstocks and Grundys and Bowdlers lurked a true obscenity, perhaps the basic raison d'être of pornography, namely "the grey dis-

ease of sex hatred," the desire to keep sex "a dirty little secret." (To him, the emancipated bohemians were not a whole lot better since, in killing off the dirty little secret through public exposure, promiscuity, and group sex, they were also managing to kill off whatever was dark, mysterious, and private in the erotic life.)

Lawrence was even more indignant on the subject of "community standards." First of all, he wondered how a community could decide on an issue of "obscenity" when no one knew what the term meant. Supposedly derived from the Latin *obscena*, meaning that which might not be represented on the stage, it is a word originally driven by the traditional Puritan hostility toward theatrical representation. Assuming we're not all Puritans, how does such a diverse and complicated society as ours manage to arrive at a single moral standard? "What is obscene to Tom is not obscene to Lucy or Joe," Lawrence wrote, "and really, the meaning of a word has to wait for majorities to decide it." Majorities, majorities. Only what Yeats called "the mad intellect of democracy" could ever have devised the caprice that the mass of people corner wisdom in this matter. "We have to leave everything to the majority," Lawrence stormed, "everything to the mob, the mob, the mob. . . . If the lower ten million doesn't know better than the upper ten men, then there's something wrong with mathematics. Take a vote on it. Show hands, and prove my count. *Vox populi, vox Dei.*"

The talented ten Lawrence referred to have usually been scornful of this populist voice, however Godlike. "Who told you art is in the service of the *people?*" asks a character in Philip Roth's *I Married a Communist.* "Art is in the service of *art*—otherwise there is no art worthy of *anyone's* attention." Shakespeare, if we are to believe his character Coriolanus, showed scant respect for "the many-headed multitude." Mill, castigating "the tyranny of the majority," characterized public opinion as "collective mediocrity." Ibsen insisted that "the majority is always wrong." Shaw joked that "Forty million Frenchmen can't be right." Mencken inveighed against "boobocracy." In response to which contemporary populists and majoritarians everywhere would undoubtedly unleash their favorite epithet: *"Elitists."*

Regrettably, the word "elitist" has now been redefined to mean

aristocratic or exclusionary when its etymology refers to leadership. Without an elite in the arts, we have no leaders, which is to say we have no vision, which is to say we have no art. Americans are perfectly capable of accepting the idea of elite skills in most other professions. We wouldn't want a democratically elected physician to operate on our gallstones any more than we would fly with a pilot chosen purely on the basis of his minority ethnic or racial background. Yet artists and intellectuals in this country are now required to submit their credentials to an ideological process that would have seemed extreme in Stalin's Soviet Union, even perhaps in Mao's People's Republic of China.

This has nothing to do with snobbery or elitism. Writers like Lawrence have been able to distinguish between what he called the "mob-self," an entity that mindlessly acquiesces in conventional opinions, and the "individual-self," the quality in all of us that is capable of original, subtle, and imaginative thought. Thoughtful people have always longed for a better-informed electorate. An enlightened majority has been an elusive ideal ever since the development of democracy. The most obvious way to achieve this goal is through widespread dissemination of works of art and intellect, through the education system, and through the culture at large. But instead of being exposed to the best that has been thought and created in any age, as Matthew Arnold desired, the mass of people in modern industrial societies are constantly being bombarded by the most debased forms of opinion and entertainment—manipulated, diddled, and scammed by those who will use any available means of communication to expand their influence or increase their profits. It was Lawrence who observed that "the public . . . will never be able to preserve its individual reactions from the tricks of the exploiter." Indeed, the ideal of an enlightened majority grows more and more remote as our advanced technology gets increasingly skilled at influencing minds. Today the religious right, among other influential groups, is using the media to blitz us with all manner of anxieties, hypocrisies, mind gropes, fears, and lies. To access wisdom, Americans no longer turn to Emerson or Dewey but to Jerry Falwell and Pat Robertson, if not to Rush Limbaugh, Geraldo Rivera, and Oprah.

The thorny issue, however, is federal funding for the arts, and why the public should be required to pay for something that offends the religious or moral sensibilities of some of its members. It is a difficult question to answer without also asking why the public should pay for things that don't interest the great majority—classical music, for example, or modern dance. This question is certainly not being addressed these days by the National Endowment for the Arts, which seems more interested in subsidizing such handicrafts as ceramics manufacturing, adobe church preservation, Ghana weaving, raven and eagle drumming, Native American Lumber drumbeating, and the like.

But as John Kenneth Galbraith often tells us, even in a capitalist society the government is responsible for a number of services not determined by the market—the police department, the fire department, public housing, health, sanitation, education, the courts, government itself. Even a galloping market economy has the capacity to recognize that certain crucial needs are not adequately supplied through competition, and among these are the serious arts. Do we need to be reminded that the greatest books of any time rarely make the best-seller lists, that the finest works of music are seldom found on the pop charts, that the best plays are almost never the biggest box-office bonanzas? Let the market drive the popular arts—Hollywood, Broadway, Madison Avenue, and Motown. Serious culture cannot survive without patronage and support.

But what right has government to assess my precious tax dollars if I'm not a patron of the opera or a visitor to museums? Put aside the fact that with the present $99 million appropriation to the NEA (.006 percent of a $1.7 trillion national budget), I'm not contributing tax dollars, or even a tax dollar, or even half a dollar to the arts but a figure closer to thirty-eight cents. Why should I be required to contribute even a penny if there's no immediate benefit to me personally?

I don't believe this is a serious question. If it were, then why wasn't I consulted when being assessed infinitely larger amounts for such inestimable boons to humankind as the Vietnam War, the B-1 bomber, the Strategic Defense Initiative, or the $2.4 billion Sea Wolf submarine? Who asked for my opinion when Kenneth Starr spent

$40 million of my tax dollars on an account of sexual relations more scatalogical than the *Kama Sutra* (though admittedly less well written) and infinitely more pornographic than any work condemned by the myrmidons of the American Family Association. It is only when contemplating subsidies to the arts and humanities that the public is supposed to have a deciding voice in policy, and even then that voice is not always respected or heeded (actually, recent polls assure us that 78 percent of Americans favor some sort of federal subsidy for the arts).

Then there is the recurrent congressional complaint that NEA grants are unfairly distributed, geographically. This was behind Representative Richard Armey's scornful reproach that a "board of censors in the East" would pretend to know better "what is or is not art suitable for the people of Iowa," and it was behind Congressman Ehler's complaint that having "one-fourth of all arts funding [going] to one state [New York]" was not "what one would call equitable funding." Is it really necessary to remind our elected representatives that, unlike the right to vote, the capacity to create is not apportioned equally among people or among states, that there is no equivalence between artistic genius and geographical parity? Yet Congress continues to demand that the artist, like the politician, be chosen according to proportionate representation. But imagine the congressman from Sparta rising to protest, in 480 B.C., that all the arts and humanities money was going to Athens, even though Athens held an obvious monopoly on artists and philosophers while the Spartans were too busy sticking foxes in their tunics to write a poem.

Nevertheless the nub of the matter remains obscenity and impiety. Should people be obliged to contribute even thirty cents to look at photographs of Robert Mapplethorpe with a whip handle up his butt, to be affronted by Andres Serrano's urine-dipped crucifix, to watch Karen Finley smear her naked body with chocolate syrup? The answer is: Nobody is forced to look. If I don't like what I see, I can always look at something else. Among the many blessings of a democracy is freedom of choice. I can either choose among the countless other works of art available to me or stay home and watch television. The Finley show, the Mapplethorpe X Portfolio, and the Serrano "Piss Christ" are only three among thousands of undisputed

artworks partially supported by federal subsidy, and no one is requiring me to patronize them against my will.

If I did, however, I might discover that Finley's infamous chocolate act was less designed for lubricious display than for making some statement about the female body, just as Andres Serrano's notorious photograph was trying to tell us something about the commercial exploitation of religious objects. I confess I don't see much value in Mapplethorpe's X Portfolio, but nobody compels me to look at it.

The issue is sectarian sensitivity. In an atmosphere of delicate, easily wounded feelings—an atmosphere to which the politically correct left has certainly contributed its fair share—such expressions are bound to outrage certain factions. But it is useful to remember that, in addition to guaranteeing the rights of the majority, our form of government is also dedicated to guaranteeing the rights of dissenters so long as they don't incite to riot or violence, or shout *"Fire"* in a crowded room. And thank heaven those rights are guaranteed. It is a fact of history that the vanguard has rarely been able to collect a majority to its ideas or creations until years after they have been absorbed by the mainstream.

It is also the obligation of a democratic society to protect the *mystique* of creative imagination from those who would politicize it into a program or a slogan. And that means, of course, giving support to legitimate visionary artists, no matter how offensive their works may be to certain coalitions. It is not the primary purpose of art to provoke the populace, but provocation is often the fallout of any groundbreaking artistic expression. Joyce's *Ulysses* originally shocked some readers with the erotic musings found in Molly Bloom's soliloquy. But the author was only trying to imagine the uncensored thoughts of a lusty woman on the verge of sleep. If this inspired erotic thoughts in pre- or post-pubescent youngsters, then one up to them!

The American civilization, like all past societies, exists not only in the present but in the future as well. We remember Athens less for the Peloponnesian Wars than for Aeschylus, Sophocles, Euripides, Plato, and Aristotle. We value the Elizabethans not so much for defeating the Spanish Armada as for inspiring the works of Spenser,

Marlowe, Shakespeare, and Jonson. We do not admire Victorian England for colonizing half the globe; we value it for the novels of Dickens, Thackeray, and George Eliot. Do Americans wish to be remembered primarily for gangsta rap, Calvin Klein ads, *Rent*, and *Titanic*? All those attempting to help mold the American future through creative expression, all those who care about how our country will be perceived by posterity, can only be dismayed by the current crisis in public funding—and grieved by our government's hostile attitude toward the arts.

[1998]

· The Philosophy of the Faculty ·

IN 1926 A. R. Lunacharsky, the People's Commissar of Enlightenment, passed his official judgment on Mikhail Bulgakov's new work, *The White Guard*: "The play . . . is not ideologically sound," he grumbled, "in fact, in places it is politically incorrect." A few years later Bulgakov's next play, *Flight*, was deemed ideologically unsound and politically incorrect and banned from the Soviet stage. So was *Othello*, the result of a campaign against Shakespeare by radical critics who condemned him for "idiotic patriarchal values." What Lenin called "the infantile disease of leftism" was not only managing to stifle the most original voices in postrevolutionary Russia but was also suppressing the work of the supreme poet of the Western world.

Sound familiar? You bet it does. As usual, we are repeating history, if not in degree than certainly in kind. But then history has always been a form of acid reflux. The contagious disease of infantile leftism not only found its way to the People's Republic of China, where it resulted in Chairman Mao's anti-intellectual, anti-artistic Cultural Revolution. It also inspired a cultural revolution in America, where it has been infecting art and education for the past twenty or thirty years.

In the 1960s radical students protesting against racism or the Vietnam War were accustomed to occupying the dean's office.

Today they are once again occupying the dean's office—not as protesters but as administrators. They have *become* the deans, in which official capacity they are laying down the laws that govern such current academic obsessions as date rape and sexual harassment and affirmative action. They are also administering all those ingenious academic innovations that have brought such distinction to our benighted times, not only in the classroom—where students can now enjoy courses in the aesthetics of acid rock, the semiotics of sitcoms, and the deconstruction of Batman and Robin—but also in the conduct of noncurricular university life. I am referring to the sort of Comstockery that led to the Antioch rules, that loony effort to merge twentieth-century sexual politics with nineteenth-century sexual morality. I am referring, in fact, to all those recent academic constraints on private behavior, and most especially speech codes.

It is a truism that minority groups entering the university for the first time in large numbers have grown increasingly sensitive to any language that might be considered demeaning or insulting. Thousands of anecdotes about the consequences of this have been compiled by conservatives and liberals alike—Dinesh D'Souza, Harvey Silverglate and Alan Charles Kors, Shelby Steele, and Nat Hentoff among them—though no one, thank heaven, has yet been forced to resign from the university for using the word "niggardly," as did a recent city administrator in Washington. Whenever people get oversensitized these days, the language inevitably gets oversanitized. In the 1990s Jane Austen would probably want to retitle her book *Sense and Sensitivity*. Facing this oversensitivity, the academic compulsion to launder the vocabulary of faculty and students alike has become increasingly urgent. The imposition of speech codes on members of the university community has added a new protection to the traditional rights guaranteed by our Constitution—namely, freedom *from* speech.

Similar constraints are being exercised today in government circles in the form of content restrictions, imposed, with the recent blessings of the Supreme Court, on any groups or individuals applying for grants from the National Endowment for the Arts. If artistic obscenity constitutes the most heinous offense to paleoliths like Jesse Helms, whose chief criterion is moral correctness, in the groves of

academe it is "political correctness" that is once again being used to stifle dissent and muffle originality. That this is happening in the American liberal arts university, traditionally the most jealously guarded home of basic artistic and academic freedoms, creates its own historical ironies.

I believe it was also Comrade Lenin who first remarked that the whole of Shakespeare was not worth a pair of boots. In this country Shakespeare's value is being measured not by his relationship to the price of footwear but rather against his capacity to solve the problems of racial, sexual, and ethnic inequality. And it must be admitted that, along with many artists of significance, he manages to fail this test with honors. Think of all the politically incorrect plays in the canon—*Taming of the Shrew* slights women, *Merchant of Venice* insults Jews, *Titus Andronicus* and *Othello* offend blacks, *King Lear* slanders bastards, *Macbeth* denigrates witches, *Richard III* demeans hunchbacks and the handicapped, and so forth. What was once called Shakespeare's "idiotic patriarchal values" are now being characterized as the sexist, racist failings of a dead white European male.

One of the few minorities to whom Shakespeare is still acceptable are the gay academics, many of whom believe that Shakespeare was gay himself. But there is very little evidence to dispute Shakespeare's heterosexuality, aside from a few ambiguous sonnets he dedicated to his patron. His domestic life, though troubled, was conventional enough. And he certainly subscribed, in his plays, to traditional Elizabethan ideals of masculinity, preferring the manly soldier who purged his blood in battle (Fortinbras and Kent) to the effeminate courtier (Osric and Oswald) whose veins were swelled with lust. Nevertheless the movement to induct Shakespeare into the gay community proceeds apace. One recent scholarly article even detects a heterosexual conspiracy against *The Two Gentlemen of Verona*, charging that critics refuse to acknowledge the greatness of this slight early work because it is so clearly a homosexual masterpiece! I'm sure there are scholarly monographs in the works on the sex toys used by Rosalind and Celia in the Forest of Arden and on lesbian practices among Lear's three daughters.

There have been rehabilitative efforts recently, notably by

Harold Bloom, to reestablish Shakespeare as an artist of thickness and doubleness rather than as a single-minded propagandist or historical relic. And the attention attracted by Gwyneth Paltrow and *Shakespeare in Love* may very well stimulate some interest in Shakespeare's writings on the part of people previously indifferent to him. Nevertheless if Shakespeare can't be hauled into service as the champion of, say, cross-dressing or bisexuality, recent scholarship would seem to have little interest in him, especially since this poor unenlightened Elizabethan continues to remain oddly apathetic regarding the pressing problems of our time. He's even being dropped from certain academic departments, and I'm not just referring to Georgetown University. Annette Bening reports that her old teacher at Juilliard, having moved to Arizona State University, was recently fired for using Shakespeare scenes in his acting classes rather than scenes from plays by African Americans, women, Latinos, or gays.

The higher administration of universities, recognizing that the larger share of disbursements, donations, endowments, jobs, and perquisites, other than grants to multicultural activity, are now being provided to the hard disciplines—science, business, engineering, and the like—has clearly decided to write off the soft disciplines, namely the humanities and the arts. These basics of the liberal arts curriculum are now being used, I suspect, not to educate young people in the treasures of past civilizations so much as to placate recalcitrant minority groups and reinforce identity politics. Let me illustrate with some personal history.

Two months ago I was invited to Dartmouth to be the 1999 Distinguished Fellow of the Nelson Rockefeller Institute. I accepted immediately. Who could resist such a flattering invitation? My mother would have plotzed. I should have taken warning from the fact that the previous Distinguished Rockefeller Fellow was my old friend August Wilson, who had organized a conference on African-American theatre at Dartmouth that conspicuously excluded such important theatrical figures as Anna Deavere Smith and Suzan-Lori Parks. Perhaps he considered them "crossover artists," as he once called the unworthy in his Theatre Communications Group address at Princeton, meaning people who had compromised their race by

entertaining the descendants of slaveowners. (All of Wilson's plays, of course, have appeared on Broadway, entertaining the same miscreants.)

Having arrived in Hanover with a speech in hand called "The Government versus the Arts," I was first asked to join a class in modern drama, taught by an amiable black instructor with about eighteen students, only two of them white. I was not surprised when the instructor made not Ibsen or Chekhov but rather my Town Hall debate with Wilson the prime subject of the class.

Although I was criticizing what I perceived to be Wilson's exclusionary racial policy regarding black actors in white plays, the press had preferred to characterize our confrontation as a battle between black and white. Nevertheless my meeting with the Dartmouth group was relatively friendly. One black student conceded that she hadn't expected to agree with me but found my position to be logical and acceptable. When it came time for my formal lecture, however, the lines were clearly drawn in a manner familiar to me from the Town Hall debate.

From my place at the lectern I could see that about a third of the audience was black, most of them students, and all had chosen to segregate themselves in the last rows of the hall. It began to dawn on me that this particular Distinguished Nelson Rockefeller Fellow had been brought to Dartmouth to be bushwhacked. For an hour the audience listened attentively enough to my argument for government subsidy of the noncommercial arts—until I concluded by saying that posterity tends to measure a civilization not by its military victories or economic successes so much as by its cultural and artistic achievements. "Does America want to be remembered for *Rent, Titanic, Seinfield,* or," as I disingenuously added, "gangsta rap?"

This remark seemed to ignite the entire back of the house. One fiery orator, who may not have been a regular student, announced that since I obviously knew nothing about "gangsta rap," which he called a "great artistic expression," I had no right even to mention it. I replied that, as a former side man in a swing band, I was not disposed to monotonous verbal rhythms and numbing percussive effects at the expense of melody. He insisted that gangsta rap was highly melodic. When I added that it was riddled with violence and

aggressiveness, particularly against "ho's" and "bitches," he accused me of playing to the white audience. I invited him to come to the podium and tell the audience exactly what was so distinguished about the form. He said he was prepared to tell the audience exactly nothing.

A black woman in the back demanded that I apologize to her race "for insulting our black culture." I was confused about how my personal distaste for "gangsta rap" could be construed as an insult to black culture. It seemed more likely that the rantings of Eminem and Puff Daddy were an insult to the great musical traditions of Duke Ellington, Ella Fitzgerald, Billie Holiday, and Louis Armstrong. Was my dislike for Schoenberg's twelve-tone system an insult to German culture? She continued to insist more and more loudly on an apology. When I continued to refuse, the back of the house began to grow abusive. One agreeable black student tried to calm the uproar by saying that "just as Americans stopped playing European sports like cricket and took up native sports like baseball, so we have to give up Eurocentric culture for our own forms of expression." Another student added that gangsta rap was a profound form of communication art while classical music was only insipid entertainment. The argument went back and forth like this for about forty-five minutes.

Was Dartmouth confirming these opinions either explicitly or tacitly? Whatever the case, in the course of the dispute I managed to get into even more hot water by saying it was not the primary function of a university to act as a mirror in which students only looked at themselves. Its function, I believed, was to expand student knowledge about other peoples and cultures. There was also a practical problem. What skills would these racially obsessed students possess after four years, what were they being prepared for, except to enter departments of African-American studies where the job prospects were limited? As for preserving your own culture, I mentioned my Polish-born father, who at home spoke Yiddish and practiced Jewish customs, but nevertheless, possessed with only a fourth-grade education, managed to learn English and understand the country to which he had emigrated.

At this the fiery orator erupted again, saying, "I wasn't allowed

to drive unless I learned your language and your culture. I have to read your street signs every day. Now I want to know about my own culture." Another student expatiated proudly about the great black cultures that predated and surpassed European civilization, chiefly that of classical Egypt. I refrained from saying that if the pharaohs were black people then his ancestors were among the earliest slave-owners—and the slaves they owned were my ancestors, the Jews.

Only one nonblack in the house entered this discussion, a young Pakistani instructor who tried to defend my position. The white academic audience sat in stoned silence during the entire exchange. Tom Wolfe once wrote a short book called *Mau-mauing the Flak Catchers* about how black revolutionaries enjoy belaboring guilty white liberals without fear of reproach or response. I experienced a great illustration of his thesis at Dartmouth.

This was a relatively mild version of something that is happening in many American universities these days—the angry confrontation of white liberal males by minority groups and radical feminists. They are demanding that their "culture" get proper recognition and proper due while at the same time affirming that only certified members of their culture are qualified to judge it. I think most of us believe in a pluralistic society, and no one can deny the fact that many minority artists have been sorely underestimated for years. But anyone who truly affirms the principles of pluralism knows how uncomfortable that concept is with the uniculturalism being practiced these days under the name of cultural diversity.

It is as if we were living in Peer Gynt's madhouse where every individual has been crowned Emperor of Self. But there is consolation—this will eventually pass. Every thirty years our country goes politically berserk, as it did in the thirties, in the sixties, and now in the nineties. Now the century is drawing to a close and with it, perhaps, the batty fashions of our latest cultural revolution. We have twenty years left to revel in reasonableness and enjoy some sanity before the whole sorry cycle begins again. In the meantime our major worry should be that the pendulum does not swing too far to the other side, because the radical Christian right in this country is capable of doing a lot more damage to our freedoms than the poor wretches who are now working to politically correct the university.

A better way to resist these repressive incursions into artistic and academic freedom is, I believe, to have a little more courage. The kind of silence I witnessed at Dartmouth shows how easily intimidating tactics can turn the professoriate, with a few honorable and brave exceptions, into a league of frightened men. One of my pleasures at Harvard during the past ten years was to produce the premiere of David Mamet's *Oleanna*—a play about the way a young female student, under the influence of campus "groups," unjustly accuses her professor of sexual harassment. Not the least attraction of this provocative piece was the fact that it was being seen in what some call "The People's Republic of Cambridge." *Oleanna* started debates that raged in the theatre, followed people into the street, went home with them, and invaded their dreams. Just as the only way to combat bad speech is with more and better speech, so the best way to combat the frozen, repressive practices at work in academia today is with complicated, nuanced, and subtle works of art and intellect. All we need are artists and intellectuals with the courage to create them, and audiences and readers with the courage to support them. In the present academic climate, it's unlikely you'll find a lot of them in the university. Ibsen's "damned compact majority" is everywhere today, including the cubicles and offices of academia. That is why he once admonished his friend Georg Brandes, battling a similar majority, "You say the faculty of philosophy is against you. Dear Brandes, would you have it otherwise? Are you not against the philosophy of the faculty?"

[1998]

· *The Arts at Harvard* ·

THE WORD "ARTS" is traditionally invoked at Harvard to describe the characteristics of its curriculum (e.g., "liberal arts") and the nature of its professoriate (e.g., "the faculty of arts and sciences"). Yet while most colleges and universities have created degree-granting departments in arts training or arts appreciation, and many have added professional schools, Harvard, almost alone among the elite

institutions, has largely limited its arts education to history and theory. This may be changing, though all change at Harvard is slow. Whatever its storied fame as an educational legend, Harvard as an educational institution has never thought of itself as a breeding ground or home for practicing artists. Its last two presidents, Derek Bok and Neil Rudenstine, have each expressed strong personal feelings for the arts. Bok's family established the Curtis Institute for Music in Philadelphia, and Rudenstine, himself a Shakespeare scholar, is married to a distinguished art historian. The faculty of the university as a body, however, seems to be less sympathetic to the arts. Harvard professors may look on benignly as their students participate in Arts First (a long weekend celebrating extracurricular undergraduate performance), but many of them regard the professional artist as a figure marginal to university life.

Poets are an exception, probably because Cambridge and Boston, both civic seats of New England *logos*, are cities historically associated with poets—Longfellow, James Russell Lowell, and T. S. Eliot among them. On the other hand, while resident composers, instrumentalists, novelists, dancers, painters, and sculptors may abound in arts-conscious colleges like Bennington, Bard, and Oberlin, they are pretty rare around the Harvard campus, unless they can be imported for a day or two by the "Learning from Performers" Series to hold a seminar and eat some lunch with undergraduates. Practitioners are admitted into the exclusive ranks of permanent Harvard faculty only if they have advanced degrees or if they can put their creative endeavors at the service of academic duties. This may even be true of poets. Before Seamus Heaney received his Nobel Prize, for example, his faculty title was Boylston Professor of Rhetoric and Oratory (he has been succeeded in this post by the poet Jorie Graham). This was a title Harvard took quite seriously. Among Heaney's duties, aside from teaching Yeats and the occasional verse workshop, was chairing a committee to select the best public speaker in the graduating class. Only after Heaney received the Nobel Prize in Literature did Harvard officially acknowledge that he was a creative artist by naming him Ralph Waldo Emerson Poet in Residence (for the two years that he's held this residence chair, ironically, he's been in "residence" in Ireland).

Similarly, for decades the poet-playwright William Alfred taught both medieval literature and a playwriting course in the Harvard English department. When he retired five or six years ago he was replaced not by a poet or a playwright but by a medievalist. A permanent course in playwriting, irregularly taught by visiting lecturers such as Adrienne Kennedy, has been suspended for the past five years, though for two of those years the English Department co-sponsored a course in screenwriting taught by Spike Lee. (When I asked why playwriting, with its obvious roots in English literature—most obviously Shakespeare—had been replaced by the myth and magic of the movies, I was told that Spike Lee would attract a lot of new students to the department).

Harvard now offers a concentration in creative writing and awards Briggs-Copeland Lectureships to those who teach it. Slowly, glacially, thanks to the openness of the last two administrations, arts education is creeping into the Yard, past the cadres of Switzers guarding the gates. Nevertheless those gates are still pretty heavily manned. It is true the University can boast a Department of Music which offers a few courses in composition and orchestration. But an undergraduate music major does most of his or her work in theory and history courses such as 18th-Century Performance Practice and Ethnomusicology. Harvard also provides an excellent curriculum in drawing, painting, and photography at the Carpenter Center. It is offered not by a Department of Art but by an area called Visual and Environmental Studies. How do you paint landscapes under the umbrella of something called Visual and Environmental Studies? It's as if Harvard wanted the outside world to believe that arts students are dedicated not to such frivolities as studio practice but rather to truly purposeful subjects like exploring the optic nerve and preserving the ecology.

There are, of course, a variety of other educational institutions in the Cambridge area, Boston University, Tufts, and Emerson College among them, which offer professional arts training on the undergraduate level, sometimes leading to a Bachelor of Fine Arts (B.F.A.) degree. This degree is rarely offered by the elite universities. At Yale and other such institutions, undergraduates in the arts usually matriculate in special departments or concentrations leading to a

B.A. degree; but they must supplement courses in their major with a variety of other disciplines, including the sciences, social sciences, history, and literature, on the premise that anyone planning a career in the arts would benefit from general knowledge in a broad range of subjects. This premise is sensible enough, even inarguable, as long as students are allowed to study legitimate disciplines (some of the arcane theories now in vogue pull them so far afield that they can graduate from college virtually uneducated in major subjects). At Harvard the options for anyone interested in the arts are even narrower. Harvard can boast of some very talented artists in music and theatre among its alumni—including Yo-Yo Ma, Stockard Channing, Tommy Lee Jones, and John Lithgow, and, more recently, Matt Damon, Natalie Portman, Ben Affleck, and Elisabeth Shue. But none of these was given much chance to practice his or her profession during school hours.

Although it is possible to major in some academic version of music and visual arts at Harvard, the University has never offered a major in theatre or dance. There have been some rumbles lately about creating a theatre concentration. It will no doubt run into strong faculty opposition. At Harvard, where the cult of the amateur is virtually enshrined, the word "professionalism" and the verb "professionalize" are more often used as pejoratives than honorifics. I have sometimes heard faculty members talk in hushed tones about a student production of Shakespeare or Sophocles in one of the resident houses as if it were far superior to anything produced by the Royal Shakespeare Company or the Greek National Theatre. Following the lead of Cambridge and Oxford, Harvard prefers its scholars to be gentlemen and gentlewomen, and its arts to be recreational. The actual practice of music, dance, and painting—aside from a scattering of studio courses—is largely left to clubs, orchestras, and choruses.

For decades, undergraduate interest in theatre had been accommodated by a self-generating extracurricular association known as the HDC, later the HRDC, or Harvard-Radcliffe Drama Club, along with a host of other student producing organizations, such as the Gilbert and Sullivan Society, Black C.A.S.T., independent productions at the Agassiz under the supervision of Radcliffe's Office of

the Arts, and shows at Harvard's resident houses. When the financier John Loeb contributed money to Harvard to build a new performance space, it was typically called not a theatre but a "drama center." And the Loeb Drama Center was dedicated largely to undergraduate theatre, even though the main auditorium turned out to be too vast to accommodate the relatively untrained skills of undergraduates. As a result, a typical HRDC production plays to about 75 people in a hall seating 556 (shows in the smaller experimental theatre are more heavily attended).

One of the reasons for the coming of the American Repertory Theatre (ART) to Harvard, and my appointment as director of the Loeb, was to help improve the quality of HRDC shows on the main stage, partly through practical courses in the craft of acting and directing, partly through professional guidance of HRDC production. But there has always been a structural fault in the position of the director of Loeb, namely that the title has no real authority. From the first we were working with an undergraduate club that wanted to retain its traditional independence and autonomy, and that sometimes regarded the ART company as usurpers. The HRDC is one of the very few extracurricular organizations that has no professional or faculty supervision. It is said that undergraduates fear the "professionalization" of undergraduate drama. But improving the quality of production on the main stage through ART supervision is no more to "professionalize" this extracurricular activity than a coach "professionalizes" Harvard football or a faculty conductor "professionalizes" the Harvard Chorus. It is, indeed, the very essence of an educational institution to have trained professionals (i.e., faculty and others) function in a tutorial and teaching relationship with unusually talented students.

There is certainly a good argument to be made against overly specialized arts training on the undergraduate level in a liberal arts university, if such training is either excessive or superficial. It's a question of degree. A theatre-obsessed student is not going to be very well educated if every hour of the day is dedicated to theatrical activities. On the other hand, how effective can a course in acting be if it follows the pattern of academic courses, meeting only three hours a week? Professional acting training requires at least forty

weekly contact hours. Still, even three hours properly used can help correct bad habits. And such courses are also enough to introduce the aspiring theatre student to the materials of the field. Those planning a theatre career after graduation would certainly be better prepared as professionals were they more familiar with theatre history and dramatic literature. I have often been struck by the ignorance of certain professional actors who, when offered the part, say, of Shylock or Iago, ask if they can read the play first. What were they reading as undergraduates?

So it is possible to argue against too little as well as too much attention to skills and practice on the undergraduate level. But we must also reckon with the almost total absence at Harvard of *graduate* professional schools in the arts. It's true that Harvard has a Graduate School of Design. Despite its misleading title, however, the Design School is essentially devoted to architecture and city planning. Almost alone among America's leading educational institutions, Harvard has no schools in the arts. The reason usually offered is that professional schools are too "vocational." True enough. So are the Law School, the Medical School, and the Business School. The real argument, I suspect, is not so much vocationalism as the nature of the vocation. Artists are notoriously bad citizens and worse breadwinners, and arts schools are traditionally far behind in their annual contributions to the Alumni Fund.

Harvard's indifference to the practical arts has had a long history. In the 1920s George Pierce Baker gave his celebrated 47 Workshop Playwriting course at Harvard as an elective in the English department. Although one faculty member compared it to a course in "butchering meat," Baker's dramatic instruction was effective enough to attract the likes of Eugene O'Neill, Philip Barry, and S. N. Behrman to Cambridge. But when Baker requested a space in which to stage scenes from the plays of his students, the administration balked. A wealthy donor from the Harkness family thereupon offered Harvard what was then the munificent sum of a million dollars to build a theatre and a drama department for Baker. In one of the few such actions in its long history, Harvard turned down the bequest. Baker took the money to Yale where he founded what was soon to be called the Yale School of Drama.

The Yale School of Drama, like the Yale School of Music and the Yale School of Art and Architecture, is a graduate professional school designed to offer opportunities for training in the practice of the arts, as the Medical School offers training in the practice of medicine and the Law School in the practice of jurisprudence. This is accomplished through course work and laboratory practice, which is to say through training in the classroom and work on the stage, sometimes in association with the professional Yale Repertory Theatre. After three years this culminates in a master of Fine Arts (M.F.A.) degree—for dramaturgs and critics a D.F.A. degree. While all of these Yale schools offer some opportunities for undergraduate participation, their curriculum is primarily designed for would-be professionals.

Lacking a department of drama or even a drama concentration, Harvard was understandably reluctant to accept a graduate professional school of drama on the Yale model. When the American Repertory Theatre came to Harvard from Yale in 1979, we originally proposed such a model for actors, directors, and dramaturgs connected to the theatre and were quickly advised that the idea would never fly. It wasn't until 1987, after noting the incidence at Harvard of institutes (the Nieman Institute, the Bunting Institute, et al.), that we submitted the proposal again, under the name of the ART Institute for Advanced Theatre Training. Possibly because we had stumbled on the proper nomenclature, we were then permitted to develop a training program in acting, directing, and dramaturgy, provided we asked for no money from the administration and offered no advanced degree (Institute students now receive a certificate from Harvard and an M.F.A. from the Moscow Art Theatre School, an institution with which the ART is currently affiliated).

The appearance of the American Repertory Theatre at Harvard in 1979 was a groundbreaking event and an unusual act of faith by the administration. It represented the establishment of the only permanent professional arts organization on campus. The ART was also responsible for the first undergraduate credit courses in theatre in Harvard history—in acting, directing, and dramaturgy, given by professional members of the company with teaching experience. These were offered and accepted on the assumption that the best teachers

in any artistic field were its practitioners. The courses were approved in what was considered to be record time, thanks to the enthusiasm of President Bok and Dean Henry Rosovsky, and thanks to the momentum of the occasion.

There is no question that the presence of the ART was a chink in the wall of the faculty's traditional resistance to studio courses in theatre. There were, however, plenty of plaster provisos to prevent this hole from growing larger. For example, the courses were accepted with a restriction applied to all other practical studio courses on campus—namely that they be related in some way to texts. This proviso—popularly known as the Bakanovsky guidelines after the wily professor of architecture who invented them—reaffirmed Harvard's commitment to academic study as opposed to mere practice, by making certain that the practice was in some way allied to texts.

The ART instructors found no difficulty assigning texts to students in their acting, directing, and dramaturgy courses. We already believed that these theatrical disciplines were a valuable alternative way to understand dramatic literature. It goes without saying that the plays of Shakespeare and Chekhov are as important to theatre professionals as Mozart and Beethoven scores are to professionals in music. Nevertheless there soon were complaints that we were not following the rules, that the Bakanovsky guidelines referred not only to primary sources such as plays but also to secondary sources such as critical commentaries. Some members of the faculty wanted courses in practical skills to be supplemented not only with readings in literature but with reading lists in literary theory.

It would seem that artists who teach make certain academics very nervous, unless they also have credentials as theorists. As one committee report recently put it, "Many specialists in drama and performances today would strenuously resist the idea that there is significant merit in the notion of a split between theorists and practitioners, between analysis and art." The same academic report goes on to question whether acting training, for example, can be properly taught by people solely interested in what it calls "aesthetics and creativity." Theatre should be considered not only a practical skill but an academic discipline influenced by "cultural context, poli-

tics, cultural differences, and global technology." The attention of the student should be drawn not only to offerings in dramatic literature—which appear in the catalogue in ever-decreasing numbers—but also to such agenda-driven courses as "The Homosexual in Drama," "Performance and Performativity," "Gender and Gender Studies," and the like. In the modern university, art is not so much banished from the campus as forced to conform to prevailing academic fashions.

It would be interesting to learn what Meryl Streep or Kevin Kline or Cherry Jones or any of the many gifted professionals whose early careers were shaped in graduate or undergraduate training programs might say were they to be told that their acting owed a debt to global technology or cultural differences. At any rate, such assertions reflect the continuing tension between the humanist and the artist, between a liberal arts education and a liberal education in the arts. For a long while I used to attribute this tension, at least in my own field, to what the movie critic David Denby once identified as "theaterophobia," and what the late Jonas Barish in his book of the same name called "The Anti-Theatrical Prejudice." Barish traced this affliction back to Plato. But he found its defining event in the closing of the English theatres during the Puritan interregnum. Harvard, like the state of Massachusetts, was founded by those very same Puritans, fleeing England after the restoration of Charles II. That fact accounts for much of the existing tension between those who practice and those who theorize.

Perhaps the *locus classicus* of this particular conflict is Molière's *Le Bourgeois Gentilhomme*, where the eponymous hero, the social climber Monsieur Jourdain, is taught the theoretical rudiments of the arts—how to dance, sing, fence, philosophize, and write love letters—by a group of specialists in those fields. He discovers that he can perform each skill much more effectively than the experts, simply by doing it. Jourdain not only learns that he has been speaking prose all his life. He also learns that he can write it with more directness and simplicity than the most learned pedagogue. In short, Molière, like his twentieth-century cousin, Eugène Ionesco, had the artist's scorn for the overschematized beliefs of his age.

I have always found it paradoxical that humanists stand in such

an ambiguous relationship to artists, considering that it is the work of poets, novelists, and dramatists that constitutes the grist of their endeavors. Obviously there would be no analysis or criticism—no deconstruction, semiotics, or gender theory—without the existence of artworks to spin theories about.

What we need to teach students most, in my opinion, is how to directly experience an artwork, not how to invent theories about it. To me the greatest obligation of education in regard to the arts—and I'm speaking now of education from the secondary-school level through the college years—is to create some appreciation for and understanding of the arts rather than competition with them. Whitman believed that great artists required great audiences. The education system has signally failed to create the great audiences that might understand, support, and maintain great works of art in this country.

And the failure is on every level. Whereas arts appreciation used to be a staple of the grammar-school education, funding for such arts programs is now very erratic. Who is the first to get fired when money is short? The music teacher. The only way to stimulate appreciation for artistic quality is through arts education in the schools, an area that has been unconscionably neglected, though the initiatives of the Annenberg Foundation have been helpful. Effective projects like the Teachers and Writers Collaborative of New York City, in which poor kids are introduced to language and poetry by practicing poets, are rare, and privately subsidized. No wonder the infrequent visit of a dance company on a grant leaves children baffled and sullen when the system employs so few full-time arts teachers to stimulate their imaginations. This is not only a cultural but a social problem. Lacking early grounding in music, drama, and painting, kids will inevitably spend their time watching action movies or playing computer games, and, when they grow up, will be likely to appease their instinctive hunger for art, music, and poetry with the easily digested fast food of graffiti, rock, and rap.

Undergraduates can be stretched in the arts not just through practice in extracurricular activities but also through being exposed to professional practice, including the literature of the field and the practical skills associated with it. After such a continuum of artistic

exposure, whether as a member of the audience or as practitioner or both, the serious student of the arts is then prepared to enter an appropriate graduate professional school for more advanced training in his or her chosen field. It is an ideal vertical arrangement that could potentially train the ideal spectator and the ideal artist. The system in operation today produces neither—only arrogant amateurs and ignorant professionals.

When McNeil Lowry was vice president in charge of the arts program at the Ford Foundation, he refused to fund any cultural initiatives associated with a university, in the belief that they were bound to be of low quality and informed by amateur standards. None of us could ever persuade him otherwise, even through demonstrated artistic achievement over a period of years in a university setting. We could never convince him that a society that had so little opportunity to find satisfying artistic experiences in the popular media might be exposed to those cultural resources in institutions of higher learning. I'm not quite ready to concede that Lowry was correct in his belief that the university would always exalt the amateur over the professional, that the cultural (as opposed to the educational) standards of academia would always be as closed to excellence as those in the world at large. Not quite yet. But I'm coming close.

[1998]

· Jews and the American Theatre ·

ANY ABRIDGED HISTORY of Jews in the American theatre would have to begin with the Yiddish Theatre movement on Second Avenue in the first half of the twentieth century, which came to America between 1800 and 1900 with the great Jewish migration. Abraham Goldfaden's *The Witch* was one of the earliest presentations, a work the German Jews tried to close down as an insult to religion ("ridiculing the Jewish people should not be permitted in a free country," one of their rabbis said, invoking a strange variant of the First Amendment).

Despite such resistance, Yiddish theatre soon developed into an enormously popular form of entertainment, featuring an army of well-loved stars, including Molly Picon, Maurice Schwartz, Paul Muni, Menasha Skulnick, Jacob and Sarah Adler, David Kessler, Boris Thomashefsky, and others too numerous to mention. Indeed these actors were so revered by the public that in death they were sometimes celebrated as national heroes; when Thomashefsky died, for example, he was laid out on the stage of the Yiddish National Theatre on Houston Street and people lined up all the way to Fourteenth Street, fifteen deep, just to see the corpse.

Perhaps because it was performed in large spaces, the Yiddish theatre was a place for large emotions, what it is probably not kosher to call ham acting. As a child, my father used to sell candy in these theatres in order to get in free. When he returned to the slum his family shared on Allen Street, he told me, he would rehearse death scenes in the hope that one day he might be discovered as another Maurice Schwartz. The best thing he ever saw, he said, was Jacob Gordin's *Gott, Mensch, und Teufel* (*God, Man, and Devil*), an admonitory tale that warned Jews not to sell out to Mammon (apparently not all of them listened).

Some of the best shows in the Yiddish theatre were written not by Jacob Gordin but by William Shakespeare, notably *The Merchant of Venice* and *King Lear*. Well, to be accurate, Shakespeare wrote them in collaboration with Gordin. For just as Goethe's *Faust* was to become *Gott, Mensch, und Teufel*, so *King Lear* turned into *Mifrele Efros*, featuring a female Lear, and *Merchant of Venice* wound up as *Shylock and His Daughters*.

What accounts for the popularity on Second Avenue of these basically gentile stories? Gordin was acclaimed for having introduced a new realism to the Yiddish stage—but a lot of theatre artists are credited with that achievement. I think it was because Gordin had discovered in Shakespeare a way to dramatize the family issues of East Side Jews—those perennial conflicts between parents and children. And, of course, *Shylock and His Daughters* has a Jewish hero— not the anti-Semitic usurer of Shakespeare's imagination but rather a suffering Jewish father whose ingrate daughter steals all his money and jewelry and then runs off with a goy. *Mifrele Efros* (*King Lear*)

featured a similar moral, being about a Jewish mother with three thankless daughters, not one of whom ever comes to visit! People lucky enough to see great Yiddish actors in those parts really had a peek into the swollen heart of an unhappy parent.

Indeed, the Jewish-American family play—Clifford Odets's *Awake and Sing*, Arthur Miller's *All My Sons* and *Death of a Salesman*, Paddy Chayefsky's *The Tenth Man* (even Tony Kushner's *Angels in America* is a variant of the genre)—was once one of the staples of the American stage. It still is, I guess, in variants such as Donald Margulies's *The Loman Family Picnic* and David Mamet's *The Old Neighborhood*. But these familiar tales of fathers versus sons, mothers versus daughters, husbands versus wives, all engaged in epic battles that invariably ended in tearful reconciliations, were ultimately derived from Second Avenue.

Speaking of quarreling families, consider the Adler clan—a family very important not just to the Yiddish stage but to any consideration of American theatre as a whole. Jacob Adler and his wife Sarah were, of course, leading tragedians of the Yiddish stage, but they also produced offspring—Stella, Luther, Jay, Celia, and Frances—who played the children roles before switching from Yiddish to English and going on the American stage. They were among a number of Jewish performers—Paul Muni and Molly Picon and Menasha Skulnick were others—who shuttled between Second Avenue and Broadway, sometimes (as in the case of Muni) going to Hollywood to become major movie stars.

The impact of Stella alone on generations of American actors is a theatrical history in itself. After cutting her teeth doing little-girl roles with her parents, she turned to playing leading parts on Broadway. Soon she joined the Group Theatre as one of its founding members, to play alongside her brother Luther, not to mention John Garfield (born Julius Garfinkle), Bobby Lewis, Paula Levin (later Mrs. Lee Strasberg), Lee J. Cobb, Art Smith, Sanford Meisner, J. Edward Bromberg, and even a few gentiles such as Franchot Tone, Elia Kazan, and Frances Farmer. She had a stormy marriage with Harold Clurman, the Group's founder and leading director. And she starred in some of the major plays of the 1930s, notably those of Odets, the Group's resident playwright, most famously (all the while

protesting that she was too old for the role) as Bessie Berger in *Awake and Sing*. After the Group failed, Stella joined the New York actors around their Hollywood pools for a while, changing her name to Ardler and her nose to an aquiline shape that never suited her as well as the original.

Stella had a lifelong family quarrel with another member of the Group, Lee Strasberg, over how the Stanislavsky technique of acting ought best to be taught. After the Group disbanded, three of its members (Bobby Lewis, Elia Kazan, and Cheryl Crawford) founded the Actors Studio. When they proved too busy to run it, Strasberg established the so-called "method" there (he later claimed it to be based as much on the naturalistic acting of the Yiddish David Kessler as on the Russian Stanislavsky). Stella started her own studio, and contrary to popular belief it was she, not Strasberg, who was the major influence on Marlon Brando.

In 1966, when she was already in her late sixties, I asked her to become our main acting teacher at the Yale Drama School where I had recently been appointed the dean. Although she taught there only two years, she had considerable influence on the next stage of American theatre—which was to develop actors for the resident non-profit companies, capable of performing both in new plays and in classics. Her acting career ended after she was bruised by the press for her performance in Arthur Kopit's *Oh Dad, Poor Dad* in London, but she never lost her lust for the theatre or her capacity to help train passionate performers for what she continued to call "the noblest" profession.

The influence of members of the Group, and later of the Actors Studio, on American theatre and American movies has been prodigious in every way. Just consider the impact of Kazan (only an honorary Jew; he is an Armenian Greek) when he gave up acting and started to direct on the Broadway stage and Hollywood. He not only staged the plays and movies of such gentile playwrights as Tennessee Williams, William Inge, and Robert Anderson, he was the prime director for Miller (Odets's rightful heir) until they split politically over the issue of naming names. But even that professional family quarrel became the occasion for a play—Miller's *After the Fall*, which Kazan, himself a character in the play, staged during his first season at Lin-

coln Center. Kazan went on to describe the split with Miller in his memoir *A Life*, as did Miller himself in his autobiographical *Time Bends*.

To illustrate further how Yiddish theatre in this country became Americanized, let me mention a somewhat more personal story, one that I have already told in a short memoir called "Boris and the Second Avenue Muse." It happened when I was a Yale Drama School student in the late 1940s, and a friend and fellow student named Boris Sagal asked me and a few others from our class to join him on the stage of the Yiddish National Theatre on Houston Street. At that time Boris was billed as the Wunderkind of Second Avenue. Why? Because he had managed to get into the Yiddish Actors union at the age of thirty-five (before Boris, the youngest member of this exclusive club had been in his late sixties). Boris wanted us Yale students (speaking in English while Boris and his company acted in Yiddish) to perform in an unauthorized stage version of a movie called *The Jolson Story*. Boris had cast himself as Al Jolson. The show was awful but rehearsing it was a delight, not least because we got a chance to eat in some wonderful Second Avenue restaurants before they, like the Yiddish theatre, faded into history.

The Jolson Story—what a perfect family story for the Yiddish stage! A young Jewish boy with a golden voice, destined—or so his doting father wanted to believe—to become a cantor in the synagogue. When Asa expresses his preference to be a *teaterzinger* named Al Jolson, performing on the secular stage, his father throws him out of the house. Years later, after Asa has become world-famous, Mama brings the father and son together again. With two tons of water spilling over the stage and into the laps of the audience, the son shouts "Papa," the father screams "Asa," and they embrace. Dynamite! Shylock and King Lear reunited with their errant children. Willy Loman reunited with Biff, his prodigal son.

On the same program with *The Jolson Story* was a vaudeville show that featured, among others, the great performer Aaron Lebedev, a Yiddish-speaking scat singer with a great talent for tongue-twisting lyrics—said to have been the chief influence on Danny Kaye. His greatest hit was a number called "Rumania, Rumania," which he sang on the vaudeville show accompanying *The Jolson Story* (the pro-

gram also included two movies and lasted four hours). He was in his mid-eighties at the time, yet he still managed to galvanize the house.

Many years later I got the idea of doing a klezmer musical based on Isaac Bashevis Singer's play *Shlemiel the First*. As drama critic for the *Daily Forward*, Singer had reviewed many Second Avenue shows, and he had undoubtedly seen and admired Lebedev. Anyway, "Rumania, Rumania" had to become the centerpiece of *Shlemiel* where, transformed by lyricist Arnold Weinstein into the rousing "Geography Song," it was and continues to be the high point of the show.

This is a long, some might think long-winded, way of saying that in the theatre, the Jewish theatre particularly, everything comes round, and everyone and everything is an influence. There are many other examples of how these influences have circumnavigated American entertainment. For example, Yiddish vaudeville had a powerful influence on American burlesque, producing such great comics as Smith and Dale, Bert Lahr, Bobby Clark, and Milton Berle. American burlesque, and its adjunct the Borscht Belt circuit, led in turn to the comedy of Berle's "Texaco Star Theatre," and Sid Caesar and Imogene Coca's "Your Show of Shows" with its great Jewish writers Mel Brooks, Lucille Kalman, Larry Gelbart, Neil Simon, and Woody Allen. These in turn generated a lot of Neil Simon comedies and Woody Allen films, not to mention Larry Gelbart's *A Funny Thing Happened on the Way to the Forum, Mash, Mastergate*, and Mel Brooks's and Carl Reiner's "2000-Year-Old Man." And those traditions clearly have a link with the Judeocentric humor of Jackie Mason.

One thinks, moreover, of the *Yiddishkeit* of Lenny Bruce and how his comedy pushed back the borders of what was once permissible. And then there is Paul Sills and the satire of The Second City (starring Alan Arkin), which led to the comedy of Nichols and May, and all those plays and films they wrote and directed together or apart. Then there is Carl Reiner's son, Rob Reiner, and Arkin's son Adam, and . . . well, you get the picture. We are the creatures of what came before, we are perpetually in debt to our forefathers, the line continues and continues. And that is why, when I think about Jews in theatre I feel the same sense of awe that Philip Roth's Port-

noy experienced when looking at all the cops, sanitation workers, and firemen in Jerusalem. Being in the theatre is like being in love. It makes the whole world seem Jewish.

[1997]

· **A Memory of Libraries** ·

(AN ADDRESS AT THE BOSTON PUBLIC LIBRARY)

LONG LONG AGO, in a far off galaxy known as Manhattan Island, boys and girls used to curl up on a sofa and read books. During the 1930s I was one of those young, print-bemused earthlings, and I still have happy memories of rushing home from school, grabbing a box of Dutch pretzels and a bottle of Nehi orange soda from the kitchen cabinet, and stuffing myself both with refreshments and with tales of King Arthur or Robin Hood, or with one of those stirring Robert Louis Stevenson adventure stories, featuring gorgeous color illustrations by Howard Pyle or N. C. Wyeth.

Since I grew up on West End Avenue, my nearest source of literature was the Public Library on Amsterdam Avenue and Seventy-seventh Street, an institution that bestowed on me the precious gift of my first library card. Amsterdam Avenue was a neighborhood dominated by working-class Irish whose young warriors were wont to grow particularly incensed at the sight of a middle-class Jewish boy invading their turf. This was especially true if said boy were wearing brown corduroy knickers and green suede shoes, the costume in which my mother insisted on dressing me for school, even though it was only slightly less provocative to bullies than short pants and long stockings. One day, having left the library with *Treasure Island* and *A Child's Garden of Verses* tucked under my arm, I was confronted by what looked like an army of glowering kids whose leader sternly asked me, "Is your name Jimmy Reilly?" To my barely audible negative reply, he barked in response, "You're a liar," and punched me in the Adam's apple. Anyone who has ever been punched in the Adam's apple knows how it can spoil your appetite

for reading, much less eating and breathing, for at least twenty-four hours.

Despite this encounter with reality, or perhaps because of it, my love of escape literature and libraries continued apace. However, just as I was eventually to replace my diet of pretzels and soda with that of meatloaf sandwiches and chocolate milk, so I was to abandon my addiction to fairy tales and adventure novels for literature of a more substantial nature. In 1947, following a period of service in World War II where I wolfed down Big Little Books—those free wartime publications represented the true beginning of the paperback revolution—I returned to Amherst College to major in medieval history under an inspiring professor named Allen Gilmore.

It was in the Greek Revival Amherst College library that I began to pore over medieval materials in preparation for a senior essay on Thomas Becket, a figure about whom I remember virtually nothing now except that he was murdered in a cathedral and that one is never to interpose the letter "a" between his Christian name and his surname (as the *New York Times* crossword mistakenly does from time to time). I do, however, have vivid memories of the almost sensuous reading desks in the Amherst library, the feel of the polished mahogany over which I loved to slide my hand until my two middle fingers got stuck in some chewing gum that a careless student had stashed under the table.

I wanted to pursue a theatrical career. My father, correctly divining that the theatre was no way to make a living, wanted me in his business. As a compromise he agreed to let me do graduate work in medieval history at Brown. Without Gilmore's inspiring instruction, however, medieval history had no luster for me. I lasted six weeks at Brown, then fled to Yale to spend a year in the Drama School. At the Yale Drama School there was little time for reading, much less for libraries—even the plays we read were in synoptic form, reduced to their plots and a few lines of dialogue. It was not the characters or themes we were supposed to reflect upon but rather the technical and casting requirements—such inspiring theatrical facts as "2 men, 3 women, 1 set, 3 hours in length."

Dispirited by what I then perceived to be the intellectual vacuum of the Drama School, I fled to Columbia University to pursue

graduate work in dramatic literature in its legendary English depart-
ment. Columbia has an imposing library building called Low Li-
brary, in front of which the female spirit of the university (known as
Alma Mater) presides over students in much the same manner as
John Harvard broods over passing undergraduates in front of Uni-
versity Hall. Across the way from Low, which is occupied primarily
by administration offices, is Butler Library, which actually contains
books. And not the least appeal of studying at Columbia were the
various adjuncts of Butler—smaller, more intimate libraries where
the books on display could be taken from the shelves and read in
comfortable chairs without the usual hassle with grumpy librarians,
crowded stacks, card catalogues, and Dewey decimal systems.

It was in one of these reserve libraries, called Carpenter, that
I did a lot of research for a master's essay on Sean O'Casey. It was
my first experience of overdosing on books. Initially attracted to
the plays of O'Casey after enjoying a production of *The Silver Tassie*
in Greenwich Village, I soon learned that reading too much too
fast of his rich urban poetry could induce a kind of literary nausea.
It reminded me of when I was nine and gobbled up too many boxes
of Crackerjack at a Giant-Dodgers ball game in the Polo Grounds.
I heaved up the contents of my stomach onto the concrete steps
of the bleachers and to this day have never been able to look
another Crackerjack box in the face. So it was with O'Casey. I still
can't read or listen to a line of his plays without thinking of Cracker-
jack.

My true mentor at Columbia was Lionel Trilling, who gave me
my biggest literary lift to date when, after a cursory interview where
I was virtually tongue-tied, he admitted me into the legendary doc-
toral seminar he regularly taught with Jacques Barzun (Barzun was
on leave for the first half of 1951, the year I took the course). I re-
turned to Carpenter Library to do research for a paper on James
Joyce's *Ulysses*, and this time every book I saw on the shelves, indeed
every event I read about in the newspapers, seemed to provide corre-
spondences invaluable to my enterprise. My paper on "Ulysses and
the World of the Commonplace" not only won Trilling's praise, it
led to my inauguration into publishing. Trilling introduced me to
Robert Warshow, the brilliant associate editor at *Commentary* in its

less belligerent, pre-Podhoretz days under the editorship of Elliot Cohen. Warshow gave me a collection of *Saturday Evening Post* stories to review for the magazine. Perhaps unconsciously influenced by a fantasy about being the adoptive son of my intellectual father, Lionel Trilling, I saw a common theme in all of those stories, namely that of adoption.

Commentary not only accepted my book review, the editors featured it on the cover as an article. I had arrived! I was immortal! My name was in the Reader's Guide to Periodical Literature! Soon after the piece was published, I rushed to Butler Library to look myself up in the Dewey decimal system. Sure enough, my identity was in print: Brustein, Robert, "Saturday's Children," *Commentary*, March 1953, pp. 352–357. *Commentary* would not accept another article from me for more than four years, aside from a short book review of a James Jones novel. But no matter. This in no way diminished my sense of pride over this initial achievement. Young people today, with their easy access to desktop publishing, have little sense of the ecstatic rush you could get from seeing your name in print for the very first time.

My next encounter with a great library was during the two years that the Fulbright Commission supported my studies in England. I had applied to Oxford and Cambridge to write a dissertation on what I perceived to be a major change in the British character after the Cromwellian revolution. What could account for the transformation of such lusty, appetitive Shakespeare characters as Falstaff and Sir Toby Belch into such vapid Restoration characters as Lord Foppington Flutter and Sir Wilful Witwoud? Why would a fashion for well-turned epigrams and pleasureless adultery replace the robust blank verse and rollicking carnal energy of the previous age? Clearly I was drawing unflattering inferences about a decline in English vigor that informed even its present-day drama, dominated as it was at the time by the likes of Terrence Rattigan. The two major British universities responded by telling the Fulbright Commission that while they would be happy to admit an American scholar that year, they would prefer not to have Mr. Brustein, thank you very much. Fortunately the University of Nottingham, perhaps because a favorite son of Nottingham named D. H. Lawrence had influenced my theories,

proved more willing to tolerate this impudent Yank and his insolent ideas.

It was nevertheless at a library of one of the universities that rejected me where I did most of my research on my subject, though it later turned into a scholarly study of the origins of anti-court satire in Jacobean drama. I was poring over the Puritan histories of the time, many of which had been banned after the Stuarts had regained the throne. Those surviving were in the dusty, cobwebbed, and unexplored stacks of that splendid example of medieval architecture known as the Bodleian. It was a source of pride at Oxford that this library was being maintained as an exact replica of the original, which meant virtually no heat in the dead of winter and very little light except for the weak illumination that poked through its narrow gothic windows. I turned over the stiff pages of my source materials with gloved hands, bundled up to the eyebrows in a heavy overcoat. Judging by the uncut pages of many of those historical tomes, I may have been the very first to examine them since they were first published in the 1650s. So transfixed was I by my reading that I barely noticed the icicles forming on my nose, the frostbite afflicting my fingers, or the chilblains swelling my toes. I had discovered the source of much of the sex nausea, the hatred of masculine women (*hic-mulier*) and feminine men (*haec-vir*), and the suspicion of flattering and adulterous courtiers that informed such Italianate court plays as Marston's *Malcontent*, Webster's *White Devil*, and Shakespeare's *Hamlet*. It was the same nausea, hatred, and suspicion that the Puritans were later to express toward what they perceived to be an effeminate court and a bisexual king.

Unfortunately for me, the historian on my doctoral committee considered all of this material to be hearsay and refused to let me use it in my dissertation. He was not much moved by my argument that it was primarily rumors and hearsay that haunted the cultural air of preindustrial England and animated its works of art. Nevertheless I always felt privileged to have been admitted into the corridors of the Bodleian and have dreamed often since of reexploring its arcane archives.

My next memorable encounter with a distinguished library was at Yale, after I had become dean of the same Drama School I had

once left in despair—namely, that unique monument to rare books known as the Beinecke. The walls of this library are constructed of a special translucent stone that admits the sun into its interior spaces in the form of gorgeous shafts of colored light. The effect is so magical that I grew accustomed, whenever planning a new production, to sit in the vestibule of the building—not to pore over illuminated manuscripts but rather to absorb illuminated rays, seeking inspiration from them as they played across the room.

During the May Day demonstrations over the trial of Bobby Seale in 1970, the Beinecke Library, for some reason, became the focus of considerable rage. Some of the more radical students were threatening to blow it up. When I expressed confusion as to why sympathy for the plight of the Black Panthers should form itself into fury against such a beautiful building, one of my distinguished colleagues explained to me that it was obscene to have a library dedicated to rare books when black revolutionaries could not be assured of a fair trial.

I was not the first to discover that even the most idealistic politics might not be friendly to literature—"All revolutions," wrote Eugène Ionesco, "burn the libraries of Alexandria." Hitler's henchmen made bonfires out of books. Stalin banned them for failing to pass the test of ideological conformity and political correctness. But this was my first personal experience of the collision between literature and politics, and how vulnerable our own fragile culture was to ideological passions.

If it is true that politics has not always been a friend to books, it is equally true that technology has not always been their enemy. On-line bookstores such as Amazon.com are making even the most out-of-print volumes available for easy purchase. But what fosters the life of books on-line may not be of equal value to off-line bookstores, and certainly not to libraries. Now that the Internet does our walking, our talking, and sometimes our reading for us, our intimacy with libraries, if not our passion for literature, has grown considerably less intense and habitual. Yet there are still many people whose love of scholarship and literature compels them to visit libraries, who manage to enjoy not only the bracing intellectual content of these buildings but their architectural embrace as well. Grateful for both, it

is with a special sense of pride and privilege that I appear before you tonight at a gala celebrating such a fine example of its kind, the stately and majestic public library of Boston.

[1999]

· *Taking the "A" Out of* NEA ·

ON A COLD DAY in February, Harvard's Kennedy School of Government played host to an event commemorating the thirty-fifth anniversary of the National Endowment for the Arts. It was open to serious question whether the proceedings were a celebration or a wake. Played before an overflow crowd of students and faculty, and a scattering of press, the evening was a theatrical event in the guise of a panel discussion, so it was appropriately moderated by the former drama critic of the *New York Times*, Frank Rich. Starring in the role of keynote speaker was the current chairman of that beleaguered agency, the genial, silver-haired Bill Ivey, former president of the Country Music Foundation. The featured players on the platform were the four surviving former chairpersons—Jane Alexander, John Frohnmayer, Frank Hodsoll, and Livingston Biddle—appearing together in public for the first time. Representing five different political administrations stretching over twenty-five years, each of these battle-scarred administrators, with the exception of Ms. Alexander (prim and trim in a white ensemble), were dressed in what appeared to be identical dark suits. Arrayed against the concrete wall of the Forum auditorium in a neat row, they looked to my increasingly glazed eyes like undertaker crows or attendant buzzards perched upon a telephone line.

The event was co-sponsored by the Office for the Arts, a mini-NEA at Harvard that, among other things, disburses small grants to artistic undergraduates. Considering the NEA's woefully declining appropriation, now fallen to $99 million from a high of $175 million in 1992, the two funding agencies were showing more in common than a mutual desire to encourage creative expression—namely a

budget that represented a laughably tiny percentage of the parent holdings. Had federal funding become so small and restrictive as to be now irrelevant to the expectations of artistic institutions? That uncomfortable issue was never raised. Instead Harvard President Neil Rudenstine welcomed the participants with a more troubling question: "Are the arts and creativity central to American civilization?"

By now the answer to this question is too depressing to repeat, which may be why nobody bothered to address it. In order to remind us of what the NEA stood for, soprano Jessye Norman came on to sing a couple of spirituals. She was just about the only genuine artist in the hall if you don't count Ms. Alexander or Poet Laureate Robert Pinsky, both there in an official capacity. After this brief display, the panelists began to hold forth on the importance of the arts to the human condition, to the human spirit, to the survival of civilization, to the quality of life on this planet, perhaps to the very future of the galaxy. (Nichols and May were already satirizing this sort of thing as far back as 1960: "The arts are perhaps the best medium of self-expression we have.") Inspirational language of this kind is the lingua franca of arts administrators. I'm often forced to use such boilerplate myself. It helps us avoid defining exactly what we mean by the arts.

Certainly the NEA in recent years has consistently failed to formulate a clear artistic definition or even to articulate a coherent artistic policy. In the earliest days of the agency, under the chairmanships of Roger Stevens and Nancy Hanks, it was evident from their support of serious artists and artistic institutions that the original mission of the NEA was to stimulate high culture. Under the regimes that followed, and under growing pressure from right-wing legislators and left-wing levelers, the NEA was to grow increasingly politicized, populist, and pop-oriented.

Ivey's skillful keynote address revealed how far advanced that process has become. Acknowledging that the agency was born out of cold war necessity, namely the need to vanquish the Soviets in every area, including education and the arts, Ivey betrayed through his choice of imagery his belief that culture was still important mainly as an extension of the political process. Reaching for a metaphor to de-

scribe the creative function, he said that "art can be the centerpiece of our international diplomacy" and that culture can be the "currency of border exchange." This was Ivey's subtle way of revealing his predilection for political utility and cultural diversity. Uneasily perched on this border, like Emma Goldman's "wretched refuse," were a variety of aliens waiting to cross over, many hungry workers and would-be citizens prepared to be employed as border ambassadors.

Ivey went on to say that "our sense of what constitutes the arts is artificially narrow," admonishing us against making any "categorical judgments" that would favor "art with a capital A." He seemed to prefer the word multi-culturalism with a small m, since that broad category relieved us of the necessity of making judgments of quality (with a capital Q). Rather than continue its traditional support for nonprofit activities, in short, Ivey now wanted the agency to include blues, jazz, country music, movies, musical theatre, and TV, all on a budget of $99 million, of which only 40 percent is devoted to "creativity." At no time did he suggest how the NEA might discriminate among all these varieties of popular culture, some of them (like jazz and blues) qualified art forms in need of financial support, others profitable enterprises perfectly capable of supporting themselves. He was more interested in the question, "How does my world engage the citizens of Wal-Mart and the shoppers at K-Mart?"

Jane Alexander, introduced by Rich as someone whose hair had literally turned white from her struggles with a recalcitrant Congress, conceded that "the Endowment has been a populist organization for a long time now." Rather than debate that point, she preferred to comment on the political climate, saying ruefully, "We need better minds in government." And no wonder. Chairwoman under Clinton, she was left out to dry by a president whose priorities never matched his rhetoric about the arts. Reagan's appointment, Frank Hodsoll, now living in Arizona as a born-again Christian, was full of Republican cheer and market savvy—for him, the arts were best regarded as "a strategic investment." Rather than lament the precipitous decline in funding, Hodsoll considered it a great accomplishment that the Endowment had survived at all. He too disapproved of art with a capital A—"the arts," he magnanimously added, "are

everything"—while warning us not to treat the NEA as a weapon against Hollywood and popular culture.

The booklet circulated by the NEA to commemorate its thirty-five years certainly confirmed Hodsoll's and Ivey's distrust of capital A art. Contrasted with photographs from the early years of theatre, dance, and opera companies, jazzmobiles, and symphony orchestras, were those from later years featuring ceramics manufacture, adobe church preservation, Ghana weaving, lace-making, basket weaving, raven and eagle drumming, Native American Lumber drumbeating, and Santos working (don't ask me).

Livingston Biddle, Carter's appointment and the first populist chairman to make handicrafts at the Endowment equivalent in importance to the arts, was perhaps the most politically focused of all the participants. He began by begging a round of applause for such friendly Washington stalwarts as Frank Brademas, Claiborne Pell, and Leonard Garment before launching into a long-winded story about the time he took Gregory Peck to meet a congressman opposed to arts funding. The point, finally revealed after a lot of pointless detail, was that two signatures were exchanged—Peck's on the autograph book of the congressman's daughter, the congressman's on the appropriations bill. Was this some kind of chapbook lesson about the myth and magic of the movies?

It took John Frohnmayer, the Bush-appointed chairman who took all the heat during the Serrano and Mapplethorpe controversies, to remind the panelists that the original mandate of the NEA was to function as a "countermarket" force in a commercial society. It was created, in other words, to support and encourage those worthy works of art generally ignored by "the citizens of Wal-Mart and the shoppers at K-Mart." A man who had been converted into a committed civil libertarian by his harrowing years in Washington (Frohnmayer was fired by the Bush administration for refusing to endorse content restrictions), he was in a position to know that "a person who has not been offended by art is not likely to be affected by book-burning." Frohnmayer was about the only one in the room willing to admit that "what we have done at the Arts Endowment has been 99.9 percent safe."

Ivey, who applauded the Supreme Court ruling that content re-

strictions were constitutional, argued, along with Hodsoll, that the head of the NEA is a "keeper of the public trust" and therefore required to make choices regarding political and sexual content. For all the talk of the human spirit, it had become perfectly clear that very few of these functionaries were willing to look squarely into the occasionally ugly face of art.

Frank Rich, as moderator, often tried to get the panel to address the unresolved issues, with little success. He noted how often the case for funding today had to use utilitarian justifications such as creating employment, increasing tourism, or raising SAT scores. And he asked how the NEA should function in a world where popular culture was being increasingly controlled and manipulated by such huge conglomerates as Disney, Livent (now SFX), and Time-Warner.

More relevant was the fate of high art in such a world, but the unspoken dirty secret of this conference was how money—or the absence of money—was contaminating the arts. With the collapse of the NEA as a significant player because of its reduced funding and confused priorities, many of the cultural institutions it used to support have had to look elsewhere for financial backing. This condition has led directly to such scandals as the Brooklyn Museum of Art's "Sensation" exhibit and its subsequent fallout. It was not hard to defend this museum against charges of obscenity coming from the office of Mayor Giuliani. Many of us did, in knee-jerk fashion, when we first got wind of the controversy. What was much less difficult to swallow were the subsequent charges of conflict of interest involving Charles Saatchi, Christie's auction house, and the way the exhibit was being used to further private financial gain. (This controversy also exposed the fact that many museums routinely ask for sales fees on paintings loaned by collectors and later sold.)

Saatchi's personal involvement in the choice of paintings in this exhibit, not to mention the way they were hung and marketed, was a striking indication of the way money dictates to, and corrupts, the world of art. In Saatchi's case, however, publicity may have played an equal part. When I visited an exhibit called "Neurotic Art 2" at Saatchi's London gallery, every single headline regarding the scandal was proudly plastered over the walls. These will no doubt be mar-

keted by Saatchi some day as a freestanding exhibit called "Sensational Me."

A similar thing is now happening in the nonprofit theatre world. Indeed, when it comes to debauching nonprofit institutions, the commercial producer Cameron Mackintosh makes the private collector Charles Saatchi look like a piker. First, his production of *Les Miz* was premiered by the government-subsidized Royal Shakespeare Company in a production directed by the then RSC artistic director, Trevor Nunn, who had also directed *Cats* there, after which both productions moved to Broadway. Then the Cameron Mackintosh production of *Carousel* opened at the government-subsidized Royal National Theatre, directed by its then artistic director Richard Eyre, before moving to the nonprofit Vivian Beaumont. And now the nonprofit Guthrie Theatre in Minneapolis, an institution traditionally devoted to Shakespeare and the classics, has mounted a Cameron Mackintosh musical (*The Return of Martin Guerre*) as part of its subscription season. That musical then moved to the nonprofit Kennedy Center in Washington where it met such sour reviews that its New York premiere at the nonprofit Vivian Beaumont Theatre at Lincoln Center (also responsible for co-producing the musical *Parade* with Livent) had to be postponed.

This is just the tip of the iceberg. Virtually every major theatre in America is in the throes of preparing a show designed to move to Broadway, always with the priming of "enhancement money" from commercial interests, and sometimes with no artistic oversight whatsoever. Clearly these theatres are now trying to make money the oldfashioned way (by earning it), and one could make the case that there is more dignity in forming alliances with commercial producers than in trying to persuade federal, state, or private foundations that you're doing enough community services or culturally diverse work to warrant their support. Yet there was a time not long ago when the NEA used to routinely monitor this sort of activity, withholding or reducing grants to nonprofit theatre companies that were selling their birthright to the commercial stage.

Now no one is watching and, even if they were, there is not enough financial leverage to make a difference. The high arts have become an endangered species in this country, being picked off by a

variety of sharpshooters, including commercial interests, populists, politicians, multi-culturalists, middlebrow critics, and not least of all the foundations. At the event celebrating thirty-five years of the NEA, I imagined I saw the heads of those extinct animals mounted on the walls, under a plaque designated "Art with a capital A—a defunct species."

[2000]

· *Millennial Blues* ·

JUST AS THE APPROACH of a millennium can inspire fears about the end of the world, so the successful passing of such a fearful date would seem to augur a cloud-free future. The first half of the year 2000, however, has thus far seemed to be less about new beginnings than about sad endings and failed initiatives. Aside from the disappointments of a variety of peace accords, the burgeoning civil wars in Africa, and a glut of natural disasters and man-made catastrophes, the year has been conspicuous for the passing of many distinguished individuals. Is it my imagination or are we seeing more of these deaths than usual, as if people had just been waiting to celebrate the millennium before letting go of life?

The theatre in particular has lost a lot of gifted artists in the first six months of the year. Dying within weeks of each other were John Gielgud and Alec Guinness, two of the greatest actors of the past century and the last remaining knights of the Arthurian age of British theatre after the passing of Laurence Olivier, Ralph Richardson, and Michael Redgrave. Granted that, in their advanced years, neither of them appeared very often on stage, it is still a shock to realize that we will never hear the sounds of Gielgud's melancholy bassoon, or Guinness's sensible English horn, reverberating through an auditorium again.

Not just because of the loss of irreplaceable artists like these, some people are coming to believe that the theatre is passing too as a vital force in everyday life. It is true that the commercial stage has

just enjoyed the most prosperous season in its history and that instead of losing performance spaces to retail shops as in the past, Broadway has been redecorating Forty-second Street with a bunch of new theatre buildings. But those predicting the death of the theatre (and such prophets have always been with us) are not likely to be swayed from their opinion by a manufactured brand of entertainment that caters almost exclusively to out-of-town tourists, foreign businessmen, and ten-year-old children.

Nor would they find much consolation in the products of the nonprofit theatres, which, following a critical decrease in contributed income from government sources and private foundations, have been growing almost indistinguishable from Broadway (and off-Broadway) in their dependence on the box office and in the lowered ambitions of their work. At the beginning of this movement it was possible to believe that every American community would soon have its own indigenous theatre, rather like those jewel boxes one finds in Italian towns like Cervia and Cesenetica, to which the villagers flock regularly before pouring into the square to argue about the play. And there is no disputing the fact that since the sixties the resident theatre movement has produced most of the interesting new plays and almost all of the significant classical revivals to be seen in the country. Many of these new plays—beginning with the transfer of *The Great White Hope* from the Arena Stage—found their way to Broadway to begin the longer life they deserved. But this transfer process was a far cry from the current fashion among nonprofit companies of accepting "enhancement money" to try out Broadway musicals for commercial producers, or naming their theatres after corporate sponsors like American Airlines. What we are seeing is the theatrical version of the hostile takeover. "Englut and devour"—the name Mel Brooks once invented for a Hollywood studio—is becoming the motto of the American stage.

The triumph of American commercialism is hardly a novelty of the millennium. What is different today is the lack of any indignation about it. It seems almost quixotic these days to criticize the relationship between art and commerce, and a little nostalgic even to try to evoke any interest in the question. Nevertheless this tension has been one of the prevailing themes of American drama, if not of American

literature (*pace* Sinclair Lewis), throughout the twentieth century. Eugene O'Neill in particular was obsessed by it. In a sense, all of his plays are (often crude) variations on the theme—from *The Great God Brown*, a parable about the way the business ethic and the creative spirit collide, to *A Long Day's Journey into Night*, where James Tyrone pauses to wonder why he abandoned a promising career as a Shakespearean actor in order to make his pile in a cheap touring show ("What the hell was it I wanted to buy?"). Indeed O'Neill designed a huge (though unfinished) eight-play historical cycle for the purpose of dramatizing the growing surrender of the American spirit to greed and materialism.

It was a subject picked up by Clifford Odets in *Awake and Sing* and then again in *Golden Boy*, when Joe Bonaparte gives up a promising career as a violinist in order to make his fortune as a prize-fighter. Arthur Miller created variations on the theme in *All My Sons* and in *Death of a Salesman*, with Willy Loman finding more creative satisfaction in building his front stoop than in a lifetime of salesmanship. And it pervades the biographies and memoirs of countless other theatre artists of the thirties and forties (chief among them Harold Clurman's *The Fervent Years*), some of them victims of the very material seductions they were trying to describe.

One of the great appeals of the American theatre has been that, unlike dance or opera, it often marries the highest and lowest forms of expression—Beckett and Bert Lahr, Ionesco and Zero Mostel, Shakespeare (and Shakespeare), Brecht (and Brecht). But the corollary of this marriage is that the American theatre also suffers from the very tensions and concessions embodied in its structure and expressed in its subject matter. Indeed it is ironic that the growing deterioration of high culture in this country—collapsing as it seems to be under the economic claims of capitalism and the social pressures of multi-culturalism—should feature as one of its principal victims such a compromised form as the theatre.

One reason is that theatre artists are so vulnerable to the lure of the marketplace. It would be highly unusual to find a ballet dancer pulled out of her company for a sitcom series or an opera singer offered a Hollywood contract (Mario Lanza was among the last). Yet these temptations await not only stage actors but also directors, de-

signers, and playwrights all the time. Anyone training for a career in the theatre these days knows that Hollywood will probably be an eventual destination, since that is where the work, the fame, and the money are most easily found.

To choose this route is not as easy as it seems. Some of the most passionate advocates of live theatre have often been those who eventually had to abandon it. Most theatre artists were originally attracted to the stage not just for reasons of ego but out of a sense of idealism. It is one of the few professions left in our society (teaching used to be another) that allows the possibility of pursuing a worthy goal with like-minded people. I respect the romance of business, but how many other industries can offer personal fulfillment equal to the creation of theatrical art in addition to their stock options and Christmas bonuses? It is partly to disguise the absence of creative satisfactions that our ravenous market economy, which now has people working sometimes twelve to fourteen hours a day in defiance of labor laws, has been making such a fetish of consumer goods in place of the spiritual enticements of the past.

Another threat to the future of theatre is the advance of technology. Recently I listened to a very brilliant friend of mine, a sometime patron of the performing arts, insisting that Internet technology would soon make all live performance obsolete. (It is already beginning to do the same for publishing.) Before long, he theorized, we would be able to stream onto our computers anything we wanted in the way of plays, concerts, dance, and opera, with the performance enhanced by high definition, even three-dimensional, video and brilliant acoustical devices. This, he argued, would obviate the annoyance of having to leave the house and ride or walk through noisy crowds to a theatre.

I was as chilled by the idea as he was excited by it. It is not just that the appetite for live theatre in this country has been evaporating, or that theatregoing is no longer an essential part of everyday life. What is also disappearing is the desire for human contact. Aside from houses of worship, how many places are there left for us to congregate in? Yes, there will always be massive sports events and rock concerts, but even these are more conveniently witnessed on the home screen in the safety of the living room. If not the theatre and the

other performing arts, what will be able to lure us away from our home entertainment centers to mix with others of our species?

If we lose this capacity to jostle and scramble, encounter and connect, the future of this provisional art form will be very dark indeed. One thing that will help preserve the theatre's future is the passion and obstinacy of the people who still continue to labor in the field. I have known playwrights who, without having had a production in many years, continue to grind out scripts. I have known actors undiscouraged by years of relative unemployment, and directors still eager to work even under the most onerous conditions. Of course these artists cannot create in a vacuum. What they need are great spirits on the other side of the stage. As Clurman wrote about his own precarious Group Theater, after it succumbed to Hollywood defections and box office failure: "For a group to live a healthy life and mature to a full consummation of its potentiality, it must be sustained by other groups—not only of moneyed men or civic support, but by equally conscious groups in the press, in the audience, and generally in large and comparatively stable elements of society. When this fails to happen, regardless of its spirit or capacities, it will wither." Clurman was not speaking of isolated sects but of unified assemblies. Walt Whitman put it more succinctly: "Great poets need great audiences." If the new millennium is to fulfill its promise, and all those dire millenarian prophecies are to be proven wrong, we need to rediscover how to congregate comfortably in intelligent, mutually supportive groups.

[2000]

· **Himalaya Criticism** ·
(A SPEECH TO THE AMERICAN THEATRE CRITICS ASSOCIATION)

I AM VERY HAPPY to see the faces here of a lot of old friends and colleagues. But I should confess my puzzlement about whether I have been invited into your midst today as a member of the critics' fellowship or as an emissary from the enemy camp. Traditionally the critic

and the artist have had about as much in common with each other as the mongoose and the cobra, though there's little doubt about which of these creatures has been doing most of the swallowing.

One source of the enmity, of course, is that the critic can wield such power over the theatre artist—whether in terms of career, development, or future employment. But another, I believe, is that these two opposing professionals so rarely communicate directly with one another. The critic can write reviews. All the theatre practitioner can write, and rarely, is poisoned-pen letters to the editor. Once Sylvia Miles dropped a plate of spaghetti on the head of John Simon, but while the gesture was eloquent enough, I don't count it as a form of communication. My point is that any fraternization between the artist and the critic is generally forbidden or condemned. One Boston media critic, who shall be nameless (a lot of people would like to see him jobless), finds any commerce between the two a sign of conflict of interest—otherwise known as COI, to use its dreaded acronym.

As you know, I hold both jobs myself, critic and practitioner, which gives this gentleman a serious case of acid reflux and makes me one of the targets of his indigestion. Another is John Lahr, partly because Lahr is a sometime playwright as well as a scribe, and partly because he occasionally conducts interviews with artists whose work he reviews. (So, by the way, without any sense of contradiction, does our fulminating Boston media critic.)

No question, there is some danger if a critic grows too friendly with an actor, a playwright, or a director. Will he modify his opinion to preserve the friendship? Will he soften his standards to mollify the performer?

There is an even greater danger, to my mind, of a critic poised to make fundamental judgments about a production without knowing very much about the artistic process. One reason for this ignorance of process is that the critic isn't familiar enough with the people who create it.

A coterie of critics, particularly those ensconced in academia, seem to believe that theatre is created not so much out of human characters or large passions as out of fashionable theories and politi-

cal ideologies. Admittedly, there is a growing number of plays being written these days that are dominated by racial and gender issues, just as many plays of the thirties were preoccupied with issues of class warfare and workers' rights. But to my mind this is a very narrow and repetitive slice of the theatrical spectrum, as well as being a boring way to write about and look at theatre. There was a time when major critical minds like Eric Bentley were guiding us toward previously unrecognized beacons of dramatic literature (not only Brecht), and when Jan Kott was stimulating unprecedented interpretations of Shakespeare and the Greeks. Today academic critics talk primarily to one another, in a language that no practicing theatre artist can be expected to understand.

If academic critics often try to bend their dramatic interpretations into feminist and multi-cultural constructions, media journalists tend to validate works of dramatic art primarily on the basis of subjective judgments. Their only obligation, they believe, is to express their opinions about plays—something I have come to call Himalaya criticism, after Danny Kaye who, when asked how he liked the Himalayas, replied, "Loved him, hated her."

No one denies that some degree of judgment is required in writing theatre criticism. And it is certainly the reviewer's opinion that the reader is most eager to skip down the page and find. Even as mighty a figure as T. S. Eliot has allowed that the function of criticism was "the correction of taste." But an equally important duty, he quickly added, was "the elucidation of works of art." There is a lot of correction going on these days, all right, sometimes verging on public spankings. But how many of us are taking the trouble to elucidate the material we review? Instead of depth analysis, what is generally offered are unsupported opinions: Loved him, hated her. Thumbs up, thumbs down. Siskel and Ebert.

Himalaya criticism is criticism for tourists, not for those who might be eager to learn more about theatre. For the Himalayan critic is essentially producing a Broadway Zagat, a theatrical consumer's guide, informing the out-of-town visitor, who has little time between her shopping and museum visits, or maybe insufficient cash for more than one night on the town, precisely what show to see on

a quick visit. This is the most disposable kind of criticism, suitable for wrapping fish in, which will be read with neither pleasure nor profit even a day after the event.

The fact is that most people today practicing the craft of theatre criticism haven't been very well trained for it. Some of them have read even fewer plays than actors have, and few of them have any knowledge of theatre history. To solve this problem we initiated a critic's program at Yale in 1966, providing training for students in dramatic literature, dramaturgy, and theatrical production. We had to abandon the program a few years later because we couldn't find suitable places for any but a few of our graduates (Michael Feingold, who found a permanent spot at the *Village Voice*, was one of the lucky ones). Instead of trained critics, the newspapers, magazines, and networks were interested in people with an entirely different kind of talent. Harold Clurman used to call such people "typists"—journalists with a knack for writing quickly who had largely come up through the ranks, stopping for a moment on the drama page on their way to or from sports, dine and dance, editorial, television, or some other section irrelevant to the arts. Yes, all these worthies no doubt saw a few shows before beginning their careers as theatre reviewers. But that's like saying that all you need to teach Scandinavian literature is to spend a couple of days in the fjords.

What qualifies these people to slide so easily from one department to another, without any apparent preparation? What can all these disciplines possibly have in common? Two things. They require a fast writer. And they require someone with strong opinions. But to adapt a rather crude analogy, opinions are like armpits. Everyone has at least two, and everybody thinks that the other guy's opinions stink. (If you find that analogy offensive, you should hear the unexpurgated version.)

Heinrich Heine, the German poet, once wrote: "The reason we can no longer build Gothic cathedrals is that they were built from convictions and all we have is opinions." What a potent distinction. Between an age characterized by passionate beliefs and one characterized by purely personal views.

Nobody believes we critics ever had the capacity to build cathedrals. But it's chilling to think we might be among the obstacles

blocking their construction. I have never been able to find a satisfactory answer for those people who ask me why my opinions should be considered any more compelling than those of the average theatregoer, especially when I've sometimes had two different opinions about the same work in the course of a week, depending on how I was feeling and who I saw it with. Yes, I have a Ph.D. in dramatic literature, but so do a lot of benighted academics. You can haul out your scholarly credentials to justify your opinions, but no amount of degrees can guarantee their accuracy. Who, then, will judge the critic's judgment? Posterity, perhaps, assuming that the future will continue to have any interest in our hasty scribblings.

Still, even the eye of history is less intrigued with a critic's correction of taste than with his style and ideas—and his gift for elucidating works of art. Bernard Shaw was frequently wrong in his theatrical judgments. He praised Ibsen's plays in all the wrong order and for all the wrong reasons. To the end of his days he disliked Oscar Wilde's masterpiece of wit, *The Importance of Being Earnest*, much preferring his plodding domestic drama *An Ideal Husband*, and he declared that we would never forget the forgettable plays of a forgotten playwright named Henri Brieux. But we prefer Shaw to, say, someone like William Archer, who had a better critical track record, because Shaw wrote out of a sense of conviction. He had a vision of the theatre larger than his estimate of individual plays.

Similarly, Kenneth Tynan's taste is seriously open to question today. He much preferred John Osborne to Samuel Beckett, whom he declared to be a poet of the decadence, and he praised Bertolt Brecht for his politics rather than his poetry. But nobody has yet been able to describe a performance in a way equal to Tynan's imagery and perceptions; nobody has ever managed to make the actor live more vividly before your eyes. Harold Hobson had better taste; Tynan was the more percipient critic.

History is full of stories of critics who missed out on the most significant works of the time. Brooks Atkinson panned Clifford Odet's *Awake and Sing* after its first night and almost closed the play. Harold Clurman invited him back to see it about a month later whereupon he wrote a rave. "Has the play changed, Harold?" Atkinson asked. "No," Clurman answered, "you have."

My own city, Boston, has been particularly obtuse about new work. One sign in a local concert hall read: "Exit in case of Brahms." Every time Stravinsky was played by the Boston Symphony—even when *Rite of Spring* is performed today—there was a long line of blue-haired Cabots and Lodges making for the door. Indeed, when it comes to the theatre, what major play of the modern period was not the subject of critical abuse when it first appeared?

The London opening of Ibsen's *Ghosts* was greeted with such a delicious array of vituperation that the collected reviews could have formed the basis for an Anthology of Fetid Terms by Eric Partridge. It was called "an open drain," "a suppurating sore unbandaged," "a lazar house," along with many other appetizing expletives. Chekhov's *The Seagull* was roundly hooted by a raucous audience and quickly closed after its opening night; it was a dead issue until Stanislavsky resurrected it for the Moscow Art Theatre some years later. Almost every major Irish play, from *The Playboy of the Western World* to *The Plough and the Stars* has been hooted off the stage. The year O'Neill's great masterpiece *The Iceman Cometh* opened in New York, the Critics Award went to *All My Sons*. When Beckett's *Waiting for Godot* came to Broadway after a disastrous opening in Florida, Walter Kerr of the *Times* declared that the play was "out of touch with the minds and hearts of the folks out front." It closed in a few months. Every time I see an uncomprehending review of a masterpiece, I think of Max Reger's note to the music critic who panned his *Sinfonietta*: "Sir," he wrote, "I am now sitting in the smallest room in my house. I have your review before me. Soon it will be behind me."

The American theatre is in considerable disarray these days, but not because it lacks fine artists in every area of activity. As a matter of fact, the quantity and quality of talent, in my estimation, has never been higher. No, it is in trouble in no small part because it lacks an informed and committed criticism that could help create an informed and committed audience. Unlike most arts, the theatre event has the great disadvantage of being impermanent ("Ephemera, ephemera," moans the older actor in David Mamet's *A Life in the Theatre*, looking out into the empty house). When hostile criticism destroys a production early on, there is nothing left of it except in the minds of the few spectators who had the opportunity to see it.

Sometimes those few spectators are enough to keep the production alive. One example I had a hand in was the premiere production of a play (or rather an "Actors Opera") called *Dynamite Tonite*. This was an unusual piece by Arnold Weinstein with music by William Bolcom that was originally offered under the auspices of the Actors Studio. Although I was a second-night critic, Arnold had invited me to the first night—a fortuitous happenstance since the show only had a first night. It was attacked so savagely by then *Times* critic Howard Taubman that the leadership of the Studio panicked and shut it down the very next day.

Later that year I had the opportunity to mount an abbreviated version of *Dynamite Tonite* for a Channel 13 television series I was doing on off-Broadway theatre. And when I became dean of the Yale School of Drama in 1966, *Dynamite Tonite* was the first show we did under the auspices of the newly formed Yale Repertory Theatre. That show went back to New York, and ten years later we staged it again. Last March, Rip Torn did yet another version of it at the Actors Studio, where this erstwhile turkey has now been stuffed and enshrined.

I mention this because it was only by sheer luck that a worthy piece of theatre was rescued from oblivion and neglect. About how many plays and playwrights can the same be said? To take another example, Don DeLillo, whose novels are justly and widely praised, wrote what I consider the best first play since Richard Brinsley Sheridan's *The Rivals*. It was called *The Day Room*, and it played to great acclaim at the ART in two separate seasons. What happened when it came to New York? Frank Rich panned it, and the play disappeared. It took Don another seven years to consider the theatre worthy of another dramatic work (*Valparaiso*).

Stories like this can be repeated in every city of the country. Indeed, the whole nonprofit system was set up precisely in order to protect theatre artists from the depredations of uninformed criticism. It was the original hope of this movement that, by developing audiences with discriminating taste through exposure to adventurous programming, our theatres would be able to neutralize the power of the critic and encourage spectators to think for themselves.

Unfortunately, this plan depended on subsidy for the arts, and

we all know what happened to that vain hope. The institutional strength of performing arts groups throughout the country has been systematically eroded by cuts in federal funding. And no independent philanthropy, either in the private, corporate, or foundation world, has emerged to take the place of government subsidy.

This weakens the hand of the artist and strengthens the hand of the critic. For without subsidy, the nonprofit theatre is inexorably forced back into the jaws of the box office, which means the hit/flop thinking associated with the profit-making theatre. And who arbitrates the commercial process and exercises the greatest power over it? Yes, our old friend the Himalaya theatre critic.

Yet, with very few exceptions, the Himalaya critic is a very conservative, very conventional arbiter who believes his taste is identical with, indeed can even predict, the tastes of the average spectator. And that may very well be true because the average spectator is by instinct hardly an adventurous theatregoer. Such people come to the theatre to stretch their legs rather than their minds, though in the typically cramped Broadway theatre they are rarely able to do either. The nonprofit theatre is also charged with stretching—but stretching talents, the talents of actors, directors, designers, and playwrights, even stretching the recalcitrant tastes of his audience. How in the world can these theatres grow and prosper without the support of an informed critical mass?

I know that some of you may suspect I am asking you to become boosters and cheerleaders for problematical artistic institutions. You well may question whether it is the critic's proper business to lend his or her voice in support of theatrical undertakings, or to be concerned with anything other than making honest judgments, regardless of the consequences. Bernard Shaw, for one, defended the value of destructive criticism, saying that construction encumbers the grounds with busybodies while destruction clears the air and encourages freedom.

I acknowledge the value of destructive criticism. But while Shaw was a critic of considerable style and grace, he was not a critic with very much power. And it is the element of power that has entered the theatre's periodic tables and changed them irremediably. I've been pretty destructive myself in my day. But I've always had the lux-

ury of writing for a periodical—*The New Republic*—most of whose readership, so far as I can tell, haven't been to a play in twenty years. I am, therefore, perfectly at liberty to say what I think without killing the hopes of the playwright, without affecting the employment of actors, without reducing the royalties of directors. You have no idea how liberating that is. It was to protect that privilege that I had little difficulty some years ago turning down an offer from the *Times* to become its drama critic.

By contrast with the critic for small magazines, the Himalaya critic has considerable power, in certain places even absolute power. And if power corrupts, as Lord Acton's proverb goes, absolute power corrupts absolutely. The supreme example of this corruption of power is the *New York Times* which, by default, and through the collapse of virtually every other New York newspaper, has become the sole arbiter of success and failure in the New York theatre.

What is more, the *Times* is aware of this power and exults in it. And this too has had a malign effect on the theatre community. Let me give you just one example (not the obvious one, the reign of Frank Rich). Three seasons ago the New York Theatre Workshop produced a prize-winning version of Eugene O'Neill's unfinished play *More Stately Mansions*. It was, to my mind, one of the most extraordinary things I had ever seen on stage. But included in the program was an essay by Arthur and Barbara Gelb, two of O'Neill's biographers, saying the play should never have been adapted, much less performed, because it was a crude and unfinished piece of work, and because O'Neill had expressly asked that it be burned after his death.

Now Arthur Gelb, aside from being O'Neill's biographer, is current chairman of the New York Times Company Foundation, after having held many executive positions with the newspaper. I suspected, sniffing conspiracies, that publishing the Gelbs' protests in the program was the theatre's effort to diffuse a powerful newspaper's potential hostility toward the production. If this was the strategy, it failed. *More Stately Mansions* was panned by both *Times* reviewers, using many of the same reasons expressed by the Gelbs.

Considering the impermanent nature of the theatre, who in the future will be able to judge whether this production of *More Stately*

Mansions was a worthless exercise, as the *Times* critics announced in unison, or a potent and successful effort to rebuild a ruined colossus.

We who stand in judgment of the theatre have been so busy arbitrating hits and flops that we have failed to provide a context for our criticism, or a consistent point of view, or any salient purpose other than a reputation for good taste. Thus we have been inexorably drawn into the commodity culture, left to traffic between the manufacturer and the consumer. What is our alternative? Without softening our opinions, cannot we season these opinions with—how hard for me to say this—a little humility?

A little historical perspective might help too. It was the critics who allowed one of the few theatrical cathedrals ever built in this country, the Group Theatre, to expire of indifference and neglect, because the critics were too busy savaging the productions to see the value of the company. "This is murder, to be exact," wrote Clifford Odets, the Group's major playwright, "the murder of talent, of aspiration, of sincerity, the brutal imperception and indifference to one of the few projects that promised to keep our theatre alive."

Where the Group differed from the commercial theatre, and where the nonprofit theatre differs from Broadway, is that it was meant to be a permanent institution for developing works of art, not a showshop for producing hits. A critic's function in regard to such institutions has to be different from a critic's function as a consumer's guide. It is not the single play that matters to these theatres but rather the whole range of the work. Few critics today are trained to be repertory critics, analyzing the evolution of an institution, and the development of a company, from play to play. Few are accustomed to observe the relationship of one play to another, or the way a company tries to refresh classics and take chances on new plays. They are only accustomed to check out the Himalayas, and that, Odets angrily observed, is not the function of a critic but the act of an assassin.

A pretty strong condemnation of our mystery. Are we prepared to go down in the dock of history as enemies of the imagination just so we can guide audiences toward an evening's entertainment? Of course, I have been talking all along about the *secular* life of the theatre, by which I mean the reputation of plays and play productions in

their own day, for which we critics bear some responsibility. What I would call their *afterlife*, the way they are perceived by posterity, may be something none of us can influence (fortunately), no matter how powerful our position. But a theatre artist can't just live in hope of a revised historical verdict, any more than the assassinated Lincoln could be expected to take comfort in having a holiday and a tunnel named after him. Every critic has a stake in the survival of the theatre because without it, what is there left for us to have opinions about? The Himalayas?

[2001]

· II ·

Plays and Performances

· *Popular Elitism* ·

WHEN I FIRST SAW Tom Stoppard's *Arcadia* in London, I was persuaded not to review it. I had gone in the company of a good friend who loved the play, a brilliant theoretician and Oxford don. Sensing my reservations, he urged that I not write anything until I'd boned up more on Newton's Second Law of Thermodynamics, Fermat's last theorem, Lord Byron's biography, and the evolution in English gardening (initiated by the eighteenth-century landscape architect Lancelot "Capability" Brown) from formal walkways to picturesque irregular ruins. I thought at the time that any cruise ship freighted with so much erudite cargo was not going to float very well or accommodate many passengers without advanced degrees, but it was possible that my sour response was owed to ignorance.

Now that I have completed a refresher course in physics and mathematics, literature and horticulture, and after visiting the Lincoln Center production and reading the play twice, I'm a little bit smarter but still unrepentant about my dissenting view. *Arcadia* is a highly literate, ingenious, and intelligent theatrical entertainment, probably Stoppard's most accomplished play. But while one must respect the playwright's wit and erudition, it strikes me as the work of a brilliant impersonator rather than a dramatist with his own authentic voice. The play smells more of the lamp than of the musk of human experience.

Stoppard's prodigious intellect may explain why he has become (as Yeats called Shaw) the chosen author of very clever journalists and the only contemporary dramatist to be endorsed by the *New*

York Review of Books. His research is impeccable and his writing is elegant. He brings real intelligence to an art form that appears to have lost its minds. Indeed he may very well restore modern drama to the mainstream of modern thought. But just as *Rosencrantz and Guildenstern* was a precious variation on *Waiting for Godot,* just as *Jumpers* was a lightweight trapeze for the logical positivism of A. J. Ayer, and *Travesties* played verbal hopscotch with the writings of Joyce and Trotsky, so *Arcadia* is a virtual grab bag of literary and scientific ideas. I hesitate to employ an epithet that is currently being used to discredit so much important art and thought, but the play seems to me a popularized expression of elitism. *Arcadia* synthesizes abstruse material not in order to advance thought or illuminate minds so much as to intimidate the ignorant. Like *Hapgood,* it is a mental exercise with no discernible purpose other than to demonstrate the author's considerable virtuosity and flatter the intelligence of the educated liberal classes.

Philosophically *Arcadia* is an effort to dramatize those tensions between science and humanism first explored in C. P. Snow's *The Two Cultures and the Scientific Revolution.* Stylistically it is an attempt to write a literary wit comedy (sometimes a sex farce) in the tradition of Congreve, Richardson, Wilde, and especially Shaw. This is a respectable enough ambition. These are the writers who constitute the central English dramatic tradition after Shakespeare. (Paradoxically, all of them are Irish.) Stoppard fits himself neatly into the tradition. Indeed, perhaps the greatest achievement of the Czechoslovakian-born Tomas Strausler is how, even more impressively than the Polish-born Joseph Conrad, he has managed to master the language of his adopted country.

Unlike Conrad, however, Stoppard still hasn't found his own style or purpose, which may explain why so much of his material seems researched rather than invented. In the *New York Review,* Anne Barton identifies similarities between the characters in *Arcadia* and those in Thomas Love Peacock's novel *Headlong Hall.* They also bear resemblances to a number of figures in the Dram. Lit. syllabus. Lady Croom, for example, the tart-tongued dowager of Sidley Park ("surely a hermit who takes a newspaper is not a hermit in whom one can have complete confidence") often sounds like Lady

Bracknell chastising Ernest for being an orphan. Thomasina, the preternaturally bright student of the tutor Septimus Hodge, reminds us, when she is not piping like Wilde's Cicely Cardew, of those precocious brats in Shavian comedy. The poetaster Ezra Chater, whose wife is "in a state of tropical humidity as would grow orchids in her drawers in January," is a scion of the dim-witted comic cuckolds of Restoration drama. As for Stoppard's diction, it alternates between Wildean epigrams and Shavian paradoxes in an impressive display of sparkling, if extinguishable, fireworks. Even Stoppard's elaborate stage directions, which identify the very books on the schoolroom table, remind us of Shaw's passion (in plays such as *Man and Superman*) for documenting the contents of libraries. *Arcadia*, which lost out to *Love! Valour! Compassion!* in the Tony Awards, is clearly the superior work, but it should have been nominated for Best Original Play of 1904.

Structurally Arcadia features two separate but parallel historical epochs, which emerge in the final scene. In the first, set in 1809, we follow the fortunes of Septimus Hodge, mathematician and literary critic, as he tutors, flatters, and makes love to the various inhabitants of the Crooms' ancestral home in Derbyshire. In the second we are back in modern times, witnessing a *logomachia* between two academic scavengers—Hannah Jarvis, biographer of Caroline Lamb (Byron's mistress), and Bernard Nightingale, her academic critic and scholarly rival—as they compete to reconstruct the events that we, the audience, have already witnessed.

Nightingale, whose scholarly insularity is exceeded only by his academic arrogance (the model for this character may be C. P. Snow's archenemy, the literary critic F. R. Leavis), concludes on the basis of minimal evidence that the person who seduced Mrs. Chater and fought a duel with her husband was Lord Byron, thus accounting for the poet's precipitous departure for the continent. Being privy to the enacted events, the audience knows that the real seducer was actually Septimus, who ended his life as the Sidley Hermit, living in architect Richard Noakes's overgrown hermitage after Thomasina's premature death in a fire.

That Bernard Nightingale emerges as the comic butt of *Arcadia* seems rather ungrateful of Stoppard, since such academic detectives,

being the likeliest ones to appreciate the arcane puzzles of his play, will undoubtedly be writing monographs about it for years to come. Bernard typically loves personalities ("who wrote what when") at the expense of facts, and like Leavis, the D. H. Lawrence scholar, he is the only one in the modern section of this putative sex farce who has any genuine interest in sexual behavior. Hannah shrewdly catalogues Bernard's erotic obsessiveness ("Einstein—relativity and sex. Chippendale—sex and furniture. Galileo—'Did the earth move?' "), but like most of the characters in *Arcadia*, even the amorous ones, she seems rather juiceless herself. Thomasina's reading of Newton's discovery that heat can't work backward is a forecast of entropy—the gradual cooling of the earth. But this cooling has already taken place among people who have neither the passion nor instinct to lift the play into poetry.

Ultimately *Arcadia* may be more successful as literature than as drama. It is certainly more enjoyably experienced in the study. I didn't much like either of Trevor Nunn's overactive productions, though (apart from Dearbhla Molloy's forceful Hannah in London) the New York version has the more convincing performances. Victor Garber makes a deliciously pompous Bernard, Billy Crudup is nicely barbed as Septimus, Robert Sean Leonard is attractive as Valentine, and Lisa Banes imperious as Lady Croom. The young Paul Giamatti manages to make his Ezra Chater into an engaging middle-aged fuddy-duddy. Jennifer Dundas has pipsqueak charm as Thomasina, and Blair Brown has a laconic edge as Hannah. Mark Thompson's circular set and period costumes, not to mention his Adam-and-Eve-in-paradise act curtain (after Poussin), establish the timelessness of the proceedings. But what Nunn fails to excavate from the text or the acting is the reality underneath the witticisms, possibly because Stoppard never bothered to plant it in this Arcadian garden.

Will *Arcadia* last? I'm not so sure. Great plays are meant to be experienced, not simply admired, and this one never aspires to touch any organs other than the brain pan. One of Stoppard's characters speaks in Shavian fashion of "the decline from thinking to feeling," but any playwright, Shaw included, who considers this a "decline" is

doomed to a transitory celebration of surfaces, a dance of showy learning and flashy wit on a highly polished floor.

[1995]

· *Homogenized* Diversity ·

IT'S A MELANCHOLY PARADOX that every principle begets its polar opposite. Consider how the current mania for cultural diversity in the arts is creating political homogeneity and intellectual conformity. The theatre provides the most telling examples. It's as if a large majority of American playwrights, directors, actors, and producers had all attended the same schools, read the same books, met the same people, shared the same friends, voted for the same politicians, signed the same manifestoes, waved the same flags.

As a result we've been breathing the suffocating atmosphere of total consensus over the past decade or longer (as evidence, read any back issue of the TCG house organ, *American Theatre* magazine— its entire contents seem to have been written by the same woolly-minded social studies graduate). In such a world all blacks are fervently if angrily protesting racism, all women are passionately confronting sexist discrimination and sexual harassment, all gays are maintaining an identical nobility, laced with bitchy wit, in the face of desperate battles with homophobia and AIDS, and all white male oppressors are either confessing their guilt or persisting in their wicked ways. Contemporary theatre, in short, now features as many stock characters as *commedia dell'arte*, as many familiar faces as a Doublemint ad endlessly multiplied. An art form wholly dependent on the element of surprise is now in the grip of mind-numbing predictability.

Even well-worn modern classics are being shaped to this jelly mold, as witness the Tony Award–winning production of *A Doll's House* (Belasco Theatre). That many of its cast and its director are British suggests that the problem is not defined by nationality—ide-

ological conformity knows no boundaries. It's not that this particular *Doll's House* lacks surprise. It's just that the surprises are so driven by fashionable agendas. In the act of accepting her Tony for best actress in the play, Janet McTeer joked that she had originally asked the producers to let her play Torvald. That, as a matter of fact, is exactly what she seems to be doing. The actor cast as her husband (Owen Teale), though relatively virile, is no match for this strapping Amazon. Rather than being terrorized by a domestic tyrant, McTeer looks as if she could break the poor man over her knee. Perhaps, like Olivier and Richardson used to do in *Othello*, McTeer and Teale ought to consider alternating their roles.

It's no reflection on the quality of her considerable acting abilities to say that McTeer has woefully misinterpreted her part. Every new production of a classic, of course, demands a fresh approach. But the reason for rethinking plays is to find your way back to the author's original intention, usually obscured under layers of orthodox piety. McTeer's resolutely ahistorical reinterpretation seems mainly designed to illustrate how a powerful woman can shatter glass ceilings.

Claire Bloom played Nora, quite properly, as a highly intelligent individual forced to act the mindless little squirrel whenever she had to ask her husband for a little pocket money. By kneeling and begging with her paws extended, she managed to shame every man in the house. McTeer's effect on male audience members, if my reaction is typical, is to raise fears for her mental balance. At times I was tempted to rush to the nearest CVS and fetch her some Valium. Giggly, hysterical, hyperactive, nervously fiddling with her blonde wig, riddled with crochets, tics, and nerves, biting her nails, McTeer comes on less as a woman in need of self-realization than a neurotic in need of group therapy. Strindberg would have adored her. She's the perfect realization of all his neurasthenic heroines, of what he called "the third sex." Strindberg might even have revised his sour view of Ibsen ("that Norwegian bluestocking") had he been able to watch McTeer transforming Nora into his own Miss Julie.

It is true that Krogstad's threat to expose Nora's forgery plunges the poor woman into a state of dithers. But McTeer shows nervous symptoms from her very first entrance. By the time she gets

to her tarantella dance, in fact, she's almost ready to be committed—
screaming like a banshee, hurling the tambourine, bouncing off the
scenery. Torvald describes this dance as "too reckless, strictly speak-
ing, it went beyond the bounds of art." He might have been charac-
terizing McTeer's entire performance. Her final declaration,
however, is a refreshing exception to the general twitching, being
quiet, controlled, determined. She plays the scene as if it were the
culmination of a serious emotional crisis, the kind that leads to a sep-
aration agreement. Still, McTeer's Nora would never have left her
house or abandoned her children. She would have kicked her hus-
band into the street and phoned up a tough divorce lawyer. When
she slams the door on her way out (an anti-climactic moment in this
production because the set is so ill-designed), she has hardly per-
suaded us she will try to realize herself through an independent life.
Rather, she seems to be slamming the door on what's left of her hus-
band's private parts.

Happily, a number of plays have recently opened that refuse
to cater to ideological expectations. One of these is Jonathan
Reynolds's bravely conceived and wittily written, if imperfectly
crafted, *Stonewall Jackson's House* (American Place), a satire-within-
a-satire on the whole sham of political correctness in the nonprofit
theatre. In the first act a black woman begs a white couple to take
her home as a slave. In the second she reveals herself to be the defi-
ant author of the mind-boggling play in which this event occurs
(thus exposing her white theatrical colleagues as pious liberal frauds).
Another source of agreeable surprise is Paula Vogel's *How I Learned
to Drive* (Century Theatre). In *Hot 'n' Throbbing*, an earlier play not
yet seen in New York, Vogel scandalized some feminists by creating a
pornographer who was not only decent of heart but female of gen-
der. In her new play she is even more incendiary, conceiving a victim
of sex abuse who actually comes to love her abuser. Despite its sub-
ject matter, *How I Learned to Drive* is neither a polemical play nor a
feminist tract. Rather, it is a strange exotic love story—a variation on
Nabokov's *Lolita* with Humbert Humbert as Lolita's uncle.

It was e. e. cummings, I believe, who first used stick-shift driv-
ing as a metaphor for sexual activity. Learning to drive for the pre-
pubescent heroine L'il Bit is also equivalent to initiation into the

mysteries of erotic experience ("Idling in the Neutral Gear," "Driving in First Gear" are some of the suggestive scene headings). L'il Bit is actually introduced to these mysteries by her Uncle Peck who has been in love with her since she was a baby. Stuck in an unsatisfactory marriage, Peck is slowly drinking himself to death. His only salvation is his passion for L'il Bit, to whom he actually proposes not only sex but marriage ("You've gone way over the line," responds the more grounded L'il Bit, "Family is family"). Curiously, the word incest is never uttered in the play. Peck seems more worried about her tender age. Touching her body, examining her breasts, he postpones any attempt at full union until her eighteenth birthday (he is then forty-five), when he will no longer be guilty of statutory rape.

As the play moves along from 1962 to the present, weaving back and forth in time, Vogel creates an oddly lyric atmosphere, culminating, after Peck's death, in L'il Bit's final speech. She is thirty-five now, in her own car, and driving with authority and control. Looking in the rearview mirror, she sees the ghost of Peck in the backseat. Repeating all the instructions he taught her, she enters a state of true transcendence. The car is moving smoothly along the road—"and then," she adds in the wonderfully elegaic tone that pervades the entire play, "and then I floor it."

This is a moving culmination of an exquisitely modulated production, sensitively directed by Mark Brokaw. And it is tenderly acted by Mary-Louise Parker as L'il Bit and David Morse as Peck. Morse—greyhaired, rugged, plagued by inner demons—is pretty much the same age throughout the action. But Parker brings her character through a variety of subtle changes from shy teenager to mature woman, and wallops us with the depth of her feeling. Despite the explosive subject matter, there isn't a judgmental moment in the entire evening. Effortlessly Vogel moves her characters out of the provisional world of morality into the timeless world of art.

Moisés Kaufman's *Gross Indecency* (Minetta Lane Theatre) does pretty much the same thing. The conflict between art and morality, in fact, is the play's basic subject matter. Subtitled "The Three Trials of Oscar Wilde," *Gross Indecency* manages to turn relatively familiar

material—the trials and imprisonment of Wilde on charges of sodomy and pederasty (the judicial British euphemism is "gross indecency")—into a damning indictment of the way government tries to regulate our private lives.

Under Kaufman's dynamic direction, a strong energy drives this play, from the moment Wilde decides to arraign the Marquess of Queensbury ("the most infamous brute in London") for calling him a "posing Somdomite [sic!]," to the day of his death after serving two years in Reading Gaol. Wilde's relationship with Queensbury's son, Lord Alfred Douglas ("Bosie"), had enraged the marquess, and Wilde, on the crest of his fame as a popular dramatist, conceived the bad idea, encouraged by Bosie, of bringing the marquess to trial for libel.

Ultimately, of course, this strategy was bound to backfire, and Wilde found himself in the dock—indicted not only for his relations with Bosie but with a number of young working men in London as well. Wilde never regarded these encounters as acts of unlawful behavior but rather as extensions of a special sensibility shared by Socrates, Plato, and many Renaissance artists. As a modern commentator points out during a break in the action, the trial was the first to treat the modern homosexual as a social subject, even though Wilde didn't consider himself a homosexual but rather (anticipating Roy Cohen in *Angels in America*) a man who loved sex with other men. Wilde didn't believe in isolating the erotic from the aesthetic components of life. But that was the source of his tragedy—that he tried to turn morality into art during an age that preferred to turn art into morality.

One of the powerful things about this play is the way it subtly suggests that such constraints are not confined to the Victorian age. The continuing conflict between artistic expression and family values is, of course, at the heart of the congressional unpleasantness over Mapplethorpe, Serrano, Karen Finley, and the NEA. At his trial Wilde predicted that "the world is growing more tolerant. One day you will be ashamed of your treatment of me." He was only half right. The press today might be more tolerant of homosexuals than the hysterical jackals of Fleet Street, but not much has really changed. Even in our more permissive time, the prohibitionist Puri-

tan impulse to impose its narrow will on the private lives of citizens remains as insistent as ever. The hysteria over adultery among army officers is only the latest example.

Wilde, as depicted in this play—and as poignantly interpreted by Michael Emerson in a performance that perfectly catches the man's arrogance and innocence—represents a flawed but inspired artist brought to his knees by people who refuse to recognize the rights of privacy or respect the twists of idiosyncratic behavior. The depressing thing is that, almost a hundred years later, the same winds are chilling individual freedom, not just from the direction of the benighted conservative Establishment but from that of its enlightened opponents on the liberal left as well.

[1997]

· *Ivanov Revisited* ·

IVANOV, Anton Chekhov's first full-length drama, was written (when the author was twenty-seven) in ten days and revised for the next fourteen years. Chekhov's original exhilaration over having composed a play "without a single villain or angel in it" was followed—in keeping with his customary depreciation of his own dramatic work—by extreme dissatisfaction with *Ivanov*, despite its success on the Russian stage. He called it an abortion, a dramatic miscarriage, and sardonically renamed it *Bolvanov* (or Blockhead).

Both of these assessments were correct. *Ivanov* is a ruined masterpiece, a wonderful mess. It reveals all of Chekhov's masterly control of character, his uncanny ability to transform the most desperate situations into comedy, and his sardonic sense of the wastefulness of Russian life. At the same time it is the most artificial of his plays, not to mention the most explicit. Each of the first three acts ends with a melodramatic flourish, including an interrupted love scene later to be recycled into *Uncle Vanya*. And the last act ends with the hero's death on stage by suicide (in an earlier version, by heart attack) as he "runs aside" and puts a bullet through his brain. All of Chekhov's

plays employ the conventions of melodrama, but in the later ones at least he managed to keep the bloodier stuff in the wings.

In style *Ivanov* is neither comedy, tragedy, nor drama but tragicomical satire. It has often been noted that the hero bears a generic name like John Doe, suggesting that Chekhov intended him to be more representative than realistic. Ivanov is meant to be typical of those indecisive liberal intellectuals who had lost their faith in social progress after the failure of Alexander II's reforms. Such characters were being idolized on the Russian stage at the time as Slavic Hamlets, objects of sympathy and concern. Chekhov was eager to explode this Romantic myth. For him the Ivanov type was neither pitiable nor heroic but rather ludicrous and absurd. He lacked what was for Chekhov a crucial component, the most precious element in the human periodic table, namely "iron in the blood."

Ivanov nevertheless emerges as the most attractive figure in the play. By comparison with him, the other characters are small of spirit and bankrupt of imagination, particularly the moralistic Doctor Lvov, who holds a single, often simpleminded view of Ivanov. Everyone does in fact. Ivanov is serially characterized as a charlatan, a Tartuffe, a ne'er-do-well, a callous monster, an anti-Semite, an object for rehabilitation—anything but what he is, a neurotic intellectual whose spiritual threads are fraying at the seams.

But however Ivanov is regarded, whether as a subject for satire, patronization, or contempt, he remains the character most percipient about his own defects. He anatomizes his sins and failings, spitting out insults and blurting out remorse, in arias of elegaic self-recrimination that are later to be recomposed by O'Casey (in *Shadow of a Gunman*), O'Neill (in *A Touch of the Poet*), Osborne (in *Epitaph for George Dillon*), and other troubadours of chronic self-hatred. When Ivanov asks the alcoholic clown Lebedev what's wrong with him, his friend replies that it's his environment that's killing him. Ivanov rejects this as a cliché, but it is very close to the truth. He is the first of Chekhov's superior men (Astrov is another) to find himself curdling in a shiftless, mindless, backbiting provincial society.

He seems, in fact, to be suffering from what we now call clinical depression. (Having no Prozac in his black bag, the moralistic Doctor Lvov prescribes self-reformation.) "I lack the strength to lift my-

self up," Ivanov says of his condition, and later, "I'm too lazy to walk to that door and you talk of America." He is suffering from a spiritual hernia, the result of hoisting too many ambitious hopes and expectations. Now he is in the grip of indolence, lassitude, indifference, and spiritual anomie. If his past was filled with energy and excitement, his present is vacuous and dull. And he feels like an exile in a mean little province very much like Chekhov's hometown Taganrog, populated with miserly gossips, scheming stewards, card-playing nitwits, immature young girls, fortune-hunting aristocrats, and title-hunting widows. His marriage to Anna Petrovna, who is suffering from consumption, has soured. In an uncontrolled moment he tells her she's dying and snarls about her Jewish origins (Chekhov himself, though he admired Jewish people and had a relationship with a Jewish woman, was not above calling Jews "Yids"). And now he is being pursued by the young heiress Sasha who wants to reform him for her own romantic purposes.

His only active moment in the play is to take his own life, presumably to save Sasha from an ill-advised marriage. It is a false moment. In real life he probably would have married the girl and repeated all his old patterns.

The Lincoln Center production of *Ivanov* at the Vivian Beaumont stays safely and comfortably within the confines of domestic comedy. It is well designed by John Lee Beatty (sets) and Catherine Zuber (costumes), and it has been directed with precise attention to detail by Gerald Guttierez. It can also boast some fine performances, notably Marian Seldes's Zinaida, a beautifully etched portrait of a woman too mean and miserly to provide her guests with anything more nourishing than gooseberry jam; William Preston's mute servant Gavrila (a rough sketch for Firs in *The Cherry Orchard*), a diminutive and ancient actor on spindly legs who can express more with his eyebrows than most actors do with their voice boxes; and, preeminently, Max Wright's Dickensian Lebedev, a sleepy, whinnying, self-deprecating rural councilor with a nose like a sweet potato and a heart as big as Mother Russia. Wright's use of his hands alone could constitute a session in comic acting.

Other performances are solid enough, notably Hope Davis's ethereal Sasha, Tom McGowran's athletic Borkin, Jayne Atkinson's

langorous Anna Petrovna, Jeff Weiss's bridge-besotted Kosykh, Lynn Cohen's gossipy Avdotya, and Judith Hawkins's buxom Babakina (the title-hunting widow). But Robert Campbell as the Alceste-like Doctor Lvov acts like a refugee from Tom Cruise buddy movies, and Robert Foxworth as the indigent Count Shabyelski doesn't cough up enough of the self-hating acid spewing from the heart of a decent aristocrat in the throes of bartering his self-respect for a widow's fortune.

Most damaging of all, there's a hole in the center. I defer to no one in my respect for Kevin Kline's abilities as a comic character actor, and I am full of gratitude for his willingness to take on taxing stage roles when he could be increasing his equities in Hollywood. But at present he doesn't seem to be paying enough of the price that must be exacted for playing a soul in hell. His anguish is all surface. Very little proceeds from his interior. The performance is intelligent, carefully worked out, and dynamic, but it lacks a single important component, depth of feeling. Likewise the staging of his suicide, with Ivanov shooting himself almost by accident, and the rest of the characters shutting the doors on his body, struck me as artificial.

I am of two minds about David Hare's adaptation. He has modernized the text considerably, sometimes, particularly with Lebedev's lines, to rich comic effect ("Zinaida, here is your money, drop dead!" "To this bulbous old nose, the marriage smells wrong," "I feel like I'm living in the skull of a demented skunk," etc.). But the elegy at the heart of the play seems to have become unheard music. The self-lacerating soliloquies don't resound with sufficient mournfulness. The pity of it is gone. And while it is probably sensible to upgrade Ivanov's age from thirty-five to forty-six in order to accommodate Kevin Kline's progress into middle age, that change diminishes the sense of loss one should feel over the untimely suicide of a gifted man.

Nevertheless this is a presentable *Ivanov*, if not a memorable one. There is a wholly realized society on the stage, engaged in some splendid comic turns. The production may not persuade you that *Ivanov* belongs in the pantheon of Chekhov's great mature plays, but it reveals enough of the author's human and artistic qualities to make you happy in his company.

Well, perhaps happy is the wrong word. *Ivanov* is Chekhov's most hopeless play. It lacks his later panacea for despair—namely, devotion to work. In depicting how Russian enthusiasm is quickly followed by fatigue, he comes as close to the brink of nihilism as he does anywhere in his writings, and only his warm humanity keeps him from falling over the edge.

[1997]

· McNally on the Cross ·

CORPUS CHRISTI means, in Latin, the body of Christ. It is also the name of a seaport town in southwestern Texas where Terrence McNally was born and raised. Today, as everyone now knows, the phrase has developed added significance as the name of a play that provoked a blizzard of controversy before it was even read or staged. There has not been so much fury directed toward a single piece of theatre since the religious uproar over *The Deputy*, Rolf Hochhuth's indictment of the Vatican's indifference to the Jewish fate in World War II.

McNally's title is aptly chosen. In *Corpus Christi* he focusses obsessively on the body of Christ, more accurately the body parts of Christ, suggesting not only that Jesus and his twelve disciples had sexual appetites just like anybody else but that Jesus and Judas were homosexual lovers. Considering the storm provoked by Martin Scorsese's *The Last Temptation of Christ* just for suggesting a little hanky-panky between Jesus and Mary Magdalene, this kind of revisionism was destined for trouble as the sparks fly upward. It certainly reignited the religious right, some of whose more maddened acolytes threatened to bomb the Manhattan Theatre Club (MTC) and kill its directors, Lynne Meadow and Barry Grove. (And people used to complain about murderous reviews!)

The Manhattan Theatre Club's instinctual reaction was to cancel the production, a decision that led an influential group of theatre figures, Athol Fugard among them, to threaten the MTC with artis-

tic quarantine. Terrorized by right-wing death threats, intimidated by left-wing ostracism, bombarded with thundering editorials in the *New York Times*, the MTC finally agreed to let the production proceed, though not before adding a few supernumeraries to the cast, namely police officers and security guards, and bringing in such additional props as guard dogs and metal detectors. Although *Corpus Christi* opened to nothing more hazardous than barking bullhorns and screeching demonstrators, nobody bombed it except the critics.

As an artistic director myself, I hope I would never bow to pressure and cancel a controversial play. At the same time I can understand Lynne Meadow's fears for the safety of her audiences, not to mention her theatre, her associates, and herself. Athol Fugard has earned his right to rebuke the MTC by withdrawing a scheduled work from its season. For years he risked his own life fighting repressive forces in South Africa. But I wonder whether there wasn't something just a little bit facile in the self-righteous way the American petitioners proceeded to jump on the MTC. A principle of artistic expression was certainly at stake, but so were human lives. Anyway, the issue is now moot. Free expression has triumphed, for the moment, over censorship and intimidation. The inalienable rights of the artist have been preserved. But given the selective way the First Amendment is being interpreted these days, I hope that in the future the theatre community will be as vigilant in defense of a play that criticizes our favorite causes as of one that promotes them.

Where Lynne Meadow and her associates can be fairly faulted is in their taste. The critical appetite for McNally's most recent culinary packages (*Lips Together, Teeth Apart; Love! Honour! Compassion!; The Master Class;* etc.) is not one that I have been able to share. But at least those plays had McNally's customary wit. *Corpus Christi* contains all the soft flaws of his canonical gay works with none of their brittle attractions. Please do not understand me too quickly. I have considerable admiration for many gay-oriented plays (Paul Rudnick's satires, for example). Tony Kushner's *Angels in America* is an often penetrating look at a universe in which everyone, including the seraphim, seem to be homosexual. Even Larry Kramer's polemics have a passion I can respect. What is considerably less appealing to me is the theatrical marketing of gay self-glorification. *Corpus Christi*

is hardly the first time Jesus has been "outed." Eric Bentley wrote a play about a homoerotic Christ some thirty years ago. But this is undoubtedly the first play in which the author seems to have confused the story of Jesus with his own autobiography.

Consider the plot. After announcing that "we are going to tell you an old and familiar story" ("no tricks up our sleeves, no malice in our hearts, we're glad you're here"), thirteen attractive young men come forward to introduce themselves to the audience and, to the sound of rising gorges, to recognize each other's "divinity as a human being." They are all native Texans from McNally's home town, Corpus Christi, dressed in jeans and T-shirts, plying local professions such as teaching, law, and medicine. One (James) is an architect who designed the Roman cross. Another (Thaddeus) is a hairdresser ("Has anyone got a problem with that?"). Still another (Phillip) is a male hustler. And then there is Judas, whom Jesus loves, whose crowning achievement is, as he says, "I've got a big dick." There are no women cast in this play (the men play the female parts), and, aside from one Asian, no minorities. The absence of multicultural representation is one of the few ways in which the biblical story has not been schlepped wholesale into the late twentieth century.

True, the character known as Peter is a fisherman, as in the synoptic gospels. And there are other resemblances to the New Testament interspersed among the modern parallels. Indeed, limp as it is, the play even begins to accumulate some power toward the end when McNally drops his preoccupation with modernizing the action and just tells the always gripping story of the Crucifixion. For the most part, however, McNally pushes his plot forward with easy anachronistic correspondences. The Virgin Mary gives birth in a motel. The Magis provide her with room service. One of their presents is a Flexible Flyer. The Lord God promises such heavenly sensations as "laughter and friendship and the joy of skinny-dipping on a hot summer's day."

Jesus, also known as Joshua, gets to celebrate his thirteenth birthday, harassed by a father who wonders why he doesn't "like pussy" and play football. This Jesus is a sensitive lad more interested in Broadway musicals—a form celebrated by D. A. Miller in his new

book *Place for Us* as the underground home for gay young men. Joshua even gets the chance to sing "I'm in Love with a Wonderful Guy" (Goy?). We may assume that eventually, had he been allowed to live past his thirtieth birthday, Jesus-Joshua might have followed McNally in writing his own musicals. Perhaps *The Zion King*.

Graduating from high school, Joshua is voted "most likely to take it up the Hershey highway." Still, by contrast with Judas who likes only boys, Joshua is attracted both to boys and girls—in a word, "people." In the midst of trying to make out with someone of the other sex, he hears hammering. In fact he hears hammering throughout the play. Only with Judas does he seem to find sexual if not emotional fulfillment. Joshua warns him, "You can come no closer to me than your body." Why? It is hard to say, since Judas has shown scant interest in anything else.

Joshua soon begins to perform some miracles. He cures a truck driver of leprosy. He exorcises a demon. He multiplies the fishes. The local doctor is unimpressed ("We don't need Messiahs," he snorts in the play's one reference to AIDS, "We need cures"). But his young male friends, including Judas, are so overcome by Joshua's dazzling gifts that they kiss his feet. Only one disciple protests—"It reeks of servitude and the language of slaves"—so Joshua proceeds to kiss *his* feet. At this point I longed to hear Jackie Mason start spritzing about gentile foot fetishism ("Jews kiss their mezuzahs, the goyim like to kiss each other's toes"). Things were getting so desperate that even Nathan Lane might have been a relief.

Then, surprisingly, McNally almost begins to tell the story straight. The language grows more formal, the action more hieratic. Joshua stops going to gay bars and preaches the Sermon on the Mount. (As in *The Life of Brian*, we're too far away to hear it.) He marries James and Bartholomew, thus giving biblical sanction to gay weddings. He excoriates the homophobic clergy ("All the fag-haters in the priest's robes") while noting that the hammering has stopped. It will begin again when he is nailed to the cross.

At the Last Supper, Joshua observes that "one of you will betray me"—it turns out to be the guy with the cigarette, the one chewing on the matzoh. Losing courage, he tells his disciples he is frightened of dying. He is brought before Pilate who asks him, "Art thou a

queer" (Joshua's coy answer is "Thou sayest I am"). One of Joshua's high school girlfriends has her knuckles rapped by a Catholic teacher at the moment he is being whipped. He is attired in a purple robe, crowned with thorns, hailed as "the King of the Queens," and laid upon the cross. The thirteen actors come downstage to address the audience: "The son of man will come at the time ye least expect him." I think we may still have some time to wait. Springing into my head was that old wheeze about John Wayne playing a Roman soldier in some biblical epic by Cecil B. DeMille, who, having been asked to speak his one line with a little more awe, drawled, "Awwww, truly he is the son of God."

Joe Mantello has guided his thirteen-member cast through this modern misery play with considerable grace, and the actors maintain their dignity speaking some pretty awkward dialogue. For *Corpus Christi* is showbiz at its most pretentious and its most self-important. Homosexuals have suffered a great deal in our country. The most recent outrage, where a gay men in Wyoming was lashed to a fence and pistol-whipped to death, bore an uncanny resemblance to a crucifixion. One could imagine a play that compared the suffering of an innocent victim like Matthew Shepard to the passion of Christ. But identifying homosexual persecution with the fate of Jesus is not quite the same as confusing the four gospels with a playwright's psychic autobiography.

[1998]

· *Pastoral Shakespeare* ·

SUMMER SHAKESPEARE has always been a joy because summer is a season that belongs to Shakespeare. No other dramatist has imagined so vividly the bracing pleasures of life in the woods. A country boy himself, he gave his own name to a rustic in *As You Like It* and his mother's name to the Forest of Arden. The allure of that Arcadian world where the banished Duke Senior finds "tongues in trees" and "sermons in stones," not to mention the magical properties of

Titania's fairy kingdom, the coastal beauties of Duke Orsino's Illyria, the bumptious rusticity of Polixenes' Bohemia, and other such bucolic sites, provide a storehouse of images that remain an indelible source of comfort through the long winter months. Two recent summer Shakespeare productions lovingly capture those recreational images—not just through verbal metaphors but through the splendors of their physical design.

Nicholas Hytner's version of *Twelfth Night* at the Vivian Beaumont is distinguished by another exquisite setting from Bob Crowley, an Irish scenic artist who is finally receiving the recognition here he has long deserved. Crowley's last assignment with Hytner was *Carousel*, a musical the designer turned into a dazzling retrospective of early-twentieth-century American art. Enhanced by Catherine Zuber's costumes, Crowley's *Twelfth Night* is set in an exotic court out of *The Arabian Nights*, bounded by circular wharves stretching out to a distant sea. Even before the lights come up, Orsino (Paul Rudd)—a bare-chested, longhaired Eastern potentate—is lolling langorously near a bathing pool in a drug-induced torpor, listening to Jeanine Tesori's oriental melodies being played on bongos and gamelons. Drowsy, languid, overfed on the food of love (music), this Orsino is almost always in the company of musicians. Accompanied by three sailors, Viola (Helen Hunt) enters from far upstage, in a seagreen gown, wading through shimmering water and mist. Accompanied by her ladies in waiting, the Countess Olivia (Kyra Sedgwick) enacts her grief in a large arbor under huge black umbrellas, moving in rhythm to a Requiem.

In tune with contemporary fashion, the production is set in no consistent culture, place, or time. Sir Toby Belch (Brian Murray) and Sir Andrew Aguecheek (Max Wright) wear contemporary Western clothes and at one point eat some Chinese takeout. The acid fool Feste (David Patrick Kelly) hops about in a green suit, an orange knitted cap, and sandals, and sings "Oh Mistress Mine" to the tune of a soft rock ballad stitched with electric guitar arpeggios. When Malvolio dons his yellow stockings, he attaches them to a pair of shorts.

The problem is that Hytner's inspiration seems to have stopped with the sets and costumes. To be sure, Brian Murray's Sir Toby

and Max Wright's Aguecheek are an engaging pair of clowns. Looking and sounding like the old movie actor Cecil Kellaway, Murray plays that renegade sot with all the florid gestures of a classical hambone. But his exploitation of Sir Andrew has a streak of mean cunning, suggestive of the way that Iago is later to gull Roderigo. As for Max Wright, he makes another rich artistic gift to Lincoln Center, following his contribution last year as Lebedev in *Ivanov*. His voice quavering through his glottis like a constipated bellows, his body jerking through space like a mechanical toy, he becomes the very embodiment of craven idiocy, of false bravado. Terrified by Sebastian, he jumps into Orsino's pool and frantically backstrokes away. I also admired the way David Patrick Kelly managed to emphasize not so much Feste's amiable charm as his bitter foolery. Almost from the beginning he is motivated by a sour vindictiveness toward Malvolio ("And thus the whirligig of time brings in his revenges").

Alas this gifted acting trio is not helped much either by Amy Hill's flat Maria (a buxom Amazon cast against type) or by Phillip Bosco's humorless Malvolio. I once described Bosco as an American actor with a face like Sir Michael Redgrave and a voice like Sir John Gielgud. Here he seems to be bucking for his own knighthood, giving an elocutionary performance that would not seem out of place at the Royal National Theatre. Bosco's Malvolio is pompous all right, but it's questionable whether that quality belongs more to the character or the actor.

Helen Hunt is giving a clean, clear, cool interpretation of Viola. She reads the verse in a controlled, informal manner, and moves with considerable grace and poise. But her air of sangfroid would have been more appropriate for Olivia—a normally regal part that Kyra Sedgwick plays as if she were the brassy, squeaky, hyperactive star of a sitcom. (I must say I found her charms more compelling when, having jumped into the pool with Sebastian, she emerged with her dress clinging to her wet body.) Hytner has staged a fine recognition scene with the reunion of Viola and Sebastian rising in an emotional swell, and there are other good things in the evening. But the deeper issues of the play often seem to be scanted, especially the ambiguous sexuality in the relationship between Olivia and Viola. Most of the plea-

sures of this Lincoln Center *Twelfth Night* are absorbed through the eyes.

Cymbeline is currently receiving its second staging in ten years by the New York Shakespeare Festival (JoAnne Akalaitis last directed it as her farewell production at the Public Theater in 1989). Produced at the Delacorte as part of Shakespeare in Central Park, this version has been concocted by the Romanian stage and opera director Andrei Serban. Serban and I have done seven shows together and are now preparing an eighth for the coming season. Three members of the cast, moreover, have been members of my company. Michael Chybowkski, responsible for the lighting, is one of our resident designers (so by the way is Catherine Zuber, who did the costumes for *Twelfth Night*). And my theatre has sometimes collaborated with the composer, Elizabeth Swados. I mention these affiliations to satisfy those interested in potential conflicts of interest. I could of course elect not to write about the production, but it deserves a review, which I will try to make more descriptive than prescriptive.

The set designer, Mark Wendland, has set this tale of ancient Britain and ancient Rome on a verdant mound of grass. The area is decorated with four cypress trees and a circle of sand with a boulder in the middle resembling the altar of a Greek orchestra, the whole thing bounded by a body of water. Ten placards—white on one side (for Britain), red on the other (for Rome)—are employed to suggest changes of scene. What has always functioned as a stage in the middle of Central Park, in other words, now seems to be an extension of the park itself, beautifully illuminated and ending at the feet of the audience. Thus we are invited as participants into Shakespeare's sylvan world, even grow complicit in his plot when Posthumus wanders through the audience raging against his supposedly adulterous wife.

Serban's other major innovation is to have the Roman gods, so often mentioned in the play, actually play a part in the action. In the text, Jupiter comes to earth at the end to serve as *deus ex machina*. In Serban's production, Jupiter, played by the saturnine Liev Schreiber with a gait that has the suggestion of a goose step, is a

fairly constant presence, both in his godly persona and in the person of the villainous character Iachimo. This doubling creates the sense that Iachimo's wager over seducing Imogen (he settles for cataloguing the items in her chamber after wading hip deep to her watery bed) has either been part of another celestial sexual intervention, like Leda and the swan, or a heavenly pretext designed to test Posthumus. That Posthumus fails the test and is nevertheless forgiven only underlines and extends the theme of exoneration that is the *leitmotif* of Serban's concept. Even the ghosts of the Stepmother Queen and her nitwit son Cloten—more accurately, Cloten's severed head—make a final appearance to join in the general benediction.

Clearly Serban is exhuming the spiritual, mythic, and religious aspects of the play—buried under two hundred years of rationalism—rather than its qualities as a tragicomic romance or fairy tale. And these transcendent qualities are nowhere better embodied than in the Imogen of Stephanie Roth Haberle. Endowed with long black hair and piercing deep-set eyes, the beauteous Mrs. Roth Haberle appears throughout most of the play clad in a long white robe (designed by Marina Draghici), which almost disguises the fact that the actress is in an advanced state of pregnancy. Yet the hint of impending childbirth emphasizes the poignance, and the danger, that follow her pursuit of Posthumus to Milford Haven. Seeing the headless body of Cloten and thinking him to be her husband, she cries "O! 'tis pregnant, pregnant," grabs her belly, and smears her cheeks with his blood.

That climax is followed by one of the most gripping moments in the production. Asked her identity by some Roman officers, she shrieks, "I am nothing" with such a shuddering sense of loss that it seems as if we have entered the world of *King Lear*. (Later, walking through the water carrying a candle, she brings to mind Lady Macbeth.) Everything ends happily, of course, in a long denouement staged with Arthurian stateliness as the British court congregates in long black-hooded gowns. But in the meanwhile we have accompanied the heroine on a perilous journey that has brought us to the edge of tragedy.

Strong qualities are also to be found in the performances of

Herb Foster as Cymbeline, George Morfogen as the Storyteller, Hazelle Goodman as the wicked Stepmother, Robert Stanton as a pink-haired Cloten, Philip Goodwin as the sympathetic servant Pisanio, and especially Randall Duk Kim playing Belarius. As the adoptive father of the king's lost sons, Guiderius and Arviragus, Kim sustains a resolute center of loyalty and strength in the face of misfortune and misunderstanding, contributing considerably to the dynamism that drives the production.

Like *The Winter's Tale*—indeed like *Othello*—*Cymbeline* is about a woman falsely accused of adultery who is ultimately acquitted of slander. The power and fury with which Leontes, Othello, and Posthumus generalize their indictments of female inconstancy suggest that Shakespeare himself may have felt a similar sting in his own marriage (it is a theme that runs throughout his work). On the other hand, Shakespeare's daughter Judith was officially charged with adultery, and his compassion for his wronged child may explain the prevailing atmosphere of forgiveness. At the very end of this production, when Imogen and Posthumus are reunited, when Iachimo is spared, when the Romans are freed from their chains, when an eagle rises over the stage and Jupiter appears in a brilliant gold gown backlit between the trees, we feel the characters being blessed with absolution. The theme of trial, misunderstanding, and reconciliation that pervades all of Shakespeare's last plays has found its resolution in the lap of nature warmed by summers in the sun.

[1998]

In the summer of 1999 the Williamstown Theatre produced a version of *As You Like It* staged by the new director of New York's Classic Stage Company, Barry Edelstein, and featuring Gwyneth Paltrow as Rosalind. I went for the same reason everybody else did, to see whether Miss Paltrow could handle a major Shakespearean role. Her luminous performance in *Shakespeare in Love* had already convinced many of us that she had the potential to be a fine classical actress.

Paltrow did not disappoint my expectations, though the production did a little. Having played both lovers (male and female) in

Shakespeare in Love, and having been shipwrecked on a strand at the end of that movie, presumably in preparation for playing Viola, she then went on to perform Shakespeare's other major trouser role at Williamstown with the same authority, grace, and luminosity she displayed in the films. Paltrow's Rosalind first appears at court in a strapless red gown at the side of her friend Celia (played charmingly by Megan Dodds) who is costumed in green. Paltrow is ravishing in a dress, but she's even more appealing in pants. Instead of bedecking her uncommon fine-boned beauty with a mustache and goatee as she did in *Shakespeare in Love*, Paltrow plays the trousers part as an ungainly youth in knickers and spectacles, his peaked cap worn backward on the head, like an awkward ah-shucks version of Twain's Huckleberry Finn or Tarkington's Penrod. Occasionally she gets a little shrill, as if she hasn't quite measured properly the dimensions of the theatre. But when she lowers her voice to that of an adolescent boy, she finds the perfect pitch of the part.

Paltrow makes her instruction of Orlando in the arts of love an act of sheer bravado. When he offers to leave her side for two hours, she demonstrates a capacity for heartbreak. Although Paltrow has the chops to show how many fathoms deep she is in love, she is no suffering Juliet. She can modify her feeling for Orlando with a charming skepticism about the relationship between passion and survival (as in "Men have died from time to time, and worms have eaten them, but not for love").

Only Mark Linn-Baker, playing Touchstone, is her equal in the cast. Dreadfully costumed as a 1940s pimp, he has the good sense to underplay his part when all around are overplaying theirs. He has a comic interlude with a model of a sheep on wheels that is sheer Chaplin, though he is required to repeat the gag at least two more times. And he is the only one in the cast capable of singing the Shakespearean songs rather than belting them out.

A jazz band sits on stage to help punch out the musical accompaniment. It's a good band, thoroughly out of place in the Forest of Arden. So is the setting, which makes this sylvan paradise look more like an overdecorated bordello. And since the good duke, played by Byron Jennings (who plays the bad duke as well) is stylishly dressed in riding boots and jodhpurs, we get little sense of the fact that he

and his court are in exile, eking out a precarious existence with limited resources.

Epstein is badly served by his designers, and he has made some odd casting choices as well. Michael Cumpsty is an accomplished classical actor, but to play Jacques like a swashbuckling soldier is to ignore the central quality of the character, which is his jaundiced disposition. Likewise the various female rustics perform as if they've emerged from the dressing room of some Broadway musical or Village discotheque—Phoebe comes on like a cowgirl out of *Annie Get Your Gun*, and Audrey has the delivery of a wannabe on *Comedy Central*. Shaw once observed that the title of *As You Like It* was Shakespeare's way of admitting he'd sold out to the audience, and much of this production seems designed to confirm that insight. But Gwyneth Paltrow is the real crowd pleaser—not because she tries to perform Shakespeare without tears, but because she has the ability to play her role with appetite, imagination, humor, and a refreshing devotion to authorial intention.

[1999]

· **A *Season of Parch*** ·

WITH ALMOST HALF the New York theatre season over, managers are reporting the largest ticket sales in theatre history. Inevitably it is the spectacles that still have the greatest drawing power—and by "spectacle" I mean eye-popping events of every description. A lot of the box office boom has been inflated by enormous advance sales for *The Blue Room*, where people seem to be mortgaging their summer homes just to get a brief glimpse of Nicole Kidman in the raw. Not many of these offerings, in my opinion, are the source of much artistic refreshment for an already parched season.

A new Sophocles production at the Ethel Barrymore Theatre is *Electra*-fying a lot of people, who are also expressing surprise over the way an ancient Greek classic has managed to become a Broadway hit. The last time this happened, I seem to remember, was in the late

forties when Judith Anderson galvanized audiences for months with a pyrotechnical *Medea* (retitled *The Cretan Woman*). Like that Robinson Jeffers version of Euripides' tragedy, Frank McGuinness's smooth colloquial adaptation of Sophocles' *Electra* provides opportunities for "great acting" by amputating most of the mythological references from the text. It's true there are not many of us left who share the religious beliefs of Periclean Athens. But you can't fully understand the plays of Aeschylus, Sophocles, or Euripides until you acknowledge that, along with the narratives of Homer, they were the scriptures of ancient Greek theology (comparable to our Old and New Testaments). In Greek theatre the orchestra area was built to house a religious altar rather than to seat paying customers. And it was not to win Tony Awards that the Chorus sang and danced around it.

It would be nice if modern productions afforded us even a shred of insight into why these works were written. But this is an *Electra* without the gods. The choral odes of the Women of Mycenae, which carry most of Sophocles' religious affirmations, have been considerably trimmed. And that Chorus has been reduced to one speaking character (powerfully played by Pat Carroll), accompanied by two relatively mute if attractive sidekicks, none of whom sing or dance. A program note by the director, David Leveaux, suggests why the play has been pulled from its own roots: "*Electra* is not an obscure classic," he writes, "a strange story of a distant time and place and people." It "is a moral struggle that resonates now from the Balkans to the streets of Omagh." In other words, you don't produce a Greek classic these days in order to expose audiences to a great matricidal tragedy. You stage it to reproduce the daily headlines.

At these ticket prices it doesn't hurt either to have a showy performance in the title role. Zoë Wanamaker enters the scenic desolation (unfinished brick walls, Queen Anne chairs buried in dirt, a large operating table supported by a broken Corinthian column) wearing an outsize overcoat and a white plaster mask. She removes this mask to reveal a set of ravaged features, topped with spiked and bloody hair, some of which seems to have been torn out of her scalp by the roots. Clearly Wanamaker is paying a huge price to

play this role, and neither the actress nor her director ever lets you forget it. Her performance is one long hoarse wail. Considering all the emotional effort, it's unfortunate that her snub nose and saucer eyes occasionally make her look less like a wronged tormented princess than like Marcel Marceau impersonating Alfred E. Newman.

Derelict and outcast, sunk in perpetual grief over the death of her father, she pukes in disgust when confronted with her magisterial mother Clytemnestra (the regal Claire Bloom). Orestes (Michael Cumpsty looking like an Irish revolutionary) finds her "beauty has been broken and miserably disfigured," and in the recognition scene—one of the greatest in Greek tragedy—they stare at each other a moment, then embrace, Electra stroking his head, his face, his hands, before running around the stage like a crazed bird.

When I saw the Greek National Theatre perform this scene, not just the brother and sister but the entire Chorus embraced each other, a few single Chorus members hugging their own bodies, as if to say this is not just the homecoming of a long lost sibling, it is the deliverance of an entire doomed nation. But Leveaux's *Electra* has been conscientiously staged around its star, which may be the reason why, for all its considerable theatrical virtues, it finally failed to move me.

At the Vivian Beaumont Theatre the Lincoln Center Theatre is collaborating with Livent (US) Inc. on a Hal Prince musical called *Parade*. The economic adversities of Livent's once hubristic empire have received a lot of press lately. *Parade* gives endorsement to the old adage (amended) that pride goeth before a flop. It is full of good intentions, earnest and high minded, even possessing a little dignity. But like a lot of efforts to endow the American musical with middle seriousness, it only proves that anything too momentous to be sung had better be spoken.

Parade concerns the horrible fate of an innocent Jewish man, Leo Frank, who was convicted, imprisoned, and later lynched for having murdered a young girl who worked under him in an Atlanta pencil factory. Since the true murderer was never identified (there were hints that a black superintendent in the building might have been guilty), the story provokes a kind of objectless abstract indigna-

tion. Not having a single villain to blame, the musical indicts an entire region, making *Parade* the occasion for a species of Dixie-baiting not so far from the Jew-baiting it deplores. The musical features more than your customary quota of Southern bigots, who begin and end the evening with a parade across the back of the stage commemorating Confederate Memorial Day. The first procession is a comic anachronism (as one character remarks, "Why would anyone want to celebrate losing a war"). The second, occurring after the lynching, is a rebuke to the entire South.

I don't doubt that the book writer, Alfred Uhry, is being faithful to the facts in dramatizing how Frank's Northern Jewishness acted like a red flag to Southern Baptists looking for a scapegoat. But the facts don't always produce the most subtle drama, and Leo's forbidding manner doesn't make him a very appealing dramatic hero either. As if acknowledging this, Hal Prince, the director, has the defendant, in a courtroom fantasy number, break into one of Pat Birch's high-stepping dances, sashaying and cavorting with the three girls who falsely accused him of ogling them in the bathroom. This gives Brent Carver, who plays the part, a chance to remove his spectacles, kick up his heels, and drop his prissy characterization for a moment. But that dance is no more relevant to the action than the other efforts to strike lyrical sparks out of flintstone. Prince is obviously stuck with an insoluble problem in *Parade*, which is how to motivate singing and dancing in people more inclined to burning and lynching.

Parade is not a total loss, but the melodies (by Jason Robert Brown who also wrote the lyrics) seem better suited to cotillion two-steps than to courtroom melodramatics; the musical comedy form simply does not have the weight to support a tale of prejudice and injustice. The right collaborators might have made a strong opera out of such tragic events—look at *Harvey Milk*. With this team, *Parade* comes to life only when it becomes a love story between Leo and his hitherto indifferent wife (beautifully acted and sung by Carolee Carmello).

I was expecting more from Paul Rudnick's *The Most Fabulous Story Ever Told* (New York Theatre Workshop) than it eventually de-

livered, though this spoof of biblical stories (and Cecil B. DeMille movies) still contains some priceless episodes. It also has the best satiric title since Christopher Durang's *When Dinah Shore Ruled the Earth*. But for one thing, the piece is too light to support its length—the two acts, barely related to each other, could easily have been separated into two different plays. For another, it features too many witticisms and too little forward movement. I was hoping for a smart rejoinder to Terrence McNally's self-important *Corpus Christi*. What Rudnick gives us instead is an overextended gay cabaret. Rudnick's perspective on biblical history through exclusively homosexual lenses has the same effect as Jackie Mason's squint at gentile mores through Jewish sunglasses. It segregates the audience. This was the first performance I ever attended in which the line outside the men's room was far longer than the line outside the ladies'.

Rudnick's most inspired notion is to see the Bible as an extension of show business, putting *Genesis*, for example, into the context of a technical rehearsal. To the accompaniment of a rock treatment of Strauss's *Zarathustra*, a stage manager calls "Oceans, go" "Thunder and lightning, Go," and we have the Creation of the World. Adam and Steve emerge in jockey shorts, immediately realizing they are gay and alone. Before long they learn the arts of oral and anal intercourse ("Lights 30," calls the stage manager, "Orgasm") and, having been ejected from the garden, appear totally naked ("You know what this means? I have to go to a gym").

Adam and Steve are soon joined by two lesbians named Jane and Mabel ("We have vaginas, they're our friends"). After they've all been drenched by the Flood ("El Nino, Go"), Steve gets the opportunity to be unfaithful to Adam with one of the animals they've paired on the ark—a rhino. In what is undoubtedly the comic high point of the evening, these gay Hebrews appear before a gay pharaoh (hilariously spoofed and poofed by Peter Bartlett) and threaten him with the plagues of *Exodus*, the worst being "the media." The act ends with the "miracle" of the Virgin Birth, as the three "wise guys" bring Jane and her baby myrrh and frankincense. There are echoes here of Monty Python's *Life of Brian*, not to mention Thornton Wilder's *Skin of Our Teeth* and Mel Brooks's *History of the World*,

Part One. But Rudnick has such an uncanny eye and ear for sexual absurdity that much of it, in Christopher Ashley's witty production, still seems fresh and original.

The second act abandons its amusing biblical setting for a modern New York apartment at Christmastime, which means that Rudnick will now be examining not the biblical but the modern plagues of human existence. Steve has contracted AIDS, Jane has become a vegetable rights activist, and Mabel ("I'm not supposed to be pregnant, I'm a bull dyke") has agreed to have a baby with Jane. (A female Mormon, an easily embarrassed comic foil, hovers around the Christmas tree, trying hard not to be shocked.)

Jane and Mabel are married by a handicapped Lesbian rabbi who carries the play's metaphysical message: "Why do good things happen to bad people? . . . I'm in a wheelchair and Saddam Hussein is in a Mercedes." Following considerable labor, Mabel is allowed to experience ("Fuck, shit, piss, get it out of me!") the miracle of birth. Steve, on an AIDS cocktail of twenty-eight pills a day, is doomed to die, leading to a tearful farewell with Adam. The emotion is unearned, a heavy conclusion to a rakish cabaret, as if we were suddenly being asked to sympathize with the medical history of two stand-up comics. But most of this show is fun.

With *Side Man* (John Golden Theatre), Warren Leight has found a wonderful idea for a play—to trace the evolution of society and the disintegration of a marriage through changes in the styles of popular music. Gene (played by Frank Wood) is a white horn player, unknown to the public but much admired by other musicians who compare him to greats like Dizzy Gillespie. None of them play for fame and money but rather for each other. And throughout the play Gene is desperately trying to find work and creative fulfillment in jazz clubs or with such swing bands as Claude Thornhill and Charlie Barnett, at a time when Presley and the Beatles are beginning to revolutionize the nature of popular music.

Encased within this pattern of social change is a very personal domestic story told by Gene's son Clifford (Christian Slater). It is the story of Gene's marriage to Terry (Wendy Makkena) and her growing decline into paranoia and alcoholism. A former flutist herself, Terry is nevertheless determined that Gene give up music and

find some gainful employment. And it is not just because he finds this unacceptable that Gene is alienated from his wife. He simply has no affect outside of his music, no feeling for anyone other than his musician friends, one of whom, having scored some heroin ("I gotta see a man about some horse"), is imprisoned for eight years.

As a former sideman myself (tenor and clarinet), I think I can testify to the accuracy with which Leight has drawn his characters, and his nostalgia about the end of the Big Band era is a feeling I share. In Gene, Leight has created a kind of neglected American hero, a man who "senses everything when he is blowing and almost nothing when he's not." That elegiac note drenches the play in a wash of melancholy and loss.

Side Man resonates with echoes of *The Glass Menagerie*, particularly in the way young Clifford addresses the audience about himself and his family. And the tortured marriage of Gene and Terry bears a certain resemblance to that of James and Mary Tyrone in *A Long Day's Journey into Night*. As directed by Michael Mayer, this year's favorite director (last year it was Scott Elliott), some of the acting would not be out of place in *Seinfeld*. But despite the mugging and overplaying of the musicians, Mayer has pulled an understated performance out of Christian Slater, a ferocious one out of Wendy Makkena, and a really lovely one, full of modesty and suppressed power, out of Frank Wood, who well knows how to reveal a character piece by piece rather than all at once. *Side Man* doesn't successfully achieve all its goals, but all its goals are worth achieving, which makes it a very welcome tonic in a season of parch.

[1999]

· *Two Moral* X-Rays ·

TWO SHARP X-RAYS of social abscess and moral atrophy are currently playing in New York theatres. *Closer* (The Music Box) follows the purposeless sexual adventures of four London professionals. *This Is Our Youth* (Douglas Fairbanks Theater) focuses on the direction-

less lives of three young middle-class New Yorkers. Both demonstrate how playwrights can sometimes be among our most penetrating cultural surgeons.

The American play, written by the gifted Kenneth Lonergan, has a misleading title. Rather than being a cautionary sociological study of wayward teenagers, *This Is Our Youth* is a tough-minded, almost clinical examination of the aimlessness, the vacuity, and the emotional deadness of a trio of privileged kids in their twenties. Set in 1982, at the beginning of the Reagan era, the play takes place in the West Side studio apartment of Dennis Ziegler (Mark Rosenthal), who at curtain rise is discovered lying in an unmade bed, surrounded by newspapers and magazines strewn carelessly around the floor. His dazed eyes are fixed upon an Abbott and Costello movie.

The apartment is a gift from his parents out of gratitude for the fact that he has no desire to live with them. Dennis has festooned the place with recruitment posters and basketball trivia. Into this squalid den comes another figure estranged from his parents, Warren Straub (Mark Ruffalo), a zonked-out airhead wearing a parka and backpack. Following a fight with his father, Warren has fled the house with $15,000 of his parent's hard-earned money. These two characters, both of them wholly concerned with sex, drugs, and rock-and-roll, resemble the kind of affectless druggies usually played in the movies by Robert Downey, Jr. Indeed the action of the play revolves around a burgeoning coke deal that begins to acquire some of the intensity of the quest for the Holy Grail.

Although Warren seems at first to be slightly brain-dead—restless, easily bored, always asking "What's up?"—the closer we get to him, the more sharply focused he becomes. He clearly has "an advanced talent for misery." His sister has been murdered in California for no apparent reason. His father has no use for him. And he's always breaking things or knocking them over—most calamitously for him, the hefty stash of coke he has managed to obtain from a pusher with his father's money. His other major passions are for "retro" objects like toasters manufactured in the sixties and a Wrigley Field Opening Day baseball cap, though he seems to have a little feeling for a young woman, Jessica Goldman (Missy Yager), who has come to the apartment to share his bag of blow. After an awkward bit of

foreplay, he books a room in the Plaza Hotel ("I happen to be ex-
tremely liquid at the moment") where the two manage a perfunctory
kind of sexual consummation.

As for Dennis, his rich mother is a big-city social worker, "a
bleeding heart dominatrix," devoted to installing swimming pools
for the poor and lording her liberal sentiments over the rich husband
who supports her. His offstage girlfriend, Valerie, is a sculptress, one
of whose pieces—two lesbians making out—is carelessly smashed by
the hapless Warren, thus leading to a major fight between her and
Dennis. The two young men move in and out of their various sexual
relationships with the same bored indifference they bring to their
sense of the future. Dennis contemplates maybe going to cooking
school in Venice, or maybe "I'll totally direct movies (get the best ac-
tors in the world and let them improvise)." Warren will probably re-
turn to his parents with what's left of the stolen money.

These are kids with no belief in themselves and even less faith in
their hypocritical parents or their disillusioned peers. For them Rea-
gan's America is populated with people once passionately eager to
change the face of civilization, who eventually said, "You know
what? Maybe I'll just be a lawyer."

What gives these creatures some life is their personal style, per-
fectly captured by the director, Mark Brokaw, and by the three ac-
tors, particularly Mark Ruffalo, his brows knitted, his shoulders
hunched, a carpenter ant trying to bore into the woodwork. Al-
though the play sometimes reproduces the drug-dazed atmosphere
of David Rabe's *Hurly Burly*, it also reminded me of *Ivanov*. The
male characters share the same flabby characteristics, the same ele-
gaic sense of loss as Chekhov's superfluous man. Kenneth Loner-
gan's capacity to evoke these qualities without moralizing about
them is the mark of a significant writer.

Patrick Marber is an even more exciting young talent. His
Closer is the most interesting new English play I have seen since
Pinter's *Betrayal*, a work it somewhat resembles. Indeed, as an
anatomy of adultery, *Closer* may be the more impressive of the
two. It is certainly a more compassionate piece of theatre—Pinter
with heart, however bitter at the root. As both writer and director,
and with the aid of a fine functional design by Vicki Mortimer and

a score by Paddy Cuneen that sounds like modern Bach, Marber has composed a piece of music himself, a classical string quartet in which the various players keep exchanging their parts and their instruments.

Put another way, *Closer* is a contemporary version of *Les Liaisons Dangereuses* where the four lovers, though less predatory than those of Choderlos de Laclos, are equally obsessed with erotic conquest and immediate gratification. Throughout the play Alice, a young striptease *artiste*; Dan, a would-be novelist reduced to writing obituaries; Larry, a dermatologist; and Anna, a photographer, keep moving in and out of one another's lives with the regularity of commuter trains picking up passengers at a station. These characters change partners as if they were the only four people in the world, satisfying their compulsive sexual needs with virtually no restraint, with only occasional pangs of conscience. At times this process becomes extremely manipulative. A justly celebrated scene in the play shows Dan with his computer on-line, pretending to be a woman, exchanging steamy sex talk with Larry in an Internet chat room (their hilarious typed messages are projected onto a screen). Pretending to be Anna, Dan entices Larry into a rendezvous with her at the Aquarium, a meeting that eventually leads to their marriage.

Sex-obsessed, these characters are also, most of them, obsessed with the truth. Larry informs Anna that he visited a whore in New York. "Why did you tell me?" she asks. "Because I love you," he replies. Anna, in turn, informs Larry that she's leaving him for Dan. It's not enough for Larry to learn she's betrayed him. He has to know all the details. "Is he a good fuck? . . . Better than me?" ("Gentler," she replies.) Later, it is not enough for Dan to hear Anna admit that she went to bed with her ex-husband. He also has to know the details. "Did you enjoy it?" "Did you come?" "Did you fake it?" "Do you fake it with me?" *Closer* is extremely explicit about the rituals of sexual transactions and extremely provocative in the way it demonstrates how for some people the act of cuckoldry can itself be a form of erotic pleasure.

If the absolute value among these four is honesty, their prime mover is not love but lust. The characters try to trick out their infi-

delities with romantic inventions, but these are easily exposed. "Stupid expression. 'I fell in love,'" muses Alice, when Dan says he's leaving her for Anna, "As if you had no choice. . . . You didn't fall in love. You gave into temptation." Toward the end she sadly concludes, "They spend a lifetime fucking and they never learn how to make love." *Closer* explores the vanishing line between conscience and temptation, treating adultery like some unmanageable habit, similar to smoking. Smoking, in fact, is the play's parallel metaphor. Those able to kick the habit are the ones most likely to be faithful. But don't count on it.

The major victim of these amoral sexual exchanges is the only one who has managed to give up smoking, namely Alice. Returning to her old profession, stripping, after having been abandoned by Dan, she is visited by Larry, who stuffs her stockings with money in the hope of getting her in bed with him. But although she is willing to show him every orifice of her body, she will not, at first, let him use it for his purposes. Significantly she is the only character who is not passionate about veracity ("Lying," she says, "is the most fun a girl can have without taking her clothes off"). Finding her again, Dan demands that she tell him the truth about her relations with Larry "because I'm addicted to it because without it we are animals." She doesn't want to lie, but she can't tell the truth. Forced to admit that she had relations with Larry, she sacrifices what is left of her identity ("I'm no one"), confesses to Dan she no longer loves him, and spits in his face.

It is because she is unable to live with truth that Alice commits suicide. At the end it is revealed that she has been living the most spectacular lie of all, having taken her name and her biography off a memorial tablet belonging to someone else. The three survivors gather around her fake memorial at the end permeated by an enormous sense of remorse.

Memorial blocks constitute the backdrop of the set—a design that gradually accumulates all the scenic pieces used in the play, as if these four lives were a detritus of props and furniture. Marber's writing is reinforced by his stagecraft, his remarkable sense of space and time, and especially his impeccable cast: Natasha Richardson's cool and reserved Anna; Rupert Graves's anguished, driven Dan; Anna

Friel's plucky if vulnerable Alice; and Ciaran Hinds's authoritative if somewhat barky Larry.

From the thirties to the sixties the theatre was usually much more explicit about sex than the movies, a medium forced to ban four-letter words and limit lovemaking to a chaste kiss before the fade-out. Following Bertolucci's breakthrough *Last Tango in Paris*, the movies became so sexually explicit they made the theatre look priggish by contrast. One of the virtues of *Closer* is that it prods the stage into joining the sexual revolution. The play tells us more about the tragic consequences of this revolution than almost any other recent work I know.

[1999]

· *Ways to Break the Silence* ·

FOR A NUMBER OF YEARS NOW, critics have been complaining that language is no longer a key element of the theatre, having been displaced by music, spectacle, and special effects. But as a matter of fact, words have rarely been the most important component of contemporary drama—or of classical drama before Shakespeare for that matter. (Analyzing the elements of tragedy, Aristotle didn't rate language at the very top of his list either.) Ibsen's famous contribution to modernism was to sacrifice verse altogether, though he was a master poet, in favor of what he called "the genuine, plain language spoken in life." After Ibsen, dramatic characters were destined to speak colloquial prose or nothing at all.

Most contemporary playwrights followed Ibsen in believing that it is better to show than tell, that a good stage picture is worth a thousand words. This development may make literary people nervous. But which dramatist strikes us as the more powerful—verbose Christopher Fry or taciturn Anton Chekhov? Who will last longer—the garrulous Sean O'Casey or the laconic Samuel Beckett, some of whose plays do not contain a single word? For better or worse, the

growing importance of "subtext" and "symbolic action" has virtually banished verbal poetry from the modern stage.

In America the war on language has been exacerbated by movies and by rock concerts, the one characterized by dazzling visual images and musical soundtracks, the other by a barrage of sometimes undifferentiated pulses and beats. Yeats's "rough beast," loutish and incoherent, was on the road to Bethlehem the moment Thomas Edison invented the phonograph and Eadweard Muybridge started tinkering with moving images. As these influences on the populace grew more powerful, the nature of dramatic character changed accordingly. Compare two members of the underclass separated by only twelve years of history, Ralphie Berger in Clifford Odets's *Awake and Sing* and Stanley Kowalski in Tennessee Williams's *A Streetcar Named Desire*. The one is a speaker, fluently analyzing his family and his social condition, the other an uneducated *untermensch* who can express himself only through violence, rage, and rape.

It doesn't help the case for language that the inarticulate Kowalski is the more indelible (and the more imitated) character of the two, no matter how discourteously he treats his sister-in-law. The elegant and civilized, if sexually crippled, Blanche DuBois may implore her sister Stella not to hang back with the brutes. But it is the delicate Blanche who loses the battle for survival in this animalistic world, while Stella and Stanley are coming together "with low animal moans." In formulating such a conflict, Williams was telling us that poetic feelings and expressive language were being obliterated by the orgiastic grunts of the *lumpenproletariat*.

Watching three recent productions in New York—one appropriate for Stanley Kowalski and the rock generation, the others more suitable for Blanche DuBois and the college-educated classes—I was nevertheless convinced that the war against language was far from over, that there were still a variety of ways to break the silence. If two of these shows made us grateful for the gift of eloquent speech, the other proved that theatre can continue to exist without words.

The case against language was tacitly argued by De La Guarda's *Villa Villa* at the Daryl Roth Theatre in Union Square. Created and directed by Pichon Baldinu and Diqui James, this group is a young

Argentine company founded in 1993 and composed of acrobat-singer-dancers from Buenos Aires. It is also composed of the audience, since spectators are totally engulfed in the action in a manner reminiscent of Andrei Serban's *Fragments of a Trilogy* at La Mama. You enter a large square area, formerly a bank, with no seats, and you stand on your feet for over an hour, crushed and jostled by the other people in the room. Somehow the experience is exhilarating—you are being swamped by an emotion of multitude.

First you discern some vague shadows flying over your head, dimly perceived through a paper ceiling. The ceiling is pelted with raindrops that, through a trick of lighting, soon give the illusion of a starry firmament. Suddenly a figure crashes through the ceiling, feet first, and carries a screaming female spectator aloft, groping her behind (not to worry, she's a plant). Before long the entire ceiling has been ripped away and you are watching sixteen men and women, equipped with bungee cords and waist harnesses, zooming back and forth and up and down in aerial flight, singly and in groups, sometimes forming a conglomerate mass like some hydra-headed alien creature.

The rest of the evening provides multiple variations on flying, bungee jumping, and wall-walking, to the accompaniment of ear-splitting music (mostly percussion) and strobe-light effects. Two women, in perfect synchronization, scramble up and down a silken scrim like twin flying monkeys. One man, standing on a platform above another man who is hanging upside down, keeps preventing the poor wretch from righting himself. The air is dense and humid, hydrated by water spouts falling from the ceiling, and at one point the space is filled with balloons. Members of the troupe are likely to break these balloons between their bodies and yours, when they are not crawling around like snarling animals at your feet and pretending to bite your behind.

This may sound impossibly intrusive to you, reminiscent of those performance-group actors of the sixties and seventies who were always climbing over your seat and sticking their bare feet in your face. Take my word for it: most of this seventy-minute presentation is exhilarating. Words are spoken, shouted, or sung during the course of the evening. Not one is recognizable. The audience re-

sponds as it would at a rock concert, a revival show, or a "rave" party, dancing and singing and gyrating with the actors. "We would like to bewitch you all, to thrill you like crazy and get under your clothes," the company announces in a program note, elsewhere adding this description of artistic intention: "Everything started with the uncontrollable desire to explode, to expand, to choose a space and take complete hold of it. . . . The tide produced by the audience is a fundamental part of the emotional upheaval of this show, where everything is fragile, everything is changeable except our tempests. The victim is reality." It is a manifesto that echoes the imagery and intentions of Antonin Artaud, and, following Artaud, De La Guarda uses language more as a form of incantation than communication. *Villa Villa* is much more good-natured than the Theatre of Cruelty, but Artaud would undoubtedly have rewarded the show with one of his gap-toothed smiles.

If my enthusiasm for De La Guarda sounds like I too may be hanging back with the brutes, let me comb my chest hairs and say that within hours of this experience I was appreciating a return to literacy, nuance, and sensibility. The occasions were Margaret Edson's *Wit* at the MCC Theater and Robert Pinsky's version of Dante's *Inferno*, presented by the Unterberg Poetry Center at Playhouse 91. I won't review the Dante, since virtually everybody associated with the show except the translator has been a colleague or student of mine at one time or another. I'll simply say that it was a pleasure to hear Pinsky's supple translation spoken aloud, though I wasn't altogether convinced it needed actors instead of readers, or a stage instead of a lectern.

Wit, on the other hand, is an eminently playable work, and it is receiving a superb production under the direction of Derek Anson Jones, with a first-rate cast headed by the enchanting Kathleen Chalfant. Edson uses the word "wit" in the Elizabethan rather than the Victorian sense, meaning intelligence, insight, and discernment—appropriate enough, considering that the heroine is a professor of seventeenth-century literature and a specialist in John Donne. Vivian Bearing has been working on the Holy Sonnets, particularly "Death be not proud," for an article in the Oxford English Dictionary. The choice of poem is cruelly apt. At the relatively young age of fifty she

has contracted an advanced case of ovarian cancer. Now, like Donne, she must learn to conquer death through language, courage, and an effort at transcendence—"And death shall be no more: death, thou shalt die"—figurative ways of killing her fear of mortality.

The playwright, aside from holding advanced degrees in history and literature, has worked at the cancer inpatient unit of a research hospital. She may parade her scholarship a bit too self-consciously at times, but she knows exactly what she's writing about. It was Shaw who said that playwrights often identify their heroes as people of genius without providing any evidence of intelligence (that is why Shaw compiled an entire "Revolutionist's Handbook" for his hero, John Tanner). He could hardly have leveled the same charge at Margaret Edson. Although this is a first play, she has drawn suggestive parallels between the way a scholar tracks down the meaning of a poem in order to illuminate literature, and the way in which a doctor explores the body of a cancer patient in order to advance research.

The trouble is that Vivian Bearing is obviously incurable, and the medical research that extends her life only lengthens her pain and suffering (as Ben Jonson said about doctors: "They flay a man before they kill him"). She is forced to endure a four-hour operation and the superfluous agony of eight full courses of chemotherapy. She has a tumor the size of a grapefruit, but it is her treatment more than her disease that is making her suffer. Although she sometimes sounds frosty and brittle in the manner of Albee's older battle-axes, she is a person of genuine charm and sensibility and, as played by Chalfant, extraordinary grace. The whole purpose of her existence up to the moment of her death is somehow to preserve this humanity while being pushed, pulled, and prodded like a helpless experimental object. Trying to keep her spirit whole as her body wastes away is the only way she can protect herself against the indignities of medicine. Afflicted by pain and boredom and the slowing down of time ("it hangs . . . and yet there is so little of it"), wracked with fevers and chills, subject to perpetual nausea, she continues to find refuge in language, which changes from Latinate constructions to plain Anglo-Saxonisms in order to accommodate descriptions of her decaying bodily functions.

The play that comes most to mind is Alan Bennett's *The Mad-*

ness of George III, where another amiable character is mangled and lacerated by the instruments of medicine. Bennett showed that even a royal sovereign is likely to be tortured by well-meaning practitioners. And just as King George learns humility from his experience, so Vivian Bearing must seek among her doctors the touch of human kindness that she gradually realizes she has denied to her own students. All they can tell her is to keep pushing fluids. As one by one her vital organs fail, she is moved from room to room (scraping hospital curtains dramatize the changes in locale) until she ends up in an isolation ward. The one person who treats her like something other than a conduit for tubes and pills is her nurse Susie. In a touching moment they share a popsicle together, Susie providing her only relief from pain; and it is Susie who must remind the doctors, after Vivian's heart has stopped, that she left strict orders not to be resuscitated.

The final exquisite scene lifts this play from an example of taste and intelligence into something more exalted. Heedless of Susie's remonstrances, the doctors are trying to bring this "data collector" back to life so that she can continue to serve as a source of research. There is pandemonium in the isolation room as their efforts fail. Suddenly the dead Vivian rises from her bed, removes the baseball cap that has covered her baldness, takes off her hospital gown, and in absolute nakedness ascends to her God. It is a little disconcerting that the most powerful moment in this eloquent play is a wordless one. But the emotional wallop of that final image would not have been possible without the language that preceded it.

Villa Villa and *Wit* approach the theatre from entirely different ends of the verbal spectrum. That each succeeds so well in breaking silence, each in its own way, is a testimony to the infinite variety of the dramatic event.

[1998]

· *Theatre Artifacts* ·

BROADWAY hasn't been a source of new ideas for decades, but only lately has it been turning into a museum. Even its musical comedies are artifacts—refurbished old hits like *Cabaret, Annie Get Your Gun, The Sound of Music,* and *You're a Good Man, Charlie Brown.* Visiting New York today is like taking a trip back into a land where time has stopped. Isn't it amazing that the biggest Broadway hit of 1999 was also the biggest Broadway hit of 1949, namely Arthur Miller's *Death of a Salesman?*

In the fullness of my years I've seen Willy Loman played by Lee J. Cobb, Gene Lockhart, Thomas Mitchell, Frederic March, Dustin Hoffman (stage and TV editions), Hal Holbrook (a touring production that never made it to New York), and maybe another half-dozen character actors whose names I've forgotten. Do we really need yet another Broadway revival of a fifty-year-old anthology nugget? The answer is a resounding yes if the revival is as powerfully acted as this one. The *Death of a Salesman* now playing at the Eugene O'Neill Theatre helps to remind us that the best museums are devoted to animating the past rather than preserving it in formaldehyde.

Imported from the Goodman Theatre in Chicago, where the play was first staged by its artistic director Robert Falls, this version features Brian Dennehy and Elizabeth Franz (who also played Linda Loman opposite Hal Holbrook) in the leading roles. It has been designed by Mark Wendland and lit by Michael Philippi in a manner that almost erases the original Jo Mielziner setting from memory—substituting for the transparent and ethereal but basically realistic landscape of Elia Kazan's production a series of backlit diaphanous panels that move along a treadmill to create a sense of abstract space.

It is true that in this version props and costumes are sometimes historically confused. Biff wears football equipment that seems to have been borrowed from the locker of Red Grange, while Bernard carries a framed tennis racket that looks like something Helen Wills Moody might have wielded at Wimbledon. But authenticity aside,

the production carries with it the sweet fragrance of the past without resorting to such nostalgic reinforcement as Alec Wilder's flute music in the original *Salesman*.

In fact, watching Dennehy lumber on stage at the beginning of the play, carrying his two valises and mumbling about his trouble driving the Studebaker, made me realize with a start how much time had passed in the interim. The playwright was in his thirties when he wrote *Salesman*. Now he's in his eighties. Willy at sixty used to seem like an old man to me. Now this middle-aged loser is my junior. The passing of time has also changed the focus of the play. Once we argued a lot about whether *Salesman* was a true tragedy or an instance of dramatized sociology, about whether one could be a tragic hero without a trace of self-recognition or simply a victim of social forces. We also used to question the consistency of Miller's notion that American success could only be achieved through cheating and chicanery in a play that includes a positive character (Bernard) who argues a case in front of the Supreme Court.

None of that seems to matter much anymore (what seems more relevant today is how Willy's "delusion" about the link between likability and success is being regularly confirmed as truth in those national popularity contests we call elections). The political issues of the play—namely the plight of the exploited common man in capitalist America—today seem infinitely less compelling than its emotional issues, which are rooted in the play's family relationships. Heartless employers like Howard ("Pull yourself together, kid") no longer throw away older workers "like a piece of fruit"—union vigilance and statutes against ageism provide some protection against that. So do government mechanisms such as Social Security, employee benefits, annuity plans, Roths and Keoghs and similar devices designed to help soften the economic problems of contemporary Willy Lomans. What has remained the same over the years, however, is the family conflicts of these people and to some extent their spiritual emptiness.

Granted that too much of Miller's plot hinges on Biff witnessing Willy in Boston being unfaithful to Mom. Nevertheless the play still has a wrenching power, much of it derived (despite occasional archaisms like "Nobody dast blame this man") from perfect-pitch di-

alogue. Much of its power is also derived from surefire Yiddish the-atre conventions. *Salesman*, like so many Second Avenue plays, cli-maxes with a rebellious son being reconciled with his estranged father. As played by Dennehy and Kevin Anderson, the moment where Willy discovers that Biff actually loves him still has the capacity to drench an audience in tears.

But the most compelling figure in Miller's family drama is now Linda Loman, a character who always seemed to me excessively saintly. As played by Franz, a half-smile masking her broken heart, she emerges no longer as patience on a monument, darning old stockings while her husband hands out new ones to his tootsies. Now she has become a pillar of outraged ferocity and tremendous emotional strength, reinforcing Willy in the same way Happy rein-forces Biff, though never unaware that something awful and un-avoidable is on the way.

Dennehy may not be the most convincing Willy in history. He's a little too mannered, a little too lacking in genuine desperation, a little too conscious of having a graceful soul in a clumsy body, to match the great ones (nobody, not even Cobb, managed to equal the underestimated Gene Lockhart). But although Dennehy occa-sionally overuses certain mannerisms, particularly the way he lets his hand play vacantly around his mouth, he is giving the performance of his career. And Robert Falls has orchestrated a production that penetrates the heart and satisfies the soul even if it doesn't provide all that much nourishment for the mind.

Partly because of this play, Miller remains one of the towering figures of postwar American drama, along with Tennessee Williams. But whereas Miller has his masterpiece sitting on a Broadway stage, Williams is currently being represented by a crude piece of juvenilia that he stashed away in a trunk, after it was rejected by the Group Theatre. It remained among his papers until Vanessa Redgrave dis-covered the play and gave it to the Alley Theatre.

This was certainly a service, though, considering how over-praised the work has been by so many critics, young people unfamil-iar with Williams's genius might very well think that *Not About Nightingales* was typical of his writing. Imagine if they were forced

to judge Miller purely on the basis of his clumsy early play *The Man Who Had All the Luck.*

Normally I'm in favor of producing anything by a gifted playwright, regardless of his posthumous instructions. O'Neill's unfinished *More Stately Mansions* was far from a coherent work, but Ivo Van Hove's production almost made it look like a work of genius. *Not About Nightingales*, currently playing at Circle in the Square, certainly has historical interest for those interested in Williams. But this tiresome three-hour-long exercise in prison melodramatics is hardly redeemed by Trevor Nunn's hyperactive production.

Writing partly under the influence of O'Neill's sea plays, Williams had also been watching a lot of Big House movies when he conceived *Not About Nightingales* (in 1938) at the age of twenty-seven. It contains just about every stereotype to be found in the genre—the brutal and lustful warden, the self-educated con with a poetic soul, the hardened killer who leads the breakout or the hunger strike, the guy who goes "stir bugs" from pressure, the bible-reading black prisoner, the sympathetic blonde secretary, the hooker from across the bay, the compassionate prison chaplain—characters formerly played (in that order) by Jack Holt, Douglas Fairbanks, Jr., Jimmy Cagney or Humphrey Bogart, Paul Guilfoyle, Paul Robeson, Gloria Grahame, Glenda Farrell, and Pat O'Brien. Lenny Bruce satirized this kind of prison melodrama mercilessly in a 1950s sketch he created about a big breakout (where the lead gorilla keeps shouting "Yadda yadda yadda, Warden") in the course of which a Negro con sings spirituals about "gwine up to heaven" (where he hopes to find out what a "gwine" is), a kindly guard warns the prisoners "not to scuff your good time," and Kicky the "nafka" hospital attendant negotiates an end to the rebellion in return for a gay bar in the west wing.

Regrettably there isn't a hint of such humor in *Not About Nightingales.* The play is as solemn as a post. Loosely based on an actual incident in the Philadelphia County prison, the work was written when Williams's social conscience was at its most active (you can still find vestiges of that conscience in *The Glass Menagerie*)—also, I fear, the most facile. Bert "Boss" Whalen (played by Colin Redgrave)

runs his "model institution" with an iron hand, stealing money from the budget by feeding his prisoners an endless diet of spaghetti and tainted meatballs. When Prison Block C goes on a hunger strike in protest, he throws the men into a boiler room called "Klondike," turning up the heat to 150 degrees and parboiling a few inmates in the process. The remaining prisoners stage a revolt, kill the warden and a few guards, and are finally mowed down by the state police.

In a subplot, Canary Jim Allison (Finbar Lynch) is a self-educated trustee who, having read some Keats, tries to write poetry. Jim falls in love with a demure but penurious secretary named Eva Crane (Sherri Parker Lee) who shares his love of literature—the recitation of "To a Nightingale" provides the only bearable language in the play. Unlike those of Keats, however, Jim's experiences are not such that he can write "about nightingales." For example, Jim and Eva try to make love in the prison yard, only to be apprehended by the guards and led back to Boss Whalen, who, viper that he is, covets the wench for himself. This cut-rate Scarpia promises this five-and-dimestore Tosca the freedom of her lover if she will yield to his lust. But just as he is about to consummate his evil cravings, and just as Jim is about to be cooked with the others in Klondike, Butch O'Fallon (James Black), the toughest guy in the joint, wrests away a guard's gun and starts the rebellion that leads to the warden's death.

If Williams was watching too many prison movies when he wrote this play, Trevor Nunn was watching too many Living Theatre documentaries when he staged it. The metallic set by Richard Hoover, where the jail cells seem to multiply indefinitely in the gloom, is quite splendid, but it looks suspiciously like Julian Beck's design for *Frankenstein* (the idea for the prison offices—everything, including the American flag, decorated in shades of grey—seem to have been borrowed from *Chicago*). Furthermore the endless clatter of the sound design, a compound of sirens blaring, whistles shrieking, truncheons banging, and cons stomping on the metal floor, produces the kind of pain once shared by actors and audiences alike in the Living Theatre production of Kenneth H. Brown's *The Brig*. There it provided a sense of powerful immediacy. Here it amounts to little more than acoustical pollution.

The difference is in the performance. While Nunn has chore-ographed this production within an inch of its life, he has totally failed to invest the acting with even a hint of truthfulness. The visual design is full of authentic detail, right down to the style in which Sherri Parker Lee's blonde hair has been bobbed. But virtually all the performances slide along the surface of the characters without ever making an effort at penetration. Redgrave's Boss Whalen never rises above the stereotype of the stiff-necked cigar-smoking, whiskey-drinking evil menace who can talk out of only one side of his mouth, and James Black's "ah you dirty rat" performance borrows Cagney's easy bravado without Cagney's compressed energy. Finbar Lynch and Sherri Parker Lee as the two lovers have a degree of romantic yearning in their love scenes, but neither is given the opportunity to explore his or her part with any degree of depth. The actors are all sacrifices to Nunn's choreographic skills and empty scenic display—a condition you may remember from Nunn's previous triumphs, *Cats* and *Les Miz*.

Williams was lucky that Harold Clurman had the good sense to reject *Not About Nightingales* for the Group Theatre. Otherwise he might have been signed up by Hollywood to write gangster movies for Edward G. Robinson. But if the newly produced *Not About Nightingales* looks more like a museum piece today than the often-performed *Death of a Salesman*, we must nevertheless welcome the Williams play with the same hospitality, if not the same enthusiasm, as we welcome the Miller—America's two leading play-wrights should always be represented on the street to which they brought such distinction. Wouldn't it be nice if maybe once in a decade some younger American writers could make it to Broadway too?

[1999]

· *Spring Roundup* ·

IT'S THAT TIME OF YEAR when plays are being crowded like cattle into Broadway corrals, opening fast (and sometimes closing faster) in competition for the Tony Awards. Facing this kind of stampede, a seasonal wrangler like myself tends to get a little behind in his branding duties. Here's a belated roundup of some of the prime beef in the latest theatrical herd—productions from England and Ireland.

The Iceman Cometh (Brooks Atkinson Theatre). With a supporting cast mostly imported from the London Almeida Theatre production, Kevin Spacey is giving a sizzling performance in this latest version of O'Neill's exhaustive and (at four and a half hours in length) exhausting study of human delusion. Spacey was a brilliant Jamie Tyrone in Jonathan Miller's fast-forward *Long Day's Journey into Night* some years ago. He is absolutely mesmerizing as Hickey here—lithe as a dancer, coiled as a cobra, with a latent fury that sometimes turns volcanic. In conceiving this character, O'Neill was inspired by the way Bruce Barton imagined Jesus—as a supersalesman who peddled his new religion as if it were a brand of detergent. The play is permeated with scriptural imagery, notably a Last Supper (Harry Hope's birthday party with thirteen guests at table), and it features more than a few types based on New Testament characters, including a Judas (Parritt, the informer), a Peter (Larry Slade, the "old foolosopher," who is the stone on which Hickey founds his church), and the three Marys from the *Quem Quaeritis* trope (Margie, Pearl, and Cora, the whores who pass as "tarts"). The true gospel of Hickey, the Jesus character, consists of absolute freedom from lies and illusions—O'Neill, with a glance at Greenwich Village opium-eaters, calls these "pipe dreams"—and anyone who fails to embrace his brand of salvation is damned.

The reason the play is so talky (and schematic) is that the author tries to include every possible form of human illusion in his fable—whether political, religious, sexual, racial, moral, or psychological. This *Iceman* seemed to me considerably longer than previous ver-

sions because, aside from Spacey and a few others, I didn't think many of the actors, particularly those imported from Britain, penetrated their roles very deeply. O'Neill creates a series of generic types characterized by a single bony trait. It is the obligation of actors to add psychological flesh.

Waiting for Hickey's entrance—he doesn't arrive until the very end of Act I—has always been a test of endurance for audiences. In this production it seems like waiting for Godot. I saw the original *Iceman* in 1946, directed by Eddie Dowling with James Barton as Hickey and Dudley Digges as Harry Hope, and I saw José Quintero's bookend versions, forty years apart, starring Jason Robards as a young spellbinder and later as an aging veteran. Spacey holds his own very well among this company, but at times he seems too isolated by the supporting actors and by the set.

I yield to no one in my admiration for the designer Bob Crowley. But in adapting his intimate Almeida design to the cavernous proscenium stage of the Brooks Atkinson, Crowley has been forced to build a barroom to the dimensions of the main concourse in Grand Central Station. As a result the characters seem less to be awaiting the coming of Hickey than the arrival of the next train to Hoboken. The critical feeling of claustrophobia, of being lost in the depths of the sea, which is the metaphor of Harry Hope's saloon, evaporates in the yawning space.

Where Howard Davies's production succeeds, however, is in underlining the symbiotic relationships between the various characters of the aquarium. I learned something from watching this *Iceman* I didn't previously know, namely that it is a play about marriage. Yes, of course, it concerns the blighted union of Hickey and Evelyn, and the way her saintly, forgiving nature drives him to the ultimate divorce, an act of murder. But Larry Slade is also married, in a sense—to the man he finally gives permission to kill himself, Don Parritt; Cecil Lewis the Brit is married to Piet Wetioen the Boer; Rocky is married to the two whores in his stable; Chuck is married to Cora, though he can't bring himself to put a ring on her finger; Pat McGloin, the ex-cop, is married to Ed Mosher, the ex-carnival tout; and so on. The entire alcoholic gang is as dependent on each other and

their leader as the Jonestown cultists were on Jim Jones, which is the reason Hickey almost succeeds in making them swallow his poisonous brand of Kool-Aid.

Via Dolorosa (Booth Theatre). David Hare's shadow has been lengthening over Broadway all this season—as a playwright with *The Blue Room* and *Amy's View*, and as an actor-writer with *Via Dolorosa*. It's easy to feel glutted by Hare's self-righteous, furrow-browed brand of political activism, especially when you're being force-fed his ideas in such large doses. With *Via Dolorosa* the written text goes down easily enough; it's the surrounding production that proves a little indigestible.

Hare was one of three writers (the others being an Israeli and a Palestinian) commissioned to compose something about the period of the British Mandate rule. Encouraged by his friend Philip Roth to mine the literary material available in post-Rabin Israel ("These people are so crazy," Roth told him, "there's room enough for all of us"), the fifty-year-old playwright undertook a trip to the fifty-year-old state, holding conversations and conducting interviews with the left and right extremes of Palestinian and Israeli opinion. *Via Dolorosa* is the result.

Hare deals eloquently, compassionately, and feelingly with most of the issues currently roiling this stormy area. He listens to extremist Israeli settlers vowing never to surrender another inch of land, and to angry Palestinians deploring the way Arabs are being depicted as terrorists in Hollywood. He sympathizes with an infuriated Israeli woman radical who believes "We're going backwards. . . . We've become stingy and greedy." He grows increasingly gloomy about the way Israel and Palestine "are bound up in each other's unhappiness." He returns to the UK, anguished by the way stones have become more important than human lives and living ideas, a concept that is a complete denial of Jewish thought.

Given the enormity of his subject, Hare does a sound if synoptic job with his material. My objections to the evening are not political or literary or substantive but rather environmental. The show simply seems uncomfortable in a commercial Broadway house. The author, by his own admission, is not an actor. He stands before us in a white

shirt and black trousers, hunching his shoulders, clenching and rubbing his hands, jerking his body spasmodically like a car idling on one cylinder, speaking in those adenoidal English public school tones so richly satirized by Peter Cook. Yet there is something appealing about his amateurism; his very awkwardness becomes a kind of style.

If Hare had just sat at a table, reading from a script like Spalding Gray, or if he had made some effort to impersonate the people he interviewed, like Anna Deavere Smith, there would have been less incompatibility between form and substance. But this Royal Court production of *Via Dolorosa* has been *staged*, and not very effectively either, by that formidable director Stephen Daldry. Instead of standing still and speaking directly to the audience, Hare has been coached to move from a desk stage left to a desk stage right; to sit; to stand; to try to reach emotional crescendos that are beyond his abilities; to find his mark for pinpoint spots on his face; and, during one badly advised climax, to have his journey illustrated by a screen that rises above his head to reveal a miniature version of the Dome of the Rock. Daldry's theatrical effects, few as they are, embroider a presentation that depends for its effect on candidness and sincerity. We are distracted from the narrative by these efforts to justify the high ticket prices of a one-man Broadway show.

Conor McPherson's *The Weir* (Walter Kerr Theatre) and Martin McDonagh's *The Lonesome West* (Lyceum Theatre) are two Irish productions that, like *Via Dolorosa*, come to us courtesy of the Royal Court—so does McDonagh's *The Beauty Queen of Leenane*, though both McDonagh productions originated with the Druid Theatre in Galway. I won't waste much space on *The Weir* since it struck me as a rather tiresome and retrograde exercise in Irish picturesque. The play is named after a dam that abuts the saloon in which the play is set. Like Ionesco's bald soprano, it is mentioned only once, though unlike Ionesco's characters, the denizens of McPherson's saloon don't show any embarrassment over its lack of relevance to the action. On second thought, "action" is the wrong word in this context. *The Weir* has very little dramatic action. It is virtually all narrative—four supernatural stories told by four different characters between gener-

ous libations of beer and brandy. The last of these tales—about the death of a little girl and her return as a ghost—has some emotional weight. The others are mostly Hibernian whimsey.

The Lonesome West, on the other hand, is a powerhouse, a considerable advance on that author's less well-crafted if more highly praised first play, *The Beauty Queen of Leenane*, indeed almost as good as his similarly underestimated *The Cripple of Inishmaan*. McDonagh's title comes from a line in *The Playboy of the Western World* about the "sainted glory in the lonesome west," and the play confirms McDonagh's position as John Millington Synge's legitimate heir. Also set in Leenane, a small village in county Galway, the play revolves around two mean-spirited brothers, Coleman and Valene Connor, engaged in a ferocious feud, and the sorrow their venomous hatred causes a saintly, whiskey-soaked priest named Father Welsh.

Having killed his own father because he insulted his hair style, Coleman has bought his brother's silence about the murder by ceding him his share of the estate. Father Welsh, distraught about the suicide by drowning of a county constable, his faith shaken by the vileness of human behavior, also decides to commit suicide in the local pond. Since Welsh has left a note imploring the brothers to patch up their quarrel, Coleman and Valene are momentarily shamed into compliance, and, in a scene as funny as anything to be found on the modern stage, each confesses to a list of sins against the other that the victim is then obliged to forgive. When Coleman, who has already roasted Valene's venerated plastic religious icons in an oven, apologizes for having cut off the ears of Valene's beloved dog, his outraged brother threatens Coleman with a huge carving knife. Coleman grabs Valene's shotgun and blows up his favorite possession, a recently purchased stove. The bereft Valene follows Coleman to a local pub, saying "Well, I won't be buying the fecker a pint."

In this play McDonagh again demonstrates that nobody today can touch him when it comes to dramatizing the extremes of human kindness and human viciousness, and nobody today can mine more humor out of people in a brute state of nature. Garry Hynes, the Druid's gifted artistic director, has drawn performances of great sub-

tlety and power from her four-person cast—Maeliosa Stafford as Coleman, looking like a malignant Barry Fitzgerald; Brian F. O'Byrne, playing Valene as if he were an unkempt Alan Alda; David Ganly, sweet and tortured as Father Welsh; and Dawn Bradfield as Girleen Kelleher, a loose, foulmouthed girl with a fourteen-carat heart.

[1999]

· *The Season of the Play* ·

YOU CAN ALWAYS COUNT on the Tony Award ceremonies to reveal how, in the theatre, modesty is the flip side of vanity. Last month's festivities, in this sense, were no different than others. There was the customary parade to the podium of tear-stained luminaries, unspeakably moved by their own emotions, thanking their spouses or their partners, their Moms or their Pops, their Lord or their agents, for this ritual recognition of their talents. There was the traditional pre-scripted celebrity banter interrupted by the usual embarrassed struggles with the vagaries of the teleprompter. There was the inevitable backstage bickering over who got cut out of the program by time constraints. How refreshing to hear Martin Short, accepting a prize for best leading man in a musical, confess, "I did it all myself."

In one important sense, however, this year *was* different. As David Hare put it—and he ought to know, having had three of his own performed on Broadway in this one season—"Straight plays are once more attracting huge and enthusiastic audiences." This may be because they are also attracting a larger share of Hollywood stars, among them Brian Dennehy in *Death of a Salesman*, Kevin Spacey in *The Iceman Cometh*, and Christian Slater in *Sideman*. Whatever the reason, the Tony Committee celebrated "the season of the play" by focusing not just on the big thumping musical, as in the past, but also on some very deserving new plays and revivals, including two genuine American masterpieces, *The Iceman Cometh* and *Death of a*

Salesman. Arthur Miller received a Lifetime Achievement Award, using the occasion to scold the "powers that be" for their traditional timidity regarding serious drama.

The straight play's renewed purchase on the soil of the commercial New York theatre is a welcome development, provided it is lasting. Welcome too is the renewed respect being displayed by the commercial theatre for such long-ignored theatrical icons as Miller, O'Neill, and Williams. And also to be welcomed is the return of seasoned Hollywood actors to the medium that first sharpened their talents. Still, despite the modest run of *Sideman*, which won a Tony Award for best new play, the new American play is still a rarity on Broadway. To see what our native playwrights are capable of producing these days you really have to go to a resident nonprofit theatre. In New York that means off-Broadway, often a small theatre housed on Forty-second Street between Eighth and Eleventh Avenues.

Richard Nelson's *Goodnight Children Everywhere* is currently struggling for survival in one of those houses, Playwrights Horizons. It deserves a longer run. Nelson's work is notable for the very thing that makes him underappreciated—the lack of a singular, easily identified style. At curtain rise, *Goodnight Children Everywhere* looks very unprepossessing: a dreary hearth and home, dank wallpaper, overstuffed furniture. The setting is South London just after the end of World War II. Three women are on stage, fixing their hair, reflecting on the past, awaiting the return of an absent brother. It looks as if we are in for a grey modern-dress reworking of *Three Sisters*.

What transpires after these opening minutes, however, is quite unexpected. The brother Peter (Chris Stafford), still in his teens, is returning home after having sat out the war along with many other English children in Canada; his pregnant sister Ann (Kali Rocha) is unhappily married to a much older man. Before much stage time has passed, she is admiring his naked body in the bath, stroking his member, and bringing him to climax with her hand. This isn't a reworking of *Three Sisters*, it is an Ealing Studios version of *'Tis Pity She's a Whore* set in modern Clapham.

True to John Ford's Jacobean prototype, this brother and the sister are totally devoted to their incest. They not only fall in love with each other, they seem altogether unembarrassed about display-

ing their feelings in front of their two other siblings. One of these girls, Vi (Heather Goldenhersh), is an actress who sleeps with directors in order to further her movie career. The other, Betty (Robin Weigert), is a nurse who is dating a man she detests. The entire family is unfulfilled and, as the play progresses, it seems to be breaking into pieces. This process of disintegration, partly an inheritance of their dysfunctional dead parents, partly a result of the war, creates a pervasive atmosphere of abandoned hopes and lost innocence, further embodied in the sweet children's lullaby that gives the play its title. By the end of the evening Ann, having given birth to her baby, has returned to her husband, Peter is sleeping with a teenage tart, and Betty and Vi are left in various degrees of hopeless stiff-upper-lipdom.

All of this is written, directed (by the playwright), and acted with the quiet intensity of those earnest British movies of the forties and fifties that used to feature such actors as John Mills and Valerie Hobson. This makes the incestuous subject matter all the more startling. Like Ford, Richard Nelson has the capacity to make you sympathize with brother-and-sister love. But unlike Ford, he doesn't try to turn incest into an expression of rebellion against a corrupt and godless world. Nelson simply reports it as a postwar event, like inflation or the collapse of the bond market. *Goodnight Children Everywhere*, taking place in such a drab daylight world, lacks the pith and power of a major play, but it does embody the inner integrity of a major play, and so do the acting and direction.

Also on Forty-second Street, in a production of the Foundry Theatre (using the rented space of the Signature Theatre), is *Gertrude and Alice: A Likeness to Loving*, an effort to replicate the celebrated lesbian relationship between Gertrude Stein and Alice B. Toklas. It is performed by two somewhat less well-known lesbian partners, Lola Pashalinski and Linda Chapman, who have also compiled the text that Anne Bogart directs. You will find the presentation honest, sincere, occasionally touching, and ultimately either mildly engaging or slightly tedious, depending on your attitude toward Gertrude Stein's treatment of the English language.

My own tolerance for Stein's prose being rather low, the intermissionless one-and-a-half hour evening passed very slowly for me, though I couldn't help admiring the effort that went into it. Myung

Hee Cho's setting tries to capture the style of modernist and post-modernist art—geometric Mondrian patterns colored in blue, green, and white, a metallic Robert Wilson–type chair (beside a Robert Wilson–like table), two alcoves harboring real objects such as a red handbag and a leopard cap, and a white pedestal.

When the lights come up, Stein (played by Pashalinksi) is standing at this pedestal while Toklas (played by Chapman) is seated in the chair with a handkerchief draped over her head. This *Endgame* image is repeated throughout the play for reasons that escaped me. Perhaps it was an effort to provide some visual relief from the relentless assault of the language.

"Bread is the staff of life," Stein opined, "and so are words." But the dough in Stein's bread fails to rise, and the staff seems gnarled and misshapen. Stein's style has often been characterized as the verbal equivalent of Picasso's painting or Satie's music. Listening to it spoken aloud over a sustained period of time, it struck me as more akin to the nonsense verses of Lewis Carroll or the rakish lyrics of W. S. Gilbert, whose light operas may have been her greatest influence. Stein's writing is certainly constructed of similar internal assonances and end rhymes ("She is my bride and more beside," "Please beget, please get wet"), the same kind of verbal epigrams and witticisms ("I dreamt that I dwelt in velvet and felt"), the same absurd punning disjunctions ("A doorway is a photograph and a photograph is a sight").

Stein's brother Leo believed her to be a dilettante, not an artist, and there were quite a few who agreed with him, Stein herself, who had an inflated sense of her own importance, obviously not among them. "I make so much absorbing literature with such attractive titles," she crowed, boasting that "I realize that of English literature in my time, I'm the only one," and adding that "I happen to be the first American since Whitman who is writing literature." I would have loved to be present when she said that to her friend Ernest Hemingway.

Ultimately, through all the arcane language and self-adulation, the outlines of a relationship—a very talky relationship—begin to emerge. Stein is the husband, Toklas is the wife. Both are extremely jealous of the other's previous intimacies. "Didn't Nelly and Lilly

love you?" Stein asks incessantly, while Toklas goes into paroxysms about Stein's strong feelings—thirty years earlier!—for Mabel Dodge. In order to placate her, Stein decides to write Toklas's autobiography for her, the story of all those years in Paris. And when this turns into an unexpected success, she embarks on a lecture tour in America.

Wearing the leopard-skin cap that Leo gave her, from which she refuses to be parted, Stein takes three rooms in the Algonquin and basks in the admiration of her disciples. She has her photograph taken for smart magazines. She goes to Chicago to see for the first time *Four Saints in Three Acts*, the opera she wrote with Virgil Thompson. But the tension between husband and wife is revived when Mabel Dodge calls in again. Stein wants to forget, Toklas wants to remember. Neither can escape the past. Back in Paris after three years absence, Stein writes *The Making of Americans*, telling Toklas that "I do love none but you." Toklas responds by sitting down in her chair again and putting the handkerchief over her head.

The piece has its poignant moments, and it is nicely acted by Pashalinski, looking very much like the Picasso portrait of Stein, and by Chapman, with her saucer eyes, rosy cheeks, page-boy haircut, and plastic features. Anne Bogart works tirelessly to provide some visual distraction from the endless palaver. And her choice of musical background is always sensitive. Still, what *Gertrude and Alice* manages to demonstrate most tellingly is how lesbian domestic relationships can be just as banal as those between married heterosexuals. And in this case, a lot more windy.

[1998]

· *Musicals and Musicales* ·

UNTIL RECENT TIMES many Hollywood movies were based on Broadway plays and musicals. Today that process has been reversed. Exemplifying the commercial theatre's dwindling capacity for originality, a lot of the "new" works on Broadway are remakes of old

movies. This is particularly true of the Broadway musical where, faced with such shows as *The Lion King, Beauty and the Beast, The Scarlet Pimpernel, Jekyll and Hyde, Les Miserables, Saturday Night Fever*, and *Ragtime*, you may not know whether you're looking at a stage or at a screen, whether you're consulting the *Time*'s ABC Directory or examining the marquee of your local cineplex.

Most of these musicals, of course, began life as literary works. Books have always been prize booty for the entertainment industry, just as novelists—F. Scott Fitzgerald, William Faulkner, Aldous Huxley, Raymond Chandler, Dashiel Hammett, and others—have sometimes been its well-paid hostages. The difference today is that Broadway is less likely to make novels into plays than to musicalize the movies that were originally fashioned from the books.

James Joyce never had the dubious fortune to be approached by Hollywood or Broadway, but *Ulysses* and *Finnegans Wake* were both adapted for the stage, and "The Dead," the lovely culminating story of *Dubliners*, was made some years ago into a sensitively directed and superbly acted film, the last movie of John Huston. But to fashion a New York musical out of this delicate story is rather like putting horsehair into a satin sachet.

Nevertheless *The Dead* is now a successful off-Broadway show poised to move to Broadway. I went to see it at Playwrights Horizons with considerable trepidation—only to be very happily surprised. Richard Nelson's adaptation of Joyce's story is both faithful and imaginative, and supports very comfortably the addition of Shaun Davey's songs, many of them with lyrics by eighteenth- and nineteenth-century Irish poets as well as by Joyce himself.

Indeed, with hindsight, a musical adaptation of *The Dead* almost begins to seem inevitable. In the story the annual Christmas dance at the Dublin home of Kate and Julia Morkan is awash with music. Songs and verses are the ladders of the evening, with the guests getting up in turn to give speeches, recite snatches of poetry, play the piano, or sing traditional Irish tunes. In short, the action of *The Dead* may not be right for a conventional musical, but it is perfectly appropriate for an old-fashioned "musicale"—a program of music performed at a social gathering—which is exactly the form the Morkan party often takes.

It is the "musicale" that is recreated on the intimate stage of Playwrights Horizons. The various characters—under the direction of the author and Jack Hofsiss—all rise to sing their Gaelic songs, facing away from the audience and upstage toward the assembled guests. Holding their hands behind their backs like amateur performers, the actors unravel the story before, during, and after the tender melodies.

There was only one formal misstep in the evening, but it was almost fatal. In a number called "Wake the Dead," the drunken Freddy Malins and the company were encouraged to break into a conventional showstopping choral number, complete with choreographed high kicks and rollicking Tin Pan Alley harmonies. This was tantamount to dumping a bottle of Miller's Lite on the delicate damask table linen. At this moment, I feared, the piece was out the window, the decorum of the convivial atmosphere broken by irrepressible showbiz spirits. But it soon recovered during a lovely scene in the bedroom of Aunt Julia, interpolated by the author, in which the ill and aging woman contemplates the ghost of her own childhood. And it recovered even more during that final scene in the hotel room of Gabriel Conroy and his wife Gretta. There, you will remember, Conroy has the gut-wrenching realization that his wife had once been in love with a young boy who died after standing in the rain outside her window, and that a song sung during the party had recalled the lad's memory to the weeping woman.

Those familiar with *The Dead* know how it seems to wander aimlessly through clusters of local color and holiday cheer before climaxing in that heartbreaking perception by Gabriel Conroy. Conroy is Joyce's portrait of the artist as a young book reviewer (he is a columnist for the *Daily Express*), who shares the author's intellectual distaste for his own country. The rather pompous speech he gives during dinner is mostly about the past and sad memories and "absent faces." He is aware neither of the irony of his rhetoric nor of how soon his images will be confirmed by reality. In the hotel bedroom, contemplating his sleeping wife, Conroy reflects on the poverty of his own feelings when compared with those between Gretta and the boy who died for love of her, as the snow falls gently upon "all the living and the dead."

Christopher Walken as Conroy speaks and sings these lines, as he does the whole of his part, with virtually no attempt at a Dublin accent and not much in the way of voice support, yet with a casual grace that is powerful in its simplicity. Walken inhabits rather than performs his roles, embodying characters rather than enacting them. He has no peer in the way he can engage with an audience, turning his hooded eyes and sudden smile into an intimate relationship with each and every spectator. Playing his wife Gretta, Blair Brown weaves a skein of buoyant middle-age beauty out of the threads of memory, regret, and nostalgia. And Sally Ann Howes's ailing Aunt Julia, Marni Nixon's lively Aunt Kate, and Stephen Spinella's rowdy Freddy—indeed the entire gifted cast—almost always manage to evoke this magnificent story without recourse to crude theatrics. That single production number is an unfortunate exception. If *The Dead* can transfer to a Broadway house without the need of show-stoppers, Playwrights Horizons may not have a megahit on its hands, but it will have something infinitely more rare and valuable—a touching theatricalization of a great piece of literature.

After *Shakespeare in Love* I was prepared to change my opinion of Tom Stoppard. Granted that his movie script was written with a collaborator, and granted that he had the luminous Gwyneth Paltrow to animate the central female role, the movie nevertheless managed to wed the playwright's wit to an emotional depth I rarely found in his plays. Perhaps he will develop these qualities more in the future. But *India Ink* (now playing in a highly praised production at the Studio Theatre in Washington, D.C.) is a regression to the old verbal acrobat and intellectual showoff, crammed with literary chitchat and cultural palaver. If sojourns in India produce plays like *India Ink* (and plays like Terrence McNally's *A Perfect Ganesh*) then some playwrights should be forcibly restrained from traveling abroad.

Stoppard has an impeccable ear—not so much for how people speak as for how other writers write. Thus far he has given us perfect impersonations of Shaw, Wilde, and Beckett, not to mention a host of existential philosophers. The gift for impersonation being the gift of assimilation, especially of assimilated Jews, it didn't surprise me much when the Czech-born Stoppard, who spent his childhood at

an army post in India, recently confessed that his parents were Jewish. In *India Ink* he does another pretty good impersonation, this time of E. M. Forster. He even pays tribute to that writer in his play. But what he produces is *Passage to India* without the Malabar caves—without, that is to say, any metaphysical reverberations.

Stoppard's gift for imitating himself equals his capacity to impersonate others. Following the pattern of *Arcadia*, which alternates between the eighteenth century and modern times, *India Ink* moves between Raj India in the 1930s and India and England in the 1980s. All this time and space travel is designed to support the story of a young Bloomsbury poet named Flora Crewes, who died young. It also advances a plot about the people who, fifty years later, are trying to reconstruct her lost past from letters and diaries, namely her younger sister, Eleanor Swan, and the research scholar Eldon Pike (*Arcadia* again). Since Flora has been familiar with the likes of H. G. Wells, Madame Blavatsky, Virginia Woolf, Gertrude Stein, and Alice B. Toklas (she even acted once in a play by Bernard Shaw), a lot of the play consists of literary name-dropping. What plot there is concerns her relationship with Nirad Das, an Indian painter, and how she manages to persuade him to paint her in the nude. The relationship remains unconsummated even though (or maybe because) she poses naked while reciting samples of her execrable verse ("yes, think of a woman in a house of net/that strains the oxygen out of the air/thickening the night to India ink"). India ink is not all the night is thickened with.

The Indian painter is an Anglophile. The English poet is an Anglophobe. Each would prefer the other to be more faithful to his or her origins. Flora not only has the chance to discuss Indian philosophy with Das. She also gets to dance a lot with the pukka sahibs at the Jummapur Club, tolerating their narrow nationalism with bemused patience. To top it off she begins some kind of relationship with the Rajah of Jummapur. The two get to talk about Indian art and the British Empire. They talk about Marxism and civil war. They talk about independence. They talk and talk and talk. And talk. More than three hours of verbal effluvium.

Perhaps this play wouldn't have given me such a rash if the production had been less stertorous and the actors less stentorian. But

under Joy Zinoman's overemphatic direction, every one of Stoppard's epigrams and aperçus are hammered into your head like carpet tacks. Faran Tahir as Das and June Hansen as Mrs. Swan manage to create some subtlety. But the actress playing Flora Crewes could use some lessons in Bloomsbury decorum. Smirking, simpering, and shimmying through the part like a demented flapper, her voice emerging from her throat like a compact disk being played backward at high speed, she doesn't make a very strong case for all that posthumous interest.

In an informative program note, the dramaturg Michelle Hall suggests that Eldon Pike's quest for the biographical facts of Flora Crewes was inspired by Stoppard's search for his Jewish roots and the unknown father who died in the Holocaust (the stepfather who reared him in India was a British army officer). If so, this is a worthy quest that could have a significant impact on his future writing. It hasn't happened yet. Too much of *India Ink* is written on stencils and carbon paper, with, I suspect, a pot of disappearing ink.

[2000]

· *Revisioning Tennessee Williams* ·

THE REPUTATION OF Tennessee Williams, by common consent among the finest postwar American dramatists, has suffered significantly from one of his virtues, namely the singularity of his style. Once you've seen a Tennessee Williams play, no matter how satisfying the experience, you may feel, as I do, somewhat reluctant to see it again in a later production. His gentle, drawling, melancholy voice imprints itself on the mind so indelibly that the language begins to seem predictable. Indeed even some Williams plays that you're reading or seeing for the first time sometimes give the impression of being overly familiar. In his later years the playwright was often accused of repeating himself, but, aside from his fondness for damaged women in extreme situations, his characters and plots are

relatively diverse. What usually strikes the ear as recycled music is the dialogue.

It is also difficult to forget the way this dialogue was initially spoken. Succeeding performances of Williams's plays usually had to proceed under the daunting shadow of "definitive" premiere productions. I am thinking particularly of the initial incarnation on stage (and later on film) of *A Streetcar Named Desire* in the version directed by Elia Kazan. Kazan, who almost did the same thing with Lee J. Cobb's Willy Loman, directed Marlon Brando in a performance so powerful and idiosyncratic that he made every subsequent Stanley Kowalski look like an impostor.

The challenge of Williams's revivals, then, is how to make them surprising to people already familiar with their content while delivering the material anew to younger audiences. I came across two excellent solutions to this problem in the past week, one more extreme than the other, but both managing to make us watch and listen to the plays with fresh eyes and alert ears.

The first was Ivo van Hove's radical reworking of *A Streetcar Named Desire* at the New York Theatre Workshop. A few years ago this Dutch director took O'Neill's seemingly unstageable *More Stately Mansions* and turned it into a near masterpiece. This time around he has adapted a familiar masterpiece into a completely new play. Critics have not been very welcoming to van Hove's reinterpretation of *Streetcar*. I found it deeply absorbing for most of its three-hour length, only the rape scene and (not surprisingly) the Stanley performance leaving me unsatisfied.

Van Hove dispenses entirely with Williams's New Orleans tenement setting. In its place he gives us a largely empty space with a single basic scenic element upstage—a long, coiled metal spring dangerously suspended between two massive oil drums. (These objects also function as some of the instruments producing Harry de Wit's eerily percussive music and sound.) The various rooms of the apartment are suggested not by walls but rather by rectangles of light on the floor. And aside from a scattering of chairs, there is only one piece of furniture on stage—namely a large period bathtub that constitutes the major playing area of the production.

The nakedness of this design may seem perverse in a play that is driven by conflict over the disposal of property (driven home by Stanley's "Napoleonic Code" rants about Blanche's loss of "Belle Reve"). But the stage has been stripped bare for the same reason that Blanche, Stella, and Stanley often strip themselves bare—not so much for erotic purposes, though there is plenty of sex onstage, but rather to underline the elemental nature of the play.

When Mary McCarthy first reviewed *Streetcar* she characterized it as an epic battle between a man and a mother-in-law over who has first dibs on the bathroom. Van Hove's treatment of the play makes this flippant remark seem prescient. Blanche certainly spends a good deal of time in the tub, not only soaping and soaking her naked body but throwing herself headlong into the suds every time she has a panic attack. In the poker game scene, the drunken Stanley is also pitched into the tub by his buddies and held under water to sober him up. As a matter of fact, the rape scene is realized when Stanley drunkenly removes his silk pajamas and hurls the nude Blanche into that now overused tub.

For although the initial image is startling, all this attention to plumbing eventually begins to seem a little repetitive and excessive. Yet, this is a minor miscalculation. Van Hove and his actors deliver such a lucid reading of the play that Williams's witty and plangent lines strike the ear with renewed power and beauty. Much of the credit for this achievement goes to Elizabeth Marvell as Blanche and Jenny Bacon as Stella, both of them delivering truly memorable performances.

As Eunice (Saidah Arrika Ekulona) presides over the stage as a mute witness, Blanche appears out of the shadows, carrying a handbag instead of a suitcase, her hoarse voice soaked in Jack Daniels. In Marvell's performance she seems to emerge out of another acting period, notably the generation of Tallulah Bankhead, just as Bacon's mercurial, appetitive, occasionally screechy Stella looks and sounds a lot like Estelle Parsons in *Bonnie and Clyde*. Stanley confronts her with beady eyes, guzzling a quantity of beer bottles, having opened them, one after the other, on a chair top. Excessive in this, he is excessive in everything. In the dinner scene, Blanche and Stella look on

numbly as Stanley, with maddening deliberation, smashes a couple of dozen plates on the floor.

Bruce Mackenzie as Stanley executes van Hove's directions, including his systematic destruction of a guitar in the drunk scene, with such meticulous care that you almost forget that his acting is mostly undifferentiated yelling. Marvell, by contrast, delivers a performance of extraordinary variety and range. This is not the fragile gossamer butterfly of Jessica Tandy and Vivien Leigh but rather a wounded panther, a dangerous snarling fury. She and Jenny Bacon, whose sexual acrobatics with Stanley are prodigious, may remind you of older actresses, but they are clearly New Women. They could eat Mitch and Stanley with their breakfast cereal. Nevertheless, following Blanche's downward spiral, Marvell goes past despair into the dead zone, speaking in slow spectral cadences that reminded me of the ghost who growled through the mouth of the medium in *Rashomon*. In the last scene, when she walks into a blinding white light, past Stanley and Stella fornicating on the floor, to join the doctor and the nurse (reduced to voice-overs in this production), she has arched into what is surely one of the most remarkable performances in recent memory.

What van Hove and his mostly fine cast have accomplished is to make us hear every single line of the play, to follow every single acting intention, with new interest. This is a revisionary *Streetcar*, all right, but like the best reinterpetations it is a production that paradoxically remains faithful to the spirit, by ignoring the letter, of the original work.

Camino Real, in a new production by Michael Wilson at the Hartford Stage Company, is also experiencing a worthy revival, though not all its fine production values can totally redeem the play. I fear nothing can. *Camino Real* is Williams's most experimental work—a valiant effort after the commercial successes of *Streetcar* and *Glass Menagerie* to advance into new and untried territory. "Make voyages! Attempt them!"—Lord Byron's exhortation to Casanova—might be an epigraph for the entire undertaking. The voyage the playwright was attempting is a dream play in the style of Strindberg. He had already refashioned an earlier, more realistic play of Strind-

berg (*Miss Julie*) into *A Streetcar Named Desire*, but like Blanche Dubois, Williams was always more interested in magic than in realism.

Set in a kind of Mexican purgatory where familiar literary and mythic figures are condemned to reenact their febrile fantasies, *Camino Real* was Williams's effort, to borrow another line from the play, "to carry the banner of Bohemia into the enemy camp." The camp was Broadway, the banner was sexual and theatrical experimentalism. But Williams has not managed to assimilate such diverse literary icons as Casanova, Marguerite Gautier, Baron de Charlus, Lord Byron, and Don Quixote with such pop culture characters as Kilroy and Gutman (modeled on Sidney Greenstreet's *Maltese Falcon* character). Failing to unify his *dramatis personae*, he creates an undigestible cultural stew. And since the play has no clear line of action or consistent style but rather jerks along spasmodically on a series of poetic nonsequiturs and borrowings (particularly from T. S. Eliot), it ends up being richly theatrical without ever becoming fully dramatic.

The initial failure of *Camino Real* made Williams pull in his horns and return to the more accessible forms that had made him fashionable. Nevertheless the play later became a feast for directors, designers, and actors (though rarely for audiences or critics)—a happy hunting grounds where many theatre artists endeavored to capture and tame the stampeding beasts.

The Hartford safari almost succeeds in that quest, partly through the quality of the acting, partly through the director's decision (perhaps on the premise that anything too silly to be said can always be sung) to turn the play into a musical. In this decision Wilson is considerably abetted by Betty Buckley as a ghostly, hollow-eyed Marguerite Gautier, who frequently breaks out of her dialogue into emotionally wrenching song. Wilson also chooses to begin the play with a stirring production number ("On the Camino Real—hey, hey, hey") during which the various characters pile onto Jeff Cowie's colorful and expansive set while skating, dancing, or doing the hootch.

Instead of recoiling from the introduction of such unscheduled elements into a dramatic play, I found myself wishing for a lot more

of John Gromada's engaging music. *Camino Real* might work very well as an opera or a musical. It still doesn't work as a play. In a world where so many characters bemoan their outcast state and the climax comes when a dry fountain squirts water and violets break through the rocks, the forbidden word is not "hermano" (as in the play) but maybe bat "guano."

Nevertheless Wilson keeps the action flowing very fluidly, and his actors play their parts with considerable commitment. Rip Torn, though he looks a little lost at times beneath his rakish fedora and spade beard, has poignant moments as Jacques Casanova. Lisa Leguillou's Esmeralda captures that character's contradictory harlotry and innocence. Remo Airaldi is comically grotesque as A. Ratt and Abdullah. Helmar Augustus Cooper and Novella Nelson contribute depth of feeling to the characters of Gutman and the Gypsy. And John Feltch brings a touching dignity to his gallery of noble figures—the Baron de Charlus, Don Quixote, and Lord Byron (whose speech about the death of Shelley is the high point of the evening).

Camino Real is an abstraction when the truth, as Brecht tells us, is concrete. Instead of acting out their fates, the characters are subordinated to the author's musings about them. The Latino environment seems to be glimpsed through the eyes of a tourist. The dialogue ("There is a passion for declivity in this world") often sounds too fruity and declarative. Nevertheless Wilson's production of *Camino Real*, along with van Hove's *Streetcar*, renewed my admiration for Williams's talent and my respect for the vitality of the American stage.

[1999]

· *Plays Fat and Thin* ·

A MOON FOR THE MISBEGOTTEN, written in 1943 during a time when O'Neill's reputation was in eclipse, did not have a warm reception at its Ohio premiere in 1947. Indeed, having been banned in

Detroit as "a slander on American motherhood," the play even failed to make it to New York. Four subsequent Broadway productions of *A Moon for the Misbegotten* helped to develop its current reputation as one of O'Neill's masterpieces, though the first revival, in the 1950s, still failed to impress the local critics.

I saw that version as a young man and was blown away. I remember an inscrutable Wendy Hiller and a sardonic Franchot Tone, the latter in a ferocious, self-lacerating performance that (as I later imagined) reflected his disgust over having abandoned the Group Theatre to become a Hollywood matinee idol. When the play was revived a second time, in 1973, it featured Colleen Dewhurst as Josie and, as Jamie Tyrone, Jason Robards, an actor who had made a brilliant debut playing Hickey in the Circle in the Square revival of *The Iceman Cometh*—afterward appearing as a younger version of the whiskey-soaked Jamie Tyrone in the Broadway premiere of *A Long Day's Journey into Night*. The third revival of *Moon*, in 1984, was a Broadway transfer from the American Repertory Theatre, with Kate Nelligan as Josie and the late Ian Bannen playing Jamie. The fourth is the current highly praised production at the Walter Kerr Theatre, featuring Cherry Jones and Gabriel Byrne.

The most difficult task in casting this play is to find a woman spiritually strong and physically large enough to play Josie Hogan. O'Neill specifies that Josie is something of a female giant, 5 feet 11 inches in height and weighing in at 180 pounds. Clearly what he had in mind was an earth goddess upon whose substantial chest Jamie Tyrone—a character based upon the playwright's haunted brother, James O'Neill, Jr.—could find momentary relief from his nagging sense of guilt (among other sins, Jamie slept with a whore on the train that carried his mother's corpse back from California for burial).

Jamie often expresses admiration for Josie's abundant breasts, but (feminists can relax) he is attracted to her less as a sex object than as a woman capable of nurture and redemption (perhaps feminists won't relax). Despite considerable banter about a possible romance between the two, Jamie clearly regards Josie more as madonna than mistress—"Nix" and "Can it," he snarls, whenever she tries to talk dirty. It is crucial to O'Neill's religious iconography that, for all her

sexual bravado and pretended promiscuity, Josie is still a virgin. In the moment that climaxes the fourth act, the playwright poses her as the Virgin Mary, cradling the spiritually dead Jamie in her lap like the crucified Jesus in the Michelangelo Pieta.

On the other hand the oversize Josie resembles the kind of female companion Jamie was attracted to in *A Long Day's Journey into Night*. In that play, dated twelve years earlier though written only two years before, Jamie visits a cathouse and sleeps with a whore named Fat Violet. Somewhat daunted by her physical surplus ("I like 'em fat but not that fat"), he nevertheless finds solace for a night on her ample bosom. "I shall achieve the pinnacle of success," he jests. "I'll be the lover of the fat woman in Barnum and Bailey's circus."

Although Josie is not quite the circus freak Jamie glumly imagines as his destined mate, her size makes type-casting virtually impossible. Among the actresses who have played the character, only Colleen Dewhurst even began to approach the requisite proportions. Wendy Hiller—so perfect for such stylish or potentially stylish women as Liza Doolittle or Barbara Undershaft—was out of her element as a lusty American Irish girl. Kate Nelligan delivered a powerful performance without making any concessions to Josie's bulk except to stuff her brassiere. And now Cherry Jones, a splendid actress usually associated with characters of slimmer dimensions, has bravely attempted the part in a production directed by Daniel Sullivan.

Unlike Nelligan, Jones does not let vanity stand in the way of her preparation for the role. In a manner somewhat reminiscent of Robert De Niro in *Raging Bull*, she has eaten her way into the character, and, many pounds heavier than when she appeared in *The Heiress*, she now stands on stage as a big strapping woman of considerable girth, if not quite the Falstaffian dimensions O'Neill prescribed.

Yet when she first lumbers out of the farmhouse, hands on hips, she gives the impression of being a slender person in a fat suit. Given the plucky self-denying way she had built her character, I didn't understand why the designer insisted on a page-boy haircut—a style more appropriate to Shakespeare's Rosalind than to the gamey

daughter of a pig farmer. And I also wondered why an actress equipped with such an excellent ear was making so little effort to approximate the rhythms of Irish speech. This Josie sometimes sounded like she had spent her youth in Jones's native Tennessee.

A little subdued and tentative at first, Jones eventually develops the size and fullness necessary for the part, reaching a fourth-act climax that will knock your socks off. If she lacks power in the early scenes, that may be because she has the handicap of performing opposite Roy Dotrice as her father, the Irish tenant farmer Phil Hogan. Dotrice's portrait of this irascible, mischievous, goatish character on elastic legs is one of the most shameless and engaging instances of scene-stealing in my memory. It is a performance, in fact, that could have come right out of Synge or O'Casey, reminding us that O'Neill not only determined the future of serious American drama but was a contributor-in-exile to the Irish Theatrical Renaissance as well.

Dotrice plays Phil Hogan as if he were Old Mahon in *Playboy of the Western World* or Joxer in *Juno and the Paycock*, taking particular delight in scolding the Standard Oil millionaire, Harker, for exposing Hogan's pigs to the frozen dangers of his neighboring ice pond (a riotous episode also recounted, with no chronological consistency, in *A Long Day's Journey*). Hogan is a character soaked not just in Irish blarney but in Irish whiskey, and so is the character of Jamie whose extended binge in *Moon for the Misbegotten* started at least twelve years earlier in *A Long Day's Journey*. Indeed, all of O'Neill's late plays are awash in bottles of booze, *The Iceman Cometh* and *A Touch of the Poet* included. It is a special brand of O'Neillian alcohol that cannot deliver either joy or peace, until the knockout punch sends you into oblivion.

Why then, with such good actors and such a powerful play, did I not feel more satisfaction with the production? Part of the problem is the way the Irish actor Gabriel Byrne is playing Jamie. Dark and intense, all sharp angles with a febrile glow in his eyes, he promises a lot on his first entrance. He takes no short cuts. He doesn't trade indecently on his screen persona. Still, Byrne never quite digs to the painful root of this ill-fated Broadway sharpie, the luckless, doomed, despairing elements of his nature, the aching remorse that accompanies large disappointments. At the performance I saw, at least, Byrne

failed to tap into the life experience needed to exhume the inner soul of this tormented man. His Jamie doesn't seem to be feeling his anguish so much as whining it. And until the powerful final moment, when he finds rest in the arms of the mother figure who speaks his epitaph ("May you have your wish and die in your sleep soon, Jim, darling. May you rest in forgiveness and peace"), nothing seems to be binding these two people together.

Daniel Sullivan's direction is perfectly competent without being penetrating. It certainly looks terrific. He seems to communicate better with his designers than his actors. Eugene Lee's superb set is a rotting clapboard farmhouse surrounded by huge boulders, nicely shadowed by Pat Collins's sculptured lighting. And Jane Greenwood's costumes prove that she can design not just elegant period gowns but authentic peasant clothes as well. I was happy to be present at this performance, happy to see O'Neill courageously facing his ghosts again. I think the play continues to occupy an important place in his works. I hope it will soon be revived again in a more consuming, more unsettling production.

David Mamet's fine play, *American Buffalo*, is also enjoying a revival in a production shrewdly directed by Neil Pepe at the Atlantic Theatre Company. First staged in 1977, this play was one of Mamet's earliest efforts to explore the tension between friendship and business, loyalty and greed, "kissass or kickass"—a conflict that remains one of the abiding themes of his work. Since it is also an abiding theme of our market-crazed society, the play remains as acid as on the day it was first etched into our brains.

The ATC was originally formed by some of Mamet's acting students. It is a theatre with a special feeling for his work. Included in the cast, playing Teach, is W. T. Macy, another of the troupe's acting teachers, who played the dysfunctional kid Bobby in an earlier version of the same play. One of the pleasures of a long career in the theatre is watching actors evolve gracefully from sons into fathers (I got the same kick watching Jason Robards grow from Jamie Tyrone, Jr., in *A Long Day's Journey* into the older Jamie in *A Moon for the Misbegotten* and finally into James Tyrone, Sr., in a revival of *A Long Day's Journey*). Macy provides the same pleasures here.

Robert Duvall was Teach in the original Broadway production

(yes, it was a Broadway premiere when Mamet was a relative un-known—can you imagine such a thing today?). Duvall was far more menacing and explosive in the part than Macy, who underlines the character's nervous tension, edginess, and weak nature. Both inter-pretations are correct. And playing opposite Philip Baker Hall's avuncular Don and Mark Webber's goofy Bobby, Macy achieves an unerring ensemble balance, proving that in the hands of good actors there is no such thing as a definitive performance.

Kevin Rigdon has designed a cluttered junkshop of a set for Don's Resale Shop that contains just about every item ever pawned—a detritus of abandoned property. Navigating around this rubble is one of the challenges the director gives to the actors, one they meet with distinction. The other successful challenge is speak-ing Mamet's halting music, his obscene poetry, his anatomy of wan-dering minds, at the same time pushing forward a coherent plot.

The plot concerns the bungled theft of a very expensive coin, with the attendant fallout in paranoid suspiciousness (Quentin Tar-entino borrowed a lot from this play for *Reservoir Dogs*). These three guys are second-rate hoodlums. None of them seems able to com-plete a simple task. And as the plan falls apart because of incompe-tence and misunderstanding, Teach grows more wired and suspicious. There is a gun in his pocket. It is a wonder it never goes off. Instead Teach wrecks Don's shop and explodes all over the hap-less Bobby, bloodying his ear and sending him to the hospital with a possible concussion. At the end, while Don consoles Bobby for his undeserved pummelling, Teach puts on a paper hat, saying, "I look like a sissy," and leaves, unrepentant over the way he has violated the contract of friendship.

Dinner with Friends (Variety Arts) is a new play by Donald Mar-gulies that is also about a broken contract, this time between a hus-band and a wife. The play follows two couples—Gabe and Karen, and Beth and Tom—over a twelve-year period. During a dinner of red wine, grilled lamb, pumpkin risotto, and polenta (food is the central metaphor of the play), Beth tells her hosts that Tom is leaving her for another woman. Their sex life has been deteriorating and, as Tom later reveals to the same friends, Beth has killed his self-confidence as a man.

What Margulies proceeds to anatomize is the impact of this marital crisis on the other couple. The four friends had passed many happy summers and consumed many gourmet meals together on Martha's Vineyard, and now their relationship has splintered beyond repair. Although there is considerable analysis of character in the play—Tom is a narcissistic lawyer, Beth a self-involved artist—the playwright is more interested in the fragile nature of marriage. What happens to couples "when practical matters begin to outweigh abandon"? Should people follow their impulses and appetites regardless of the children? How do we respond to the need for change without hurting others? Can Gabe's friendship for Tom survive the breakup? Tune in tomorrow.

If I've made the play sound a little soapy, I apologize. Domestic though it is, the plot is more sophisticated than Jack loves Jill and Jill loves Bill and Bill has the hots for Phil. By cutting back and forth in time, Margulies creates a mood of bittersweet nostalgia, touching on a subject that has a lot of relevance today—the breakdown in sexual relationships. He also writes nice scenes for actors, and, under Daniel Sullivan's smooth direction, Matthew Arkin, Lisa Emery, Carolyn McCormick, and Kevin Kilner (reminding us a lot of his anagrammatical namesake, Kevin Kline) give sprightly performances.

Dinner with Friends appeals to audiences by turning a mirror on those audiences, prosperous Baby Boomers in the throes of broken marriages and fractured friendships. But Margulies provides no context or basis for the condition he observes. Since the breakdown seems to occur in a social vacuum, we end up feeling less like engaged participants than like detached voyeurs. Eugene O'Neill gives us characters harrowed by family circumstances, breaking under the weight of a discarded religious inheritance. Arthur Miller gives us characters trapped and floundering in a heartless social mechanism. David Mamet gives us characters molded by a world of avarice and greed. Margulies just gives us characters, with nothing more at stake than personal satisfaction—the appearance of life in a contextual vacuum.

[2000]

· *Women of the Theatre* ·

THERE WAS A TIME, not that long ago, when you could count the number of truly gifted women in our theatre on the broken fingers of one mutilated hand. Of course, there was never any shortage of terrific actresses, but what female playwrights could you name other than Susan Glaspell, Sophie Treadwell, and Lillian Hellman? Who among directors apart from Margaret Webster? Who among artistic administrators after Hallie Flanagan Davis, Nina Vance, and Zelda Fichandler? I'm sure you can identify other worthy exceptions to this generalization that I'm too foggy to remember, but the point is that, with women now making up an important creative core of the American theatre, you no longer need to look for exceptions. Female theatre artists are abundant, and not just segregated in feminist enclaves, doing plays on women's issues. They constitute some of our most brilliant writers, directors, choreographers, and designers as well as holding key producing positions in the nonprofit and commercial theatres.

Emily Mann of the McCarter Theatre in Princeton is among a cadre of women now heading major nonprofit theatres across the nation. Some other mainstream female artistic directors are Carey Perloff at the American Conservatory Theatre, Anne Hamburger at the La Jolla Playhouse, Molly Smith at the Arena Stage, Irene Lewis at the Center Stage, Lynne Meadow at the Manhattan Theatre Club, Martha Lavey at Steppenwolf, Tina Packer of Shakespeare and Company, and Sharon Ott at the Berkeley Rep, not to mention Elizabeth LaCompte, still at the helm of the adventurous Worcester Group, and such former artistic leaders (of the New York Public Theatre and the Trinity Rep) as JoAnne Akalaitis and Anne Bogart.

Mann, a Harvard graduate, has been running the McCarter since 1990. Talented both as a playwright and as a director, she is now being represented on American stages not only with her adaptation and production of *The Cherry Orchard* at the McCarter but with her touching adaptation of *Meshugah*, Isaac Bashevis Singer's semi-autobiographical tale of sexual obsession after the Holocaust, recently staged in an engaging production by Oskar Eustis at the

Trinity Rep in Providence. Both works reflect her deep engagement with social issues.

Mann's *Cherry Orchard* features an abstract geometric design by Adrienne Lobel, a combination of wing-and-border scenery and floating white panels framed in cherry wood that dislocate the play from its traditional Slavic setting. True, the characters have been allowed to retain their period clothes (designed by Jennifer von Mayrhauser) and their Russian patronymics. But the adaptation and the casting suggest that this country estate may have been transported from provincial Russia to the American South some time after the Civil War.

There are no references to serfs or serfdom in Mann's *Cherry Orchard*—nor for that matter to slaves or slavery. But many of her choices suggest that the "emancipation" referred to in her version was ordered not by Tsar Alexander II but by President Abraham Lincoln. Joshua Logan once attempted the same sort of geographical transformation for *The Cherry Orchard* in a play he called *The Wisteria Trees*. Emily Mann's version is more successful for being less specific. You can interpret it as a commentary on the way the gentry were yielding power to the middle classes in turn-of-the-century Russia—or you can see it as a history of race relations in America from the nineteenth century to the present.

Mann has included African-Americans in the cast not, as is customary in classical productions, to play nontraditional (or color-blind) roles but rather as conspicuous examples of a racial and social divide. Firs, the old retainer, is black. So is Varya, the housekeeper, and so is Lopahin, that successful son of a bondsman (the house servants Yasha and Dunyasha, on the other hand, for reasons that escape me, are Caucasians). Firs, played with endearing absentmindedness by Roger Robinson in a full white beard and under a shock of white hair, is clearly meant to recall Uncle Tom, especially when he is showing excessive concern for his white master, Gaev, or expressing nostalgia for the halcyon days "before the catastrophe—before freedom" ("those were great old days," Lopahin retorts, "lots of whippings anyway").

By contrast, Lopahin, as performed by that resonant actor Avery Brooks, seems to represent the modern black entrepreneur.

He has gotten very rich too quickly to develop the manners that go with his wealth (Gaev's contempt for Lopahin's crudeness and for his "cheap cologne" here verges on racism). Lopahin is urged to marry Varya (Caroline Stefanie Clay) because "she loves you and she's your sort." But he is clearly carrying the torch for Ranevskaya, his white patroness.

Come to think of it, it may be that Yasha and Dunyasha were cast with white actors because they are less sympathetic than the other servants. Yasha (Jefferson Mays), especially, is even more detestable in this production than usual. He shows no respect for his elders or his superiors, he smokes cigars so foul you can smell them in the auditorium, and in the second act he practically rapes Dunyasha on stage. Indeed in the last act, weeping bitterly at Yasha's impending departure, Dunyasha falls to her knees and undoes his fly, in preparation for fellating him—a telling demonstration of how this future commissar will be treating his women. I was prepared to argue with the easy racial equations of Mann's *Cherry Orchard* as contrary to Chekhov's more complicated sense of human character. But while I questioned some of her choices at times, at least her interpretation was one that provoked debate. Both in her adaptation and her staging, she had freshly rethought every moment of the play.

And her production was also very confidently acted. Jane Alexander brought a preternatural graciousness and serenity to the role of Ranevskaya. Avery Brooks's performance eventually won me over, though in the early scenes he lacked some of Lopahin's vulnerability and warmth. (And the reverberating basso he favored belonged more to the noble Othello than to a clumsy self-made entrepreneur.) John Glover, looking like a swashbuckling John Wilkes Booth with his cavalry mustaches, flowing scarf, and cutaway coat, also managed to finally convince us that he inhabited the character of the escapist Gaev, spiritually if not physically. Rob Campbell was a compact ball of wire as Trofimov, and Anne Dudek presented a winsome Anya. But the actor who truly engaged me was Barbara Sukowa playing Charlotta the governess. Expert in demonstrating her magic tricks, she demonstrated even more effectively how her lonely life in exile was bringing her close to breakdown. Among a talented if somewhat

frosty ensemble, Sukova revealed the delicately poised poignance of a warm-blooded woman in the act of wasting her life.

Mann's adaptation includes a second act scene that Chekhov cut at Stanislavsky's urging in which Firs tells Charlotta how he once spent two years in prison as a result of false arrest. This version also brings on Grisha—the child who drowned while the charming and feckless Ranevskaya was busy making love—turning him into a ghostly presence, an innocent little boy with a balloon, subtly rebuking the irresponsibility of the household. Both of these interpolations were used by Lucien Pintillie in his Arena Stage version of *The Cherry Orchard* in 1988. It was nice to see them again here in a production so notable for its intelligence, style, and grace.

Julie Taymor has brought to Broadway her off-Broadway production of Carlo Gozzi's *The Green Bird* with all of the same gifted designers and most of the inspired original cast. It makes for an equally enchanting and even more scenically spectacular evening of theatre. I reviewed this piece with enthusiasm in 1996 when it was first produced by the Theatre for a New Audience. It is not my habit to re-review productions that move from one venue to another, and I won't do so here. But it might be useful to speculate about why the same artist who triumphed on Broadway with *The Lion King* was unable to win the major reviewers over with *The Green Bird*, a far more brilliant fairy tale written by a far more imaginative playwright.

It is true that this *Green Bird* has its longueurs. There may be one too many journeys, two too many magical transformations, three too many *coups de théâtre* to constitute a perfect theatrical journey. About half an hour over length, it might well have benefited from some curbs on Taymor's abundant imagination. Still, the production is an unmitigated delight for eyes and ears, and it has some of the most raucous low comedy acting and writing I have witnessed since Minsky went out of business and the Keith vaudeville circuit closed its doors.

And that may be a reason for the muted critical response. A culture that gives the Pulitzer Prize to a domesticated piece of fluff like *Dinner with Friends* is probably not prepared to embrace a fantastical play in a phantasmagoric production, especially when it comes without the Disney imprint. Also, for some reason I fail to understand,

there seems to be a general consensus in this reviewing generation that slapstick and burlesque are inferior forms of theatre. Most of our theatre critics, sounding like Tony Lumpkin in Goldsmith's *She Stoops to Conquer*, usually dislike anything that's "low."

Low comedy, farce, vaudeville, and burlesque, on the other hand, though often banished from the stage at a time when sentiment is in the ascendant, have always been among the most vibrant forms of theatre, from Aristophanes to Ionesco, from *commedia dell'arte* to the Marx Brothers. In Taymor's *Green Bird* these forms are momentarily finding renewed life on a commercial stage where great clowns like Bobby Clark, Jimmy Savo, Bert Lahr, Sid Caesar, and Milton Berle once were kings. That this kind of virile, often erotic buffoonery is now being created by a woman (feminists have been known to scorn it as demeaning to their sex) is yet another example of how women are achieving true hegemony with men in every aspect of the American theatre.

[2000]

· Ascents and Dissents ·

DAVID HIRSON'S first play on Broadway, *La Bête* in 1991, triggered a fusillade of negative reviews, despite the participation of an imaginative director (Richard Jones) and a courageous producer (Stuart Ostrow). A Yale-trained scholar writing in scrupulous imitation of Molière, Hirson not only composed a period piece worthy of seventeenth-century French comedy but wrote the play in rhyming couplets. He was also *chutzpadik* enough to fulminate, Alceste-fashion, against the vulgarization of culture and the debasement of taste—and to the patrons of the Great White Way, no less! On Broadway this was tantamount to a temperance zealot urging abstinence and sobriety on the denizens of a Third Avenue tavern. Predictably this unwanted interloper was roughed up by the local barflies, who, ignoring the prizes his play had garnered abroad,

booted him into the street before returning to their preferred bottles of booze.

Nine years later (Hirson is not exactly prolific) he has picked himself out of the gutter, dusted the street off his clothes, and staggered back into the barroom with another temperance lecture called *Wrong Mountain* (Eugene O'Neill Theatre). Once again the local toughs have done their job on him, thrashing the playwright and closing his play in just over two weeks (*La Bête* lasted two weeks longer in the same theatre). It would seem, as far as criticism is concerned, that history is repeating itself, but so unfortunately is Hirson. I strongly believe that *Wrong Mountain* deserves more respect and a longer life than it managed to receive. After all, how many new American plays are allowed to make their way to Broadway these days, especially those engaging serious intellectual issues? But it must be admitted that, despite its estimable intentions, *Wrong Mountain* ends up looking like a contemporary reworking of *La Bête* without its wit, color, or charm.

Hirson's current hero is the poet Henry Dennett—a bilious Jeremiah in the style of Allan Bloom—who, while fighting a monster tapeworm in his gut, has been angrily witnessing the death of literature from a surfeit of bad taste and inane ideas. His antagonist is Guy Halperin, a "tremendously successful" writer of Broadway musicals, now living with Dennett's ex-wife. Although Halperin concedes that real talent often toils in obscurity, he also believes that the purpose of art is not to trouble the mind with questions of beauty and truth. It is rather to find the materials that will be more inclusive of women, teenagers, and people of color. In short, Hirson is recapitulating the familiar, unresolved debate about art in a democratic society, whether it should stress quality or accessibility.

Although the characters and circumstances may be somewhat different, the argument also recapitulates the conflict in *La Bête* between the poet Elomire and the poetaster Valère. Dennett, like Elomire, believes that one achieves popularity only by bartering one's soul. Quoting (at least three times) from Strindberg's introduction to *Miss Julie*, he calls conventional theatre a "Biblia Pauperum," a bible in pictures for the benefit of the lazy and the illiterate,

written "to sustain the interest of an easily bored mind that is always threatening to revolt." Guy, like Valère, believes that writing hit musicals is just as difficult as producing good poems. Warning Dennett that he may have spent his entire life "climbing the wrong mountain," Guy challenges him to ascend a new peak by writing a successful play.

Despite his disdain for middlebrow taste, "that mountain of toxic kitsch," Dennett accepts the challenge, probably because he stands to win $100,000 from Guy if he succeeds. In the next scene, after a miniature train has transported us between two peaks to the accompaniment of Grieg's "Hall of the Mountain Kingdom," we are deposited in the "Lila W. Hirschorn Rehearsal Pavilion," the site of a Sundance-like play contest located somewhere in the Rockies. There we find Dennett competing with two younger playwrights for the grand prize.

It is in this rehearsal studio that Hirson starts to climb the wrong mountain, clouding his original premise with a feeble satire on a theatrical troupe (an idea also borrowed from *La Bête*). This one is in the throes of rehearsing not only the competing plays but a production of *Romeo and Juliet*. Hirson's overwrought histrios, especially the plummy, henna-haired festival director, Michael Montresor, spring more from the imagination of Charles Dickens than from anything recognizable in our own time. Played as a flaming if absent-minded poof by the gifted Daniel Davis, Montresor looks less like a contemporary member of Actors Equity than like some addled old laddie from the Garrick Club, continually referring to, and misquoting, the "Bard" while hamming up roles he has long outgrown.

When he is not rehearsing Romeo, the aging Montresor is busy leading his company in group hugs and animal exercises. Captivated by celebrity and boastful of his friendship with "Kiki" (Laurence Olivier), whose wig he once combed, he is full of admiration for Dennett, even though he can't seem to pronounce his name correctly. As for Dennett, he seizes the opportunity to restate his elitist views ("find out what slop the livestock wants and treat curtain up as feeding time") when he engages in debate with a competing playwright who finds him incredibly twisted and condescending.

Despite his constant, increasingly tiresome screeds against medi-

ocrity, Dennett grows surprisingly benevolent as his Festival experience draws to an end. This is partly because his play has won first prize and partly because he has drunk some transfiguring waters from the fountain of the goddess Lithea, who may personify Success. He admits to having been softened by the nature of the actors. He is impressed by "the amazingly beautiful scepter" he has won for his play, which is also entitled *Wrong Mountain*. Does this Pirandellian conceit suggest that Hirson's play may be secretly autobiographical?

Only Dennett's son, a sour disciple of a surly guru, dissents from the generally high estimate of his father's play, which he calls "an embarrassing piece of kitsch" articulated through "the voice of a pornographer." Reminding his father of his own belief that success is the ultimate betrayal, he confronts him with the discarded mirror image of what he once was. As for Dennett, he has become indistinguishable from Guy. His play, which he describes as "the rare drama that is courageous enough to examine where we are and where we have to go," is headed for Broadway. When it gets there, Dennett's *Wrong Mountain* will no doubt suffer the same fate as Hirson's *Wrong Mountain*. Death from an avalanche of critical scorn.

Ron Rifkin plays Henry Dennett with a corrosive lacerating hatred that sometimes turns on itself, maintaining consistency of character even when the playwright abandons it. And Tom Riis Farrell as Dennett's doctor has a few very funny moments enjoying his patient's physical distress. In his second attempt at a Hirson work, Richard Jones shows some of the frustration that results when an essentially visual director tries to stage an essentially verbal play. The pace is too fast, and most of the scenic effects seem superfluous. What was Hirson's reason for writing *Wrong Mountain*? To satirize bad theatre—or to chastise himself for his own involvement in it? For that answer we must wait for the playwright's next temperance lecture.

Claudia Shear's *Dirty Blonde* at the New York Theatre Workshop has a lot of charm, but it seems more like an act of heroine-worship than an as yet fully realized work. Written in coordination with its director, James Lapine, the work is an effort to pay tribute to Mae West—particularly the bold way she challenged sexual taboos on stage and screen. The adjective "dirty" in the title describes both

the color of her pre-peroxide hair and the character of her post-pubescent mouth.

Played within a perspective box designed by Douglas Stein, which initially features a glimpse of Mae's seductive eyes, *Dirty Blonde* is performed by the author and two other actors, all of them in a variety of roles. Shear, for example, enacts both the part of Mae West and one of her latter-day admirers, while Kevin Chamberlain plays one of her vaudeville partners and Charlie, a young man whom West once asked to impersonate her for the sake of tourists passing by her Beverly Hills home. (Charlie, the proud owner of the dress she gave him for the purpose, soon gets in the habit of wearing it in private.)

Shear also has a chance to try on a Mae West dress, in the character of a young woman named Jo whom Charlie takes to a Halloween party. To advance their budding romance, Charlie must persuade Jo that his own love of drag does not necessarily mean that he is gay. It could simply mean that he is overcome with admiration for a great female personality. These psychological insights are not the strongest things in the evening.

Nevertheless the performers make *Dirty Blonde* quite winsome, even when the writing remains somewhat cursory and impressionistic. And the show benefits from some lively period music played on piano by Bob Stillman (who also enacts Mae's first husband and her gravel-voiced Beverly Hills assistant). Stillman is also the composer of the catchy title song, nicely sung and nimbly danced by the other two performers.

The playwright is always threatening to obscure her engaging factual material with her not very interesting fictional subplot. Too often *Dirty Blonde* falls into the pattern of an "unforgettable character" sketch or, at best, an entertaining bio-pic. It is pleasant to be reminded of Mae West's journey from vaudeville, where she earned a bad name for her "ribaldry," to Broadway shows like *Sex*, where her risque double entendres got her arrested for public indecency, to her long career in Hollywood where she discovered Cary Grant (featuring him in *She Done Him Wrong*), after which she quarreled with W. C. Fields during the making of *My Little Chickadee*, and then committed the monumental mistake of turning down *Sunset Boule-*

vard because she wouldn't play a has-been. The evening manages to shovel in most of West's legendary one-liners ("Me, I feel like a million—one at a time, one at a time"), though it curiously omits the best of them: "Is that a gun in your pocket or are you just glad to see me?"

Shear expertly distinguishes between her own fine job as an actress playing Mae West and her character Jo's clumsy impersonation of the woman. Gradually building a legend out of the sequined gowns and peroxide wigs, she skillfully captures the working-class dockside accent, the suggestive glinting stare, the insinuating parted lips, the left hip that gyrates like an idling engine with bad cylinder heads. Shear never exaggerates a personality that is already something of an exaggeration. But the main problem with her play is Platonic—she gives us an imitation of an imitation. Mae West being something of a female impersonator herself, any theatrical impersonation of her removes us two degrees from the reality.

[2000]

· *The Staged Documentary* ·

THE LARAMIE PROJECT, at the Union Square Theatre in New York, is the joint product of the director/playwright Moises Kaufman and a group of eight lively actors who call themselves the Tectonic Theatre Project (TTP). "Tectonic" refers to deformations in the earth's crust, and *The Laramie Project* suggests that these deformities are often caused by humans. It is a play about the well-publicized murder of twenty-two-year-old Matthew Shepard, a gay Wyoming student, by two particularly brutal hoodlums who, after beating him nearly to death, virtually crucified him against a wire fence. (Terrence McNally would have done better to have made Shepard, not the crucified Jesus, the gay hero of his play *Corpus Christi*.)

Some years ago the same collaborative team gave us *Gross Indecency*, about the three trials of Oscar Wilde on charges of sodomy

and pederasty. It is apparent that the tectonic deformations perceived by Mr. Kaufman and TTP are often related to the treatment of homosexuals in a homophobic society. This is an important theme for dramatic investigation. It is also a theme that is getting somewhat overworked. Writing this I am aware that it must seem callous to apply artistic standards to the presentation of barbaric social happenings like the Matthew Shepard case. But if the personal is political, then the political is also aesthetic. Kaufman and TTP succeeded in drawing an engrossing evening of theatre out of the unjust treatment of the homosexual Oscar Wilde in *Gross Indecency*, partly because the hero was such a brilliant man. *The Laramie Project* also has its moments, but the piece lacks a compelling protagonist.

Actually *The Laramie Project* has too many protagonists to be compelling. It is less concerned with the murder of Matthew Shepard than with the way the local residents reacted to the public notoriety they received as a result of the crime. It starts from the very sensible notion that when a particularly heinous event occurs, the entire area is often perceived as sharing in the guilt of the perpetrators. Reporters refer to "Columbine" and "Watts," for example, as a shorthand method of identifying disturbances. But in employing such generic language they manage to implicate everyone in town. As one of the Laramie townspeople ruefully remarks, "We've become Waco—Jasper—a noun."

Apparently inspired by the process of Anna Deavere Smith—conducting interviews that serve as material for an enacted scenario—*The Laramie Project* is much more a documentary than a play. Like Smith visiting Crown Heights or South Central L.A., Kaufman and his Tectonic actors went to Laramie to meet with the citizens and ask each of them in turn, "What was your response when this happened to Matthew Shepard?" Over a period of two years and six different visits, they interviewed about two hundred people, most of them only too eager to try to rescue the reputation of their town from infamy. More than sixty of these characters are represented on stage by the eight actors, who also sometimes play themselves. This is a very generous representation. By the end of the evening we feel that we have met a fair sampling of Laramie resi-

dents. The problem is we can't tell them apart very well or remember many of their names.

On a bare stage, dressed with five tables and eight chairs and backed with a brick wall against which "Journal Entries" are projected, the actors represent a police chief, a university theatre head, a woman rancher, a limo driver, a university president, a lesbian waitress, a lesbian faculty member, a Muslim feminist, a student defying his family by performing in *Angels in America*, and any number of friendly people just sitting around and musing about how this sort of thing could have happened in their neighborhood. Some critics have pointed out resemblances between Laramie and *Our Town*. Indeed people even show up at Shepard's funeral carrying black umbrellas. But considering what happened to Shepard, this *Our Town* is at times closer in spirit to Kenneth Tynan's satire than to Thornton Wilder's play—a lily-white American village where they lynch blacks, spit on Jews, and punch out the lights of gays between visits to the drugstore for a vanilla soda.

This is not to say that the people interviewed by the TTP actors are in any way evil or malign. Quite the contrary, virtually all, including the governor of Wyoming, testify to having been "sickened" by the murder. "We don't grow children like that here," says another, adding, "But it's pretty clear we do grow children like that here." Laramie's attitude toward gay people, says another, "is live and let live." One clergyman affirms that he doesn't condone that kind of violence—or, as he can't resist adding, "that kind of lifestyle." Although this particular murder was motivated by hatred for gays, one woman notes, Matthew was neither a saint nor a martyr. If the victim had been a policeman, would the newspapers have shown the same interest?

Nevertheless most of them—save a few anti-gay fanatics (one carrying a placard reading "God hates fags")—are tolerant of homosexuals. A hundred people march on behalf of Matthew Shepard wearing yellow armbands. Others wave placards reading "Peace and Love." And although one angry lesbian demands the death penalty for Matthew's killers, his father asks clemency for them, and they get it—in the form of life imprisonment. The citizens of Laramie, in

short, are more likely than not to show a benevolent face. So, in fact, are the well-scrubbed actors who play them (even the cigarettes they smoke are environment-friendly, being unlit). Sitting on stage watching each other perform, their expressions alternating between piety and approval, these actors work very hard to avoid the chief danger of this kind of presentation—self-congratulation. One can almost sense the director leaping up to squash the impulse toward condescension, not always successfully. With a few exceptions, notably Mercedes Herrero as a tough-minded policewoman worrying about contracting AIDS because she cleaned up the blood of the HIV-positive Shepard, the performers are too often unspeakably awed, on the verge of tears, by the inspirational way they are playing their characters. In a filmed documentary it is easy to respond to the simplicity of average people. In stage impersonations that simplicity too easily falls into fake folksiness. *The Laramie Project* brings up unintended questions about the relationship of the stage to reality and the responsibility of actors to the actual people they are trying to impersonate.

And this brings us to the main problem with the whole enterprise. Although inspired by one of the worst hate crimes in recent American history, it draws back before the fact of human evil. For all the references to the killers, Russell A. Henderson and Aaron J. McKinney, by friends, family members, prosecutors, and police officers, we leave this play knowing as little about them as when we first arrived at the theatre (we also know very little in the end about Matthew Shepard). What kind of individuals could snuff out a life because they thought someone was coming on to them in a bar? What does this tell us about human behavior and human motive?

Instead of penetrating character, the play prefers to argue for legislation, as if special laws could somehow change the way people behave. But as Andrew Sullivan argued persuasively in the *New York Times Magazine*, passing more laws will not eradicate racial, religious, or sexual hatred. It may just drive it underground to fester in uglier forms. A priest in the play says it sows the seeds of violence to say "fag" or "dyke." But it is a real question whether laundering the language—sometimes known as "freedom from speech"—would lower the incidence of violence. The crime for which Henderson and

McKinney were apprehended, tried, and convicted was not violating speech codes. It was murder, for which there are already plenty of laws on the books.

Upon reflection, *The Laramie Project* may be more important as a purgative than as a performance, for it succeeds best as a rite of exorcism for a lot of troubled people, a kind of dramatized encounter group for the entire town. One resident may insist that "Hate is not a Laramie value," but as another replies, "We need to admit we live in a country where shit like this happens."

The play also manages to make an argument for the normalcy of being gay, foreseeing a time when people will consider homosexuality neither right nor wrong but simply a fact of biology. This is devoutly to be wished, for reasons at once political, personal, and aesthetic. Such a belief might very well help to eliminate gaybashing. It might also help restore the theatre to an earlier purpose—which is not to confirm audiences in their liberal pieties but to uncover the veiled mysteries of the human heart. Such a belief, furthermore, might permit our artists once more to explore the nature of sexuality rather than the issue of sexual preference, sexuality being a condition of the whole of humanity and not just some of its divided categories.

[2000]

· *Tell Me Where Is Fancy Bred* ·

PROOF, which recently reopened at the Walter Kerr Theatre after a run at the Manhattan Theatre Club, is the latest in a string of plays with one-word titles that represent the theatre's belated tribute to the conceptual intelligence. Tom Stoppard probably started the whole fashion with *Arcadia*, a period comedy that features, among other things, dialogues on English gardening and Newtonian physics. But the trend has exploded in the last few years to include Yasmina Reza's *Art*, an argument provoked by a postmodern painting, Margaret Edson's *Wit*, an infirmity play surrounded by a frame of metaphysical poetry, and Michael Frayn's *Copenhagen*, a scientific

discourse on the subject of quantum theory, indeterminacy, and atomic fission. These are the major examples of a genre with terse titles and prolix personae that has now managed to occupy the middle (or middlebrow) ground of the Western stage.

I'm still trying to figure out why this development is leaving me less dazzled than it does my critical colleagues. I realize we should encourage anything that raises the intelligence level of our woefully benighted theatre; and it is also true that some of these plays (notably *Wit*) have a lot more going for them than intellectual pyrotechnics. But the danger of this kind of Cliffs Notes approach to playwriting is that by simply dropping names or equations, the dramatist will feel relieved of the obligation to investigate the emotional and spiritual aspects of the material, and the spectator will leave the theatre feeling a lot more intelligent than he actually is. "Tell me where is fancy bred," Shakespeare asked, "Or in the heart or in the head." There is little doubt that for Shakespeare, at least, fancy (the seat of the imagination) was lodged in the noncerebral parts of the human body.

Proof is David Auburn's first major production and, if not exactly the brilliant debut that some have been claiming, it represents the work of a writer with a fairly decent grasp on his not terribly fanciful material. The "proof" of the title is a breakthrough mathematical equation regarding prime numbers, the authorship of which is a subject of dispute. Catherine (Mary-Louise Parker) is the daughter of an intermittently psychotic and recently deceased professor at the University of Chicago (Larry Bryggman), whose ghost comes to visit her from time to time. She has a fling with one of her father's graduate students (Ben Shenkman) after she finds him rifling through her father's notebooks. She is in conflict with her rather unimaginative sister (Johanna Day) who wants to sell the family house and move Catherine to New York. And when this relatively undereducated woman claims to be the author of the theorem in question (I'm ruining for you what is intended to be a stunning first-act revelation), there is some debate as to whether she isn't treading in her father's demented footsteps.

We never learn the actual nature of the discovery, or why it constitutes such a great contribution to world knowledge. The author,

by his own admission, doesn't know or care much about mathematical theory. But what makes this play problematical is not Auburn's ignorance regarding prime numbers. It is the thinness of his plot. He runs out of material so quickly that by the middle of the second act the play stops moving forward and starts running in place. *Proof* sometimes looks like a rather austere stage version of *Good Will Hunting* insofar as it features a whiz kid central character who is also an *idiot savant*. But if *Good Will Hunting* was concerned with questions of class, *Proof* focuses on questions of gender—how "Shakespeare's sister" could have written all his plays if she hadn't been forced to shine unappreciated on the ocean floor. You know the tune.

Auburn's writing may not be terribly electric or dynamic. But Daniel Sullivan's direction muffs the few opportunities the playwright offers to hoist the action out of the quotidian and the ordinary. *Proof*, with its spectral visitations from the heroine's father and its nonlinear treatment of time, is, after all, something of a ghost story. But the production remains mired in relentlessly realistic domesticity, with John Lee Beatty contributing another in his gallery of Edward Hopper brick structures, and Neil A. Mazzela's lighting failing to distinguish between the gritty present and the ethereal past.

Where the evening does prosper is in the acting, especially in Mary-Louise Parker's Catherine. I first saw this fine actress in 1988 playing Emily to Eric Stolz's George in the Lincoln Center *Our Town*. Young as she was at the time, she made it instantly clear that she was born for the stage, a promise she confirmed nine years later playing L'il Bit in *How I Learned to Drive*. Here she turns the twenty-eight-year-old Catherine into a restless, angry rag doll of a woman with a frazzled slouch, who manages to accomplish one of the speediest costume changes in recorded history (she goes up a whole flight of stairs, then appears seconds later on stage in a completely new set of rumpled clothes). That she can also create such texture out of her underwritten role is an even more impressive feat of stage magic.

Anne Bogart's *War of the Worlds*, a production that played briefly at the Brooklyn Academy of Music after its premiere at the

Humana Festival in Louisville, is an effort to do to Orson Welles what Orson Welles did to William Randolph Hearst—namely, expose his character weaknesses through a semi-fictional action. In a program note Ms. Bogart writes that she was astonished to find Welles such an object of respect in Europe when he is remembered in America "as a fat man on talk shows who also appeared in advertisements for wine." Actually he has remained a figure of considerable interest, if not always of veneration, in our own country, and not just among theatre and film connoisseurs. It is true that people love to take potshots at him. Pauline Kael famously questioned his authorship of *Citizen Kane*, Simon Callow in a recent biography exposed his arrogant treatment of actors, and just this year Tim Robbins made him the crude egotistical center of his movie *The Cradle Will Rock*. "Sometimes I goe about and poyson wells," sneered Barabas in Christopher Marlowe's *Jew of Malta*. He did not know he was initiating a cottage industry.

But Welles has always been a subject of considerable admiration as well as poison. Some Hollywood directors have worshiped the man this side of idolatry. When not writing biographies and critical studies of Welles, for example, Peter Bogdanovich was usually impersonating his directing style. Ms. Bogart offers much the same tribute of imitation on stage. *War of the Worlds* is a biography of Welles dressed in the clothes of *Citizen Kane*, using the same situations, dialogue, characters, and structure—on the implied assumption that Welles was the secret hero of his own film. "What you are about to hear is the real story, absolutely true, based on solid fact," argues the actor playing Welles (Stephen Webber) in the act of impersonating his incessant cigar-smoking, his footloose ungainliness, his sly insinuating smile.

The idea must have seemed irresistible in theory. In actuality, while Bogart's stagecraft is always ingenious, it sometimes seems like an effort to beef up the recalcitrant writing of Naomi Iizuka. While it is nice to hear reprises of some of your favorite movies and radio plays, and engaging to watch evocations of Joseph Cotton, Everett Sloane, Agnes Moorhead, and the rest of Welles's repertory company, the novelty quickly palls and one soon begins longing for the originals. There are besides too many glib postmortem judgments

on Welles ("He was a great man, but in the end he destroyed himself"), too many easy comments on his deadly sins of sloth, gluttony, vanity, and pride. In the end, *The War of the Worlds* seems unconsciously to embody one of its themes—that we live off the corpses of the cultural heroes we help destroy.

The Syringa Tree (Playhouse 91) has very little in the way of stage effects outside of a swing and a cyclorama. It is a solo performance, written and acted by Pamela Gien, part fiction, mostly fact, about her childhood in South Africa during apartheid. It is also, let me quickly add, uncommonly moving, even wrenching. Ms. Gien was once an actress in my company, but nothing in her previous work prepared me for what she is delivering here—a series of character transformations so instantaneous and so intense that you believe the stage is peopled with multitudes. Still, it is not just the technical achievement that startles one into attention. It is the way she manages to delineate, physically and vocally, a whole world of whites, blacks, coloreds, Jews, and Afrikaners—a world of divided identities where the very fact that a black baby has been born without "papers" can destroy her and uproot everyone around her.

The various incidents of the play are seen through the eyes of a half-Jewish child in Johannesburg, and, if the evening has a weakness, it is that the voice Ms. Gien has chosen for little Elizabeth tends to grow rather irritating. But she has perfect pitch in the way she characterizes the harassed father, dispensing precious medicines, the slightly hysterical mother, the Faulknerian maid and her hapless little "pickaninny," the hard-nosed Afrikaners praying for rain, all as a prelude to the terrible events of Soweto. The grown-up Elizabeth leaves for America as a result, and her subsequent return to Johannesburg to find her past again constitutes a poem of inconsolable loss and nostalgia that leaves the American audience grieving for the beloved country as much as the central character. My friendship with Ms. Gien should prevent me from reviewing her work at length or getting too enthusiastic about it in print. But never mind—it's too good a thing to miss.

Bill Irwin also has a one-person show this season—an enactment of Samuel Beckett's *Texts for Nothing* at the Classic Stage Company. Irwin has done extraordinary things in his career but few

as remarkable as persuading the notoriously recalcitrant Beckett estate to let him put four of these thirteen prose pieces onto the stage. As a result of his persuasive powers and his own meticulous stage work, he has managed to create a new Beckett play, or at least a new Beckett performance piece, that could very well find a permanent place in the theatrical canon.

Irwin maintains that *Texts for Nothing*, written a year and a half after *Waiting for Godot*, is actually a companion piece, and he is undoubtedly right. The prose texts deal with the same refusal to persist coupled with the same compulsion to persist—the futility of continuing colliding with the necessity for continuing—that underlies the trials of Didi and Gogo. Under Irwin's direction, Doug Stein has imagined a terrain that looks like a particularly bleak part of the Rockies—steep escarpments stocked with mud holes, boulders, and one small tuft of green on the mountain, representing (like the second-act leaf in *Godot*) a trace of hope for renewal in an otherwise barren landscape.

When we first see Irwin he is sliding helplessly down this mountain on a stream of dirt and pebbles. He is an exile from paradise, and he will spend the rest of the evening trying to scale the heights again. Accoutered in a bowler hat, baggy pants, a collarless shirt, and a tight-fitting jacket, he looks for all the world like Chaplin in *The Adventurer*—but unlike the ingenious Charlie, this is a clown that has lost his resources. "Suddenly, at long last, I couldn't any more, I couldn't go on. Someone said, 'You can't stay here.' Can't stay and can't go." (Or as Beckett puts it more tersely in *Godot*, "Well, shall we go?" "Yes, let's go." *They do not move.*)

Irwin physicalizes this dilemma with his rubbery features and elastic limbs, bungling into mud holes, tripping over stones, wriggling down slopes. At one point he walks over what looks like solid ground, only to be plunged into a cavernous cavity ("I'm in the hole the century dug"). Nancy Schertier's lighting brightens and darkens, marking an unbroken sequence of endless nights. "It's always night," Irwin observes, "why is that?" and quickly answers, "To give the best to look forward to." In this continuing conversation with an absent God, where language is less a path to salvation than a means of survival, life itself becomes a purgatorial punishment. By the end,

like Winnie in *Happy Days*, Irwin is up to his neck in his hole, continuing to babble until eternity comes.

Bill Irwin has contributed wonderful performances in the past, including a memorable Lucky in the Mike Nichols *Waiting for Godot*. And he does wonderful things here. But to be perfectly honest, because of his rather flat American vocal resources he can't produce the reverberant music of such great Beckett actors as Barry McGovern, Jack McGowran, and Patrick Magee. As a result the evening sometimes seems considerably longer than its eighty minutes, and at times the audience gets ahead of the material. But what Irwin fails to verbalize he certainly manages to physicalize and theatricalize—making up as a mime, dancer, and clown whatever he might lack as an actor. *Texts for Nothing* may not be the greatest Beckett work in the theatrical repertory, but it belongs there nevertheless. It demonstrates anew where fancy is truly bred—in our hearts, where Irwin's epic struggle with that intractable mountain has etched itself indelibly.

[2000]

· *Deconstructing Susan* ·

SUSAN SONTAG'S PLAY *Alice in Bed* has enjoyed at least three productions in recent years, its appeal lying less in any intrinsic qualities as a dramatic work than in the way it functions as a kind of theatrical *tabula rasa*. The play is an instrument on which gifted musicians may play whatever music they please. Sontag's writing here has an almost porous quality, its terse, disjunctive style absorbing subtextual interpolations like a sponge. This quality, along with the author's willingness to allow her collaborators the widest latitude, may explain why the work has attracted some of the world's most adventurous experimental directors. Robert Wilson gave *Alice in Bed* a workshop production in Germany some years ago. Bob McGrath staged its world premiere at my own theater in Cambridge in 1996. And now Ivo van Hove is presenting it to New York audiences at the

New York Theater Workshop. Each production has revealed an entirely different play. Sontag may have written the ultimate postmodernist work, not only open to deconstruction by outside interpreters but simultaneously deconstructing itself.

On the page *Alice in Bed* has some of the itinerant qualities of a *nouvelle vague* novel. Essentially a monologue, it is composed of the daydreams of Alice James, the younger sister of William and Henry, living in London and confined to her bed by a combination of physical and neurasthenic complaints. Although she mostly talks to herself, Alice also has some hallucinatory dialogues with members of her celebrated family as well as joining in conversation with a trio of ghosts during an imaginary tea party inspired by *Alice in Wonderland*. Among Alice's invited guests are the transcendentalist bluestocking Margaret Fuller, the great reclusive poet Emily Dickinson, and Kundry, the wandering seductress of Wagner's *Parisfal*. This array of historical and fictional female celebrities sometimes makes the play look like an avant-garde version of *Top Girls*. But no single style is allowed to dominate the evening. In a surprisingly conventional final scene, Sontag abruptly shifts gears and starts writing in the manner of Victorian drawing-room comedy. The episode recalls the sickbed scene in Shaw's *Too True to Be Good*, where an incompetent burglar surprises Alice, then delights her so much that she actually manages to rise up from her bed of pain.

Sontag's purpose in these brief and impressionistic vignettes is to celebrate the unsung qualities of an unusual woman who may have been the most brilliant talker of all the elder James's "brilliant, talkative children." An invalid desperate for attention, she finds little comfort in conversations with her brother Henry, and even less with her father, Henry Sr. "Aren't you impressed, father, by how unhappy I am," she asks. "Make an effort," he replies. "May I kill myself?" she inquires. "You must do what you want," he responds. Eventually she dies, though not from suicide, at the age of forty-three. Possibly she was chilled to death.

If each production of *Alice in Bed* reveals a different side of the play, the current one also reveals a different side of Ivo van Hove, the redoubtable Dutch theatre artist who is currently general manager and resident director of one of Holland's most daring theatre ensem-

bles, Het Zuidelijk Toneel. Thanks to invitations by James C. Nicola, the artistic director of the New York Theater Workshop, van Hove has been arousing American audiences in recent seasons with his audacious reinterpretations of American drama, beginning with O'Neill's *More Stately Mansions,* followed by Tennessee Williams's *A Streetcar Named Desire,* and now Sontag's *Alice in Bed.* Each of these productions has been created in collaboration with van Hove's imaginative designer Jan Versweyveld, who is managing to invent entirely unexpected, and at the same time curiously inevitable, environments for works that have hitherto been frozen in realism.

Van Hove and Verseyveld reduced the cluttered New Orleans tenement of *Streetcar* to one isolated bathtub. The fashionable London flat of *Alice in Bed* has been transformed into an abstract collage of found objects hanging by strings above Alice's bed. The bed itself is a metal construction that looks like a medieval torture machine. But all the junk hanging from the flies looks suitable for torture—a mirror, a comb, a teapot, a syringe, and other props referred to in the course of the play. Actually, though, the major design element is not solid stage material at all. It is a series of diaphanous surfaces that are raised and lowered, or pulled around the bed like a curtain, to function as a screen for still projections and moving pictures. The result is a dazzling display of visual images as powerful and adroit as any to be seen on the contemporary stage.

Alice begins the play in furious debate with herself, alternately using the guttural tones of a grown woman and the squeaky shrieks of a little girl. In the powerful virtuoso performance of Joan Macintosh, the woman is a frenetic force of nature, a tornado confined in an eggshell. When talking to her father, the Cambridge social theorist Henry James, Sr. (played by Jeroen Krabbe), she is communicating with an image on a screen, whose face keeps morphing into that of her mother (sometimes played by Macintosh herself, sometimes by Valda Setterfield). The film is slowed and stopped, the dialogue falling purposely out of sync with the lips that are speaking it. The screen images chase each other around the stage. Alice chases the images. Sometimes Alice observes herself on the screen. Sometimes she converses with a life-size image of herself, a quasi-hologram. The images split, divide, and multiply, like the characters in Strindberg's *A*

Dream Play. The ghost tea party (reminiscent of the Ghost Supper in another Strindberg play, *The Ghost Sonata*) is also a filmed sequence in which Alice wanders around the cinematic action and sometimes into it. At the end Alice is back in stage reality, still torn by a fatal ambivalence, arguing with her younger self: "Let me fall asleep. Let me get up." A child's voice is heard, speaking in German, gently saying "*Schlaf.*"

On the page *Alice in Bed* looks slight and underwritten, meandering, perhaps even a little precious. On the stage it is an engrossing and sometimes moving experience. In demonstrating how a minor work of literature can provide the occasion for a major piece of theatre, this production heightens the value of the collaborative arts.

Oliver Py's *Requiem for Srebrenica*, which recently played at BAM's Harvey Theater in Brooklyn, is an attempt to create a theatrical documentary out of the 1995 massacre of seven thousand Bosnian Muslims by the invading Serbian army. The thirty-five-year-old Py is a French playwright and director who, aside from occasionally performing in drag cabarets, heads the Centre Dramatique National in Orleans. I understand that he is emerging as a major force in French theatre. I'm sure he has better pieces in his repertory than *Requiem for Srebrenica*.

I suppose that it is callous to apply aesthetic standards to works driven by political passions, and especially to such a ghastly event as the Srebrenica massacre. But that may be the basic fault of Py's piece. It is such a relentlessly single-minded indictment of everything and everybody—of the Serbs, and the UN forces that stood idly by while atrocities were taking place, and the indifferent French authorities, and perhaps the passive audiences listening to the play—that it ultimately fails in the one area a work of propaganda is required to succeed. Instead of stirring the spectator's indignation to some kind of action, it manages only to stimulate our guilt, which may be why we end up judging the show more severely than the atrocity.

Occasionally there are effective theatrical resources employed in *Requiem for Srebrenica*. The account of the events is spoken by three women (Anne Bellec, Irina Dalle, and Frederique Ruchaud) because all the men in Srebrenica have been slaughtered. The actresses are strong performers, but what they deliver is essentially a flat stage lecture documented with statistics of horrors, calamities, and mutila-

tions. At one point a metal wheelbarrow is pulled up to the flies by a rope as we hear an account of how the Bosnians tried to hang themselves. A stage image like that is worth a thousand words. Unfortunately it is drowned out by considerably more than a thousand words.

There is no doubt that events transpired at Srebrenica pretty much as this play describes them, and none of us liberal theatregoers doubts that the Serbian commanders responsible for the massacres should be tried and punished for war crimes. Although most of us came to the theatre with that belief, it is the one truth we hear repeated during the hour and a half that the evening lasts. But it is the design of drama, it is its very essence, to accommodate a multitude of truths—which is why a play proceeds through dialogues and not through monologues. Perhaps there are some subjects that are too monolithic for theatre to accommodate. Judging from *Requiem for Srebrenica*, the Bosnian conflict may be one of them.

[2000]

· *Dreaming a Dream Play* ·

AUGUST STRINDBERG wrote *A Dream Play* in 1902 after experiencing a nervous breakdown in Paris that led him to the brink of madness. Called the "Inferno crisis" after the intensely subjective memoir he later wrote about the experience, this was a period in which Strindberg's incipient paranoia had blossomed into full-blown persecution mania. Among his many curious delusions was the conviction that he was being tortured by feminist witches. He was convinced they were pumping gases into his body by means of an infernal electrical machine through the walls of his hotel room.

His recovery from this dark night of the soul, under the tender care of his mother-in-law, led to a radical transformation in his personality, his religious convictions, and his approach to theatre. Whereas Strindberg formerly believed, for example, that what passed for love between men and women was strife, a crude Darwinian struggle for supremacy resolved only through the victory of one sex

over the other, by the time he writes *A Dream Play* he has abandoned his naturalistic strategies and misogynistic dogmas and embraced a kind of rueful asceticism modeled on Eastern religions.

Strindberg's change in mood was further influenced by the dissolution of his third marriage to the actress Harriet Bosse. Previously inclined, and on the slightest pretext, to accuse his female partners of infidelity, lesbianism, careerism, uncleanness, sloppy bookkeeping, and trying to emasculate him (his model was Hercules, robbed of his club by Omphale and forced to do female tasks), Strindberg was beginning to concede that he just might share some of the blame for the way his relationships had been unraveling. Trapped in a repetition compulsion, he recognized that he was producing the same neurotic patterns over and over again.

As a result *A Dream Play* has a cyclical rather than a linear form. Also as a result Strindberg's central character in this play is no longer a raging victimized male, as in his pre-*Inferno* writings, but rather a composite of bewildered men (called the Lawyer, the Officer, the Poet) on a quest for salvation. As for his traditional antagonist, the scheming or castrating female, she has been replaced by the tender and compassionate daughter of Indra, Vedic ruler of the heavens and god of storms. Indra sends the girl down to Earth through a suffocating atmosphere (in this passage Strindberg could be predicting the pollution of our major cities) to find out why people are so full of complaint. In order to learn this she must first take on human form (her terrestrial name is Agnes, or Lamb of God) and become a kind of female Christ. After witnessing countless instances of human suffering and enduring a lot of suffering herself as the battered wife of the Lawyer in a household where the maid pastes out all the air, she returns to heaven, spent and exhausted, leaving her mortal remains in the purifying fire. Indra's daughter has concluded that life is a tragic contradiction, a struggle between irreconcilable opposites such as spirit and matter, love and hate, the male and female principles. These are the conflicts that split the human heart in two, forming the basis for her repeated perception that "Humankind is to be pitied."

This moist, often self-pitying choral moral, however, is not what is remarkable about the play. Nor is the work especially unique in its

perception that we dream away our lives and wake only into death. Calderón framed this concept hundreds of years earlier in *Life Is a Dream* ("What man is there alive who'd seek to reign/Since he must wake into the dream that's death?") and so did Shakespeare more famously in *The Tempest* ("We are such stuff/As dreams are made on and our little life/Is rounded with a sleep"). No, the innovation of *A Dream Play* (and of *To Damascus*, the trilogy that preceded it) is its nonrealistic form, later to be called expressionism. It is a form where, in the playwright's words, "Anything can happen; everything is possible and probable; time and space do not exist . . . imagination spins and weaves new patterns made up of memories, experiences, unfettered fantasies, absurdities, and improvisations."

Strindberg hadn't read Freud, though he was familiar with the writings of Charcot, whose experiments with hypnotism influenced Freud's early theories. Nevertheless his method uses a kind of Freudian stream of consciousness, and his play is full of Freudian insights, including the notion that the unconscious observes "no secrets, no incongruities, no scruples, and no law."

Because the work follows the episodic, fluid, and fragmented form of a dream, where characters, in Strindberg's words, "are split, double and multiply . . . evaporate, scatter, and converge," it has always been fearfully difficult to produce on stage. Aside from the fact that the work is all theme and virtually no action, an existential cry of pain, Strindberg calls for at least nine major changes of scene, and his final image is that of a burning Castle topped by a flower bud that bursts into a giant chrysanthemum. Imagine the pandemonium in the scene shop when you order that little number! Since the ideal dream medium is the cinema, you would think that some inventive avant-garde filmmaker might have turned *A Dream Play* into a surrealistic movie, on the order of Cocteau's *Blood of a Poet* or Bunuel's *Andalusian Dog*. Indeed it would have been a perfect project for Ingmar Bergman, many of whose films are Strindberg *hommages* (*Wild Strawberries* borrows its academic procession scene from the one in *A Dream Play*). But Bergman elected to produce this Strindberg work onstage rather than on screen, and in that intractable medium even Bergman was unable to make it work.

In fact *A Dream Play* has never succeeded, to my knowledge, in

the theatre until Robert Wilson decided to stage the play with the resident company of Stockholm's Stadsteater. Performed in its original language, Wilson's version was brought to Brooklyn for a brief run as part of the New Wave Festival at the Brooklyn Academy of Music, where it proved to be not only one of the most striking theatrical events of the season but also one of Wilson's most imaginative productions.

Wilson solves the insoluble problems of the play largely by ignoring them completely. There are, in this production, no Faustian prologues in heaven between Indra and his daughter, no contrasting views of Fairhaven and Foulstrand, no Quarantine stations, no flaming castles flowering into chrysanthemums. Although the text (most of it preserved in this version) is displayed in supertitles above the stage, what transpires on stage is virtually another play, filled with Wilsonian inventions that are sometimes only vaguely connected to those of Strindberg. Wilson, in short, is not uniting with the play so much as running alongside it. It is as if he were dreaming *A Dream Play*, adapting its subterranean melodies to his own unheard music.

Although purists might object, these parallel works are fascinating to watch in tandem, especially for those already familiar with the original, because Wilson's images bounce off Strindberg's text in an almost reverberant manner. Paradoxically the production begins to flag only when Wilson's approach becomes illustrative rather than metaphorical, which is to say when he begins to observe the letter rather than the spirit of the text (in the disappointing Opera scene, for example, where Wilson fails to find an interesting visual correlative for the officer's ordeal of waiting for his beloved).

The evening begins with an overture of Michael Galasso's shimmering, deeply amplified music as we study a painted drop curtain depicting a frame house, a yard, and two young girls in frocks standing beside their bicycles. The drop having been raised, we observe four workmen in white aprons mechanically wielding tools (a hammer, a plane, an awl) as a luminous, short-haired young woman slowly descends down a ramp holding a shoe. This is the daughter of Indra (played by Jessica Liedberg with porcelain delicacy), and the shoe is a symbol of the earthly possessions that she, along with the others, will divest herself of in the final scene.

Liedberg, like the rest of this excellent company, has been trained within an inch of her life in Wilsonian choreography. And nowhere has the influence of George Balanchine on Robert Wilson been more manifest than in the physical twists and turns of this production (Wilson casts his actors not by determining how well they can read text but rather by how accurately they can count time). The result is a kind of painting in motion, with the dialogue functioning largely as another musical element—in keeping with Strindberg's desire to have his plays achieve the condition of music. Featuring a sequence of exquisite settings and lighting effects, and a costume palette where all but one character are dressed in shades of whites and blacks, the production offers an immense variety of vivid stage pictures and vibrant acoustical shocks. It is like listening to a guide explaining the paintings in a museum, except that here the pictures illuminate the guidebook instead of vice versa.

Although Wilson grows a bit repetitive in the second part of the evening, most of his exhibits are loaded with detail. The maid (Kajsa Reingardt) flirting with the Officer (Henrik Rafaelsen) by moving her body coquettishly while snapping her teeth. Three huge white cows being milked to the accompaniment of comic sound effects while men in riding habits stand witness to the action. A woman standing on a beach accompanied by a man bestriding an enormous nineteenth-century cannon. A three-dimensional perspective of the opening-act curtain, with two maids standing near a well, against the background of a leafless tree. A greenhouse constructed of large windows and skylights and filled with potted plants, near which a maid serves food from a lectern. A brick wall, a large barrel, a blackboard on which the Poet, wearing a one-piece bathing suit, writes.

I find it impossible to describe, one can only experience, how these seemingly vagrant visual images charge the atmosphere and mood of the play. But it is not just handsome designs that enhance the evening; it is also a wry comic tone. Wilson adds a great deal of humor to a work that might otherwise have seemed a little lugubrious and more than a little plaintive. And while he eventually runs out of ideas, there are enough fresh images to make this *Dream Play*, almost a hundred years after its composition, a major theatrical event with which to start the new century.

In the last scene all the characters have their precious identifying props lifted into the flies instead of being burned in a purifying fire, and Agnes slowly ascends the ramp to rejoin her father. Here the production has managed to achieve the state of harmony and atonement with which Strindberg wished to leave the spectator: "Sleep, the liberator," he writes in his author's note, "often appears as a torturer, but when the pain is at its worst, the sufferer awakes—and is thus reconciled with reality."

"Everything is atoned for," Strindberg said on his deathbed while pressing a Bible to his breast. *A Dream Play* was designed to be an act of penitence and contrition for a badly lived life. The Robert Wilson production—not perfect but still the finest realization of the play I have yet seen—catches the remorse of the author without his self-dramatics, thus managing to raise Strindberg's pathological imagination to a new spiritual plateau.

[2000]

· The Play About the Play ·

EDWARD ALBEE'S *The Play About the Baby*, now playing off-Broadway at the Century Center for the Performing Arts, has attracted what may very well be the most divided reviews of the season. Ben Brantley of the *New York Times*, for example, considers the play to be on a level with Albee's best work, while *New York*'s John Simon dismisses it as totally worthless and inept, a bigger lemon than *The Man with Three Arms*. Like most creative work, the play will undoubtedly have a longer life than will the critical opinions about it. But for the record, indifferent as it usually is to our hasty rulings, let me come down squarely on both sides of the equation.

During the first act of this two-act drama, Simon's assessment seems to be correct. During its first hour *The Play About the Baby* looks like the theatrical equivalent of a doodle, a boring exercise in throat-clearing by a man with nothing in particular to say. It is bulging with grandiose typewriting and pretentious choplogic of

which the following is a typical example: "Nobody dies from not being remembered. From being forgotten, yes. Or are they the same thing?" You can fill a whole turkey with semantic stuffing like this, and Albee almost does. Only his self-conscious references to the theatrical process take up more space in the cavity. A more accurate title for this work might have been *The Play About the Play About the Baby*, considering how hard Albee labors to turn his metaphysical meanderings into meaningful metatheatre. Characters address the audience directly, chatting about the nature of playwriting, the length of intermissions, the function of exposition, the dangers of smoking, the joys of drinking. The writer reminds me of a wayward bus driver making detours, shifting gears, careening off dividers, or slamming on the brakes to let passengers examine the landscape. If a character says something such as "No more shenanigans," that character is then obliged to stop and inquire about the origin of the word "shenanigan" ("Is that Irish?").

This can get very tiresome very quickly. But aside from the extra-dramatic digressions, the greatest drain on the patience of the audience is the abstractness of the play. The moment a playwright decides to call his characters Man, Woman, Boy, and Girl, he is destined to lose our confidence in them (and him), especially when he invests these abstractions with so little detail. Strindberg invented this convention, with generalized characters called the Poet, the Lawyer, the Lady, the Stranger, and so forth, and O'Neill was inclined to do the same sort of expressionist heavy breathing before he picked up Ibsen's "family Kodak," as he called modern realism, and started snapping photographs of life as it is experienced. Abstract characters also used to be a favorite device of such radical German dramatists as Kaiser and Toller, as well as of (in this country) Marc Blitzstein and Elmer Rice, though not of Brecht, who famously said, "The truth is concrete." At the Century Center the only concrete thing in sight is the foundation supporting the stage.

Albee's love of abstraction is an obstacle in the way of David Esbjornon's otherwise capable direction, even in John Arnone's simple symbolic setting, a wing-and-border design featuring a number of suspended baby objects (an antique wooden rocking horse, a wicker carriage, a huge pacifier, two colored blocks). Boy (David Burtka)

and Girl (Kathleen Early) bounce through this space like bumptious teenagers, then scuttle offstage to have a baby. He is enchanted with her bosom ("I think I like both of your breasts equally") and would like to share her milk with the suckling infant. Between their liberal lovemaking they run around buck naked, somewhat like Adam and Eve, a fact the author chooses to italicize ("You'd think it was Eden, wouldn't you?"). Or maybe they are Adam and Steve in Eden, since Albee strews hints that Boy may be gay, and since the baby, at the end, turns out to be imaginary.

Albee has written about imaginary babies before, notably in *Who's Afraid of Virginia Woolf.* (Because he was adopted at birth, there has been considerable speculation about whether this recurring phantom infant might not be a stand-in for the author.) But the baby is not the only device linking *The Play About the Baby* to *Virginia Woolf.* Man and Woman seem like a milder version of George and Martha, especially in the way they eventually affect the younger couple. (In the act of scolding Man, Woman even borrows a line Martha uses when scolding George: "You go too far!") Man, elegantly played by Brian Murray, has traces of George's lacerating wit, though here it creates bumps rather than blisters. He smells his hands a lot, in the tradition of Chekhov's Solyony, and dresses in the crisp double-breasted fashion of a Conservative British politician. The capable Marian Seldes plays Woman with a blend of vacant good nature and theatricalized hysteria, boasting about affairs with painters and novelists in language that seems to have been borrowed from the pages of erotic novelists such as Molly Bloom's Paul de Kock. With her emphatic eyebrows, straining neck muscles, and knife-slashed mouth, Seldes always seems to be simultaneously smiling and screaming. It is she who provides the comic crust of the play.

Man and Woman are two more portraits in Albee's gallery of rich elegant WASPs, and they may or may not be married to each other. Indeed relationships are far from certain in this plot, as Albee, in *Tiny Alice* mode, revels in the playful role of Mr. Mystery. Boy and Girl have no idea why this older couple is wandering through their house ("Have we rented out rooms?"), and they make no effort to eject them or to call the cops. In their innocence they have only vague intimations that trouble is in store for them. "Is there anyone

out there that wants to hurt us?" Boy asks the audience. "We have a baby, we don't understand each other yet, so give it a thought, give us some time."

The plea is poignant, especially in light of what is to follow, but the naiveté of Boy and Girl eventually begins to wear on the audience. Albee has not caught their rhythms very well, and he doesn't always capture their idiom with much precision either (for example, kids of that age don't use the word "asshole" to mean a stupid person, as our generation did, but rather to signify someone mean and bad-tempered). Still, Man and Woman manage, just barely, to hold our attention during the longueurs of Act I, first through their repartee and badinage, then through their growing menace. "What do you want?" asks Boy. "Eternal life," Man answers. "It's really very simple: we've come to take the baby."

It is at this late point that the playwright finally gets down to business and begins to invest his hitherto flaccid material with some muscle and sinew. I don't mean to say he altogether manages to shed his mannerist posturing, a quality that almost seems woven into the fabric of the plot. There is a lot of palaver about how "we can't take glory because it shows us the abyss," and other such quasi-philosophical non sequiturs. There is considerable sucking up to the audience (unusual for Albee), especially in Man's postintermission maunderings. There is a pious, mechanical, and totally irrelevant reference to the lot of the "less fortunate." And there is a good deal of mystification for its own sake, such as when Man claims to have six children—two white, two black, and two green.

But there is also a certain amount of genuine tension created regarding the fate of the baby and whether or not it actually exists. Girl has no evidence of scarring after her cesarean section, just as Boy has no sign of a fracture in the arm that was broken by hoodlums. One of them had unzipped his fly as if to urinate on him ("Maybe it was what you wanted," insinuates Man). "I am your destination," Man tells Boy, going on to add, "If you don't have the wound of a broken heart, how do you know you're alive?" Remarks like this can have a rising effect on the gorge. For Man is suggesting that the kidnaping of Boy and Girl's baby, the exposure of their illusions, the stripping of their hearts, is all being done for their own good, to bring them

into some kind of emotional maturity. Albee, however, manages to rescue the moment from total mawkishness by means of a comic device. While Man is expatiating on the meaning of life, the importance of suffering, and blah blah blah, Woman starts signing his speech, as if for an audience of the deaf. There are times when you wish the whole play had been signed.

By the end the baby is revealed to be nonexistent, through "the old blanket trick," a device reminiscent of the fake gun in *Virginia Woolf*. All that remains is for Boy and Girl to accept the reality of their childlessness and the bleakness of their fates. Man takes them through a doleful catechism: "You have a baby?" "Yes." "I don't know." "You have no baby?" "No." "Maybe later, when we're older." But once having admitted they were never parents, they immediately take refuge again in illusion. "I hear it crying." "I hear it, too."

Like most of Albee's work, *The Play About the Baby* is three parts charlatanism, two parts pretension, and one part genius. Trying to find a true gem amidst this heap of fake rhinestones is exhausting work for an audience. The effort returns only intermittent rewards.

[2001]

· III ·

People and Places

· **A Little Touch of Harry** ·
(AN OBITUARY TRIBUTE)

HARRY KONDOLEON entered the Yale School of Drama in 1978, the last year I was there as dean, and immediately established himself as one of the wittiest and most audacious playwrights ever to endure the rigors and miseries of New Haven. I missed his last two years as a student and always regretted it. I would have loved to have been a close observer of his development, because he struck me as one of those precious discoveries—part satirist, part surrealist, part cabaret artist—that come along so seldom in our theatre to keep us happy while reordering our sense of priorities and moral postures. His aesthetic was influenced by what I had come to think of as the Yale style, patented and copyrighted by Christopher Durang, Albert Innaurato, Wendy Wasserstein, Ted Talley, Keith Reddin, Paul Rudnick, and others: totally irreverent, mischievous, and howlingly funny, but issuing from a deep core of personal pain.

That pain, I should add, was always brilliantly disguised because most of us thought of Harry primarily as a merry man. We had a lively correspondence, which grew especially active toward the end of his life, and nowhere in his letters do I find anything but a buoyant and exuberant tone, even when he knew he was dying. He loved writing and getting produced. Most of his letters are accounts of plays being composed or staged, awards and compensations being tendered, writing residencies in attractive places like Bellagio, MacDowell, and Yaddo, and finally the pleasure he was taking in the publication of his new novel, *Diary of a Lost Boy.* "Come to the book

party. Big," he wrote. "I'm blowing my own horn. I'll close before you vomit or I have another seizure."

The awfulness of the disease he had contracted was never, except in those last dreadful months, the cause of recrimination or despair. It was even less the source of self-pity. Rather he knew how to turn his own suffering into an increasingly original form of dramatic art, beginning with *Zero Positive*, which may very well be his masterpiece, but also permeating his novel and his splendid late play, *Houseguests*, where disease and debility become the occasion for the most outrageous scenes of farce.

He was suffering from a plague that was taking away an increasing number of his predecessors and contemporaries at Yale in what Tennessee Williams called that "endless parade to the graveyard": Peter Evans, Harold de Felice, Bobby Drivas, Tony Holland, Peter Schifter, countless others—a plague that continues to eat its way through the body of the creative community. He knew he was doomed, but he faced his death with extraordinary bravery, incredible dignity, and unparalleled wit. He kept the dogs of death at bay by continuing to write, and what he wrote was enough to put a smile on the face of the Grim Reaper. Harry literally said "Fuck you" to death, and in that way managed not only to endure through his works but made it easier for his friends to witness his suffering. Harry's sense of life as fun and his ebullient cheerfulness were reflected on his face, and are best suggested not in photographs but in the impish self-portrait he painted as cover art for *Diary of a Lost Boy*—arched eyebrows, huge almond eyes decorated with large black strokes representing eyelashes, and a full mouth tilted in the suggestion of a smile. He went to his grave smiling, leaving us all bereft yet proud to have been his friend. He is still among us and always will be, bringing us through literature and memories a little touch of Harry in the night.

[1994]

· *David Mamet at Fifty* ·

(ADDRESS TO THE DAVID MAMET CONFERENCE IN LAS VEGAS)

IS IT POSSIBLE that this vigorous and dynamic young writer has reached the half-century mark? Yes, there's a bit of grizzle showing in his beard—that is, when he has a beard. It seems to come and go from one day to the next. Some people spend their hours just watching his face hairs grow. He's given up cigars, a sure sign of maturity (I haven't). And there's no question that he's growing more philosophical in his writing and more paternal in his relationships. But David at fifty? Hard to imagine.

I first met Mamet about twenty years ago when he was beardless and barely thirty and puffing on ten cigars a day. We had invited him to Yale on a fellowship to the Repertory Theatre and the Drama School. His job was to teach our students playwriting and to write a play for the Rep. He'd been writing plays for some years, but this may have been his first gig as a teacher.

The play turned out to be the lovely short piece, *Reunion*, a moving story of a belated meeting between a father and his estranged daughter, which we paired with a vignette called *Dark Pony*, about another father telling his little girl a story while riding in a car. We thought, though David never confirmed this, that these were the same parent and child at different periods in their lives. *Reunion* had a lot of references to exotic-sounding places near Boston like Lechmere, names that were soon to become more familiar to me when the Rep moved to Cambridge and David began to let us do his plays there.

We had cast two actors from our company in *Reunion*—the veteran Michael Higgins and the young Lindsay Crouse. Although we were a resident acting ensemble, David had objections to our casting actors without his permission. No one has the chutzpah to try that today! Now he insists on controlling every element of production, right down to the design of the poster, the moment the curtain goes up (promptly at 8 p.m.), and whether or not patrons are to be admitted into the theatre after the show starts (the answer is No).

At the first rehearsals of *Reunion* Mamet voiced some doubts

about Lindsay Crouse. These doubts soon evaporated in rehearsal. He had so few doubts, in fact, that he married her the next year, had two girl children by her, and wrote most of his female roles with her in mind. Apparently both of them had doubts about ten years later when they got divorced. But before that breakup the couple lived what seemed to many of us an exemplary life in Cambridge, though it took Lindsay a few years to start furnishing the house (not a good marital sign).

A major argument erupted between Lindsay and David over some casting in *Speed-the-Plow*. Actually Lindsay and David used to argue a lot about the nature of acting. As someone who was also once married to an actress, I can attest that such arguments usually take place over the appetizer, soup, main dish, and dessert of the evening meal. They are the bitter vetch and sour cream of a professional marriage. David has a notorious disdain for any actor with the bad taste to express emotion on stage. Lindsay once explained this, and his equally famous prejudice against characterization and interpretation, by saying that though he once took classes from Sandy Meisner, he never got past the basics (Stella Adler had a similar explanation for Lee Strasberg's misreadings of Stanislavsky.)

In his new book *True and False*, David writes that the actor's only purpose is to enact the playwright's objectives. It's all in the text. Forget about emotion or interpretation. Just say the lines. And don't bother about training. Acting schools are money factories; acting teachers are charlatans. The subtitle of this book is "Heresy and Common Sense for the Actor." It strikes me as a lot more heresy than common sense. Anyone who remembers the expressionless death scene of that usually brilliant actor W. T. Macy in David's film *Homicide* can check out just how well this theory works in practice. Macy just says the lines, all right, but he dies as if he's ordering a BLT on rye. Mamet's contempt for training and his rejection of interpretation, by the way, are among the few things about which he and I disagree. The copy of *True and False* he sent to me bore the inscription, "A loving refutation of everything you stand for."

Loving and refuting, these are among David's strongest passions. The only passions that match it are telling jokes and playing poker. Almost all his jokes involve a rabbi. Some of them involve a

bear. As for poker, I advise you never to sit at a table with him. He is a master at disguising the "tell." His hooded eyes reveal nothing except that you're about to part with a lot of money.

He is, on the other hand, a very generous man, a thoughtful husband, a doting father, a vigorous disputant, a loyal friend. Loyalty among friends, in fact, even when they're thieves and charlatans, always seemed to me the leitmotif of his work, starting with such early plays as *American Buffalo*. For Mamet the worst human sin is to betray a buddy. Even in *Glengarry Glen Ross*, where Mamet creates a world of extraordinary venality and corruption, populated by birds and beasts of prey reminiscent of those in Jonson's *Volpone* and Henri Becque's *The Vultures*, Brecht's *Threepenny Opera* and Churchill's *Serious Money*, the one redemptive quality is loyalty among friends. The real estate salesmen of that play have considerably more camaraderie, and a considerably higher code of honor, than the ruthless slugs who run their lives. At least they live by their wits, not by their schedules. "It's not a world of men," says the salesman Levene, "it's a world of bureaucrats, clock watchers, office holders—we're a dying breed."

That kind of didactic remark you will rarely find in a Mamet play. When he first came to attention, around 1974, with the Organic Theatre's production of *Sexual Perversity in Chicago*, his work was marked by two striking characteristics: (1) An uncanny ear for the rhythms of everyday urban speech as spoken by middle-class and working-class Americans, and (2) a nontendentious, nonmoralizing approach to life as it is lived. Chekhov believed the playwright's duty was to write not about life as it should be but about life as it is. Mamet learned that lesson at Chekhov's knee. His first brief dramatic efforts were about the kinds of things you might overhear on a Chicago subway between stops—straphanger's incidents, turnstile events.

As for dialogue, no other playwrights except perhaps Samuel Beckett and Harold Pinter, his two major influences, have captured so well the pauses, ellipses, and hesitations of contemporary speech. But Paddy Chayefsky was pretty good at this too in such things as *Marty* and *The Tenth Man*—so good, in fact, that some critics suspected he wrote his plays with the aid of a tape recorder. But while

the surface of Chayefsky's plays looks brittle and hard, the center tends to be mushy, melted by sentimental thematic impulses and soft character motivations. (Paradoxically, Chayefsky's movies, e.g., *The Hospital* and *Network*, have a lot more starch and brittleness.)

Not so Mamet. His drama is as hard as nails in its evaluation of human motive and its view of human character. And while he has strong moral, social, and even, one suspects, political purposes in writing plays, these are almost completely hidden beneath the gritty surface of everyday life and overheard speech. Mamet's way with dialogue is so pungent that it is easily parodied—most recently in a David Ives skit called "Speed-the-Play," which was the centerpiece of Ives's recent skit collection, *Mere Mortals*. There Ives satirized Mamet's celebrated hemming and hawing (one character can only say "I-I-I"); his dramatic succinctness (all of his plays take one minute each to perform); and his capacity for profane language (the entire vocabulary of the characters consists of obscenities). I'm sure you know the joke about the beggar who asks a passing stranger for a handout. "Neither a borrower nor a lender be—William Shakespeare," says the passerby. "Fuck you—David Mamet," replies the beggar. When you become the subject of satire and the center of jokes, you know you have have reached an enviable plane.

American realists have traditionally been accusers and indicters. Clifford Odets and the other political protest dramatists of the thirties often concluded their plays with clarion calls to overthrow a callous system of economic oppression and social injustice. Arthur Miller and the social dramatists of the fifties, though more discreet about announcing alternative political systems, were also preoccupied with the victims of oppression, with the false values of success held by such illusionists as Willy Loman, and with an unfeeling economic system that could throw away an aging worker "like a piece of fruit." David Rabe and the anti-war protesters of the seventies—in plays like *Sticks and Bones* and *Paylo Hummel*—indicted the audience for complicity in the death and maiming of innocent soldiers in Vietnam. And today the racial-ethnic-gay-and-gender-driven playwrights of the eighties and nineties generally accuse Americans of a variety of common sins, including racism, homophobia, indifference to AIDS, sexism, imperialism, anti-Semitism, and other iniquities.

Mamet is impressively different because, without muting his powerful rebellion and without exonerating a faulty system, he is able to lance our bloody impostumes without inflating the surgeon's bill or excusing the patient. He undoubtedly agrees that Attention Must Be Paid, but you'll rarely find such a bald pronouncement in the mouth of one of his characters.

Mamet writes in a febrile neo-realistic tradition, indebted less to his American predecessors than to such German playwrights as Georg Buechner, and such latter-day Buechnerians as Fassbinder and Kroetz. Like them, he has been primarily interested, at least until recently, in essentially semiconscious characters, whom he depicts with exact, almost microscopic attention to their mores, idioms, and behavior patterns. A prime example of this technique is his brilliant, sadly underestimated work *Edmond*, a kind of contemporary *Woyzeck* set in the urban metropolis, about a lower-middle-class man driven to madness and violence by the madness and violence of city life. In his surreal odyssey through the urban demi-world, Edmond kills a prostitute, is apprehended, tried, and convicted, and ends up in prison, half in love with the black cellmate who has raped him.

This is perhaps a rather extreme example of the male bonding one often finds in Mamet's work, a quality David Ives also satirizes in *Mere Mortals*. Contrary to received opinion, however, Mamet can write terrific parts for women. Look at the mother in *The Cryptogram* or the protagonist's sister in *The Old Neighborhood*.* Still, there is no question that he is fascinated with the interaction of men under extreme conditions. Perhaps one more name we should add to the list of literary influences I've mentioned is that of another recently maligned male bonder, Ernest Hemingway.

As in the typical Hemingway tale, one finds in Mamet, underneath the apparently random surface of everyday life, a style, a purpose, and a direction—or rather an indirection, for it is by indirections that Mamet finds directions out. In this he resembles Hamlet, and it's interesting that his last name is almost an anagram for that of Shakespeare's hero. Perhaps that's one of the reasons

*Mamet's capacity to write parts for women was demonstrated more recently in his movie *The Winslow Boy* (1999) and his play *Boston Marriage* (2000).

he's so eager to direct that particular play (possibly to be retitled *Mamlet*).

As in Buechner and Chekhov, realism of this kind takes on such intensity that it almost becomes surrealism. Lurking below the surface of a play like *The Cherry Orchard*, for example, is the dreamlike anomie of *Waiting for Godot*. And lurking below the surface of a Mamet work are not only a pungent theme and implacable purpose but also the suggestive quality of dreams. Take *The Shawl*, a short mystical exercise not unlike Yeats's *Words Upon a Windowpane*, about a medium who may or may not be a charlatan, who may or may not be able to communicate with the dead. Mamet's naturalism is only apparent. He is essentially a dramatic poet, and, like all gifted poets, he is in touch with the symbolic reverberant interior of our unconscious lives.

This supernatural edge may explain David Mamet's growing interest, an interest amounting almost to a passion, in his religious heritage. I once asked him why he wanted to move from Boston to Newton. He replied that it was because he needed to be closer to his rabbi. Indeed his Newton housewarming reached its climax when that rabbi nailed a mezuzah, containing the word of God, to the front door. It is perhaps no accident that David's most recent book is called *The Old Religion*.

Mamet's work has taken so many unexpected turns and embraced so many genres that there's no telling where he will go next. Aside from his drama, which constitutes to my mind the most important aspect of his art, he has written essays, poems, novels, screenplays, teleplays, acting treatises, and children's stories. He has not only directed his own plays but also his own screenplays. He has helped to found a theatre—the Atlantic Theatre Company—with a group of his former students. Despite his contempt for acting teachers, he continues occasionally to conduct acting classes, contradicting his own dictum that acting can't be taught. And despite his heavy work schedule and prodigious output, he has found the time to start another family, marrying a lovely and gifted actress, Rebecca Pidgeon, who has borne him a charming little girl.

Is this not a man for all theatrical seasons? Considering his fascination with chance and passion for gambling, and considering that his first movie was called *The House of Games*, isn't Las Vegas the per-

fect place to celebrate his birthday? And consistent with the mystery of his work and his inscrutable character, isn't it appropriate that he won't be here to receive our birthday praises? Hell, let's toast him anyway!

[1997]

· The Las Vegas Show ·

TO GET THERE you have to fly over the vast gorges of the Grand Canyon until the Colorado empties out into Lake Mead. Once past this spectacular display of natural splendor, you are rewarded with a terrific view of the Hoover Dam, one of the great engineering triumphs of the thirties. Then, almost immediately, the bluffs, tablelands, and mesas still visible in all directions, your aircraft is circling another awe-inspiring man-made construction—the glittering city of Las Vegas, nestled in a plain between mountains and desert, perhaps the most stupendous tribute to the power of artifice and the appetite for glut in the history of the planet.

On my last trip to Las Vegas I gave the keynote address at a David Mamet Society meeting held at the University of Nevada (UNLV). What city could be better suited to host a conference celebrating the theatrical master of the scam? My pretext for this more recent visit was an invitation by the English and Theatre departments of the University to talk on a topic of my choosing. I also wanted the opportunity to see the new show being presented by the Cirque du Soleil. The title I offered for my talk was "The Decline of Culture." I didn't realize until I started speaking how hopelessly premeditated that topic would sound, but I had chosen it with no conscious intent to impugn my hosts or their city. When I arrived at the podium, I began to feel a bit like Joseph Cotton in *The Third Man*, an impostor babbling away on a subject that confused the audience and embarrassed him. To tell the truth, I have a sneaking affection for Las Vegas. Not as much as Robert Venturi, mind you, but it's still the closest thing I know to total immersion in the fleshpots of antiquity. The decline of culture indeed. Las Vegas doesn't so much represent

the degeneration of civilization as its evolution into a new kind of civic mutation.

I began to realize there was more here to review than the Cirque du Soleil; perhaps I ought to review Las Vegas itself. But how does one begin to critique a production of such scope and magnitude? Awash in neon twenty-four hours a day, Las Vegas is one of the wildest Wild West shows on earth—a conglomerate epic extravaganza in which the come-on, the shill, the barker's patter constitute almost the entire offering.

In the early days the basic purpose, indeed the exclusive idea behind Las Vegas, was to stimulate the gambling glands (Lenny Bruce once called it "Lost Wages"). Hotels virtually gave away their food, drink, and lodging in order to draw the suckers to the tables. Gambling, of course, is still the city's major industry. Almost the entire ground floor of each cavernous and sprawling megahotel, some of which take up as many as three city blocks, is devoted to relieving you of your cash. You cannot find the registration desk or the coffee shop without walking through acres and acres of slot machines and gaming tables, without hearing tons of silver dollars rattling through the chutes. The weekend I was there, an elderly woman of sixty-seven hit the megabucks machine and went home with $23 million in cash. Nowhere is America's obsession with instant wealth exploited more efficiently than in these trackless gambling wastes, where thousands of funereal characters, many of them women, huddle over machines like wraiths. I thought of the damned in one of Dante's circles of Hell ("I had not thought death had undone so many").

Still, something decidedly odd has been happening to Las Vegas lately. Like Broadway, which it resembles in so many ways, it is being scrubbed, homogenized, turned into Disneyland. In the early days Las Vegas hotels were identified by such mildly exotic titles as the Sands, the Tropicana, and the Flamingo, reflecting their desert origins and the limited vocabulary of the romantic visionaries (innocents like Bugsy Siegel and Meyer Lansky) who created them. Today the newer hotels are theme parks with names to match—the MGM Grand, the Mirage, the Luxor, the Desert Inn, Treasure Island, not to mention the most recent, most extravagant addition to the bunch, Steve Wynn's Bellagio.

Bellagio cost $1.6 billion to build and features an art collection estimated at $300 million. Ads for the hotel impudently answer an unasked question: "Because you can't sleep at the Louvre." A sign in the lobby trumpets triumphantly: "Appearing nightly: Picasso! Monet! Van Gogh!" I suppose it is relevant that Wynn borrowed the name of his hotel from a town on Lake Como, famed for a Rockefeller villa where artists and scholars are invited both for the purpose of group conferences and for pursuing individual research. An air of artistic and intellectual pretense hangs heavy over the velvet public rooms of Bellagio.

Alas this air has also infected the atmosphere of the Cirque du Soleil, which has become one of the central features of Bellagio. Each of the hotels has traditionally featured some sort of nightly attraction, whether Bobby Darin or David Cassidy or a big girlie show like "Enter the Night," where silicon-heavy exotic dancers compete for your attention with acrobatic ice skaters. Representing the more wholesome family appeal of the new Las Vegas are the attractions of the Cirque du Soleil. This Quebecois institution has had one show called *Mystère* playing at Treasure Island since 1993, in a theatre expressly designed for it. The new show at Bellagio, performed by a second company, is called *O*. It has been lodged in a multi-million-dollar eighteen-hundred-seat palace built to the specifications of a fourteenth-century European opera house. At ninety and one hundred dollars a ticket, *O* is scheduled to play there until 2008.

The title of the show is a pun on the French word *eau*, because it takes place almost entirely in, on, and under water. For this purpose Bellagio has built a massive pool onstage, twenty-five feet deep, which holds more than 1.5 million gallons. When the clowns come on with their red noses and sad looks, they are holding pots, strainers, and filters, and squirting water at the audience. A woman bicycles by playing a cello on wheels. A tall emaciated compere with an enormous fright wig sails past on an inverted umbrella.

The show proper begins with about twenty pair of feet sticking out of the water. What transpires looks like myriad variations on an Esther Williams aquatic ballet had it been choreographed by Busby Berkeley. Much of this is visually spectacular. So are the handsome sets and costumes. And the aerialists, suspended above the water by their ankles, are the most graceful such daredevils to be found any-

where. But like so much in the American theatre today the show is held captive by its special effects. Lacking a writer, it has no forward movement, no story, theme, indeed no purpose other than to wow you. And it is not helped by an acoustical score that functions like a relentless wrapper of tuneless sound.

It's a pity to see this wonderful troupe fall victim to the surfeit and ostentation of the new Las Vegas. But since the whole city is a show, the planned entertainments would seem to be a bit superfluous anyway. The real Las Vegas show goes on twenty-four hours a day, and what characterizes it most vividly is its geographical desperation. This Nevada city, artificially created out of the desert and therefore lacking an identity of its own, is trying to resignify itself by cloning more confident places. On my previous visit to the city, some months ago, I looked out of a window and with a start saw the New York skyline—the Statue of Liberty, the Empire State Building, the Chrysler Building, the World Trade Center, etc., all bunched together against a background not of Jersey cliffs but of Nevada desert. It turned out to be the façade of a hotel called New York New York, and to the eyes of an ex–New Yorker it was truly disorienting. Another hotel called the Luxor, now under reconstruction, has been designed in the form of the Great Pyramid of Cheops. It won't be fully operative until the engineers iron out some ventilation problems stemming from their belated realization that such structures were originally intended for sarcophagi rather than for tourists. The Treasure Island Hotel, its motif inspired by the Robert Louis Stevenson novel, features an outdoor sea battle every half-hour between a pirate ship and a frigate manned by His Majesty's Navy. As the vessels lurch toward each other ominously and the British cannons belch fire, tearing holes in the pirate flag and burning the masts, the manly buccaneers ("Belay my hearties!"), having been menaced by the British ("I say, are you blackguards ready to surrender?"), proceed to taunt their effete aristocratic manners, eventually letting loose a fusillade of their own that sends the English ship to the bottom.

Outside the window of the hotel room provided for my wife and me at the Mirage, an artificial volcano erupts every fifteen minutes, sending red-hot lava hissing and boiling into the pools below. The hotel also features innumerable outdoor waterfalls, a dolphin

park, a secret garden, and a sumptuous theatre entirely devoted to the magic and animal acts of Siegfried and Roy (an idealized statue of the German duo decorates the exterior walls of the hotel). The newest hotel in town, called the Venetian and still under construction, has reproduced the entire Piazza San Marco, including a full-sized Campanile, and no doubt will soon be ferrying patrons to their rooms in gondolas. The hotel will have to compete with the other Italianate resort in town, namely Caesar's Palace, which features life-size busts of most of the Roman emperors and a commercial Forum that includes the most fashionable shops—all this under a cloud-covered roof that changes from day to night and back again every twenty minutes.

This compression and distortion of time is famously typical of Las Vegas. Staying there is rather like being at one of the polar caps during a winter solstice. There is no daytime, indeed there are precious few clocks in the gaming rooms of the hotels. It's hard to know whether you ought to be eating breakfast, lunch, or dinner. Outside, on the other hand, you are blinded by the merciless glare of the sun, supplemented by millions of bands of neon. So massive and so elaborate is the structure identifying a hotel—say, the vertical station in front of the Flamingo—that one could easily mistake it for the hotel itself.

Las Vegas runs a twenty-four-hour marriage and divorce industry (in the Graceland Chapel, for example, you can get married by an Elvis Presley look-alike minister). It has also become the home for innumerable conventions. The weekend I was there the city was gearing up for an international computer convention, but it was also playing host to a counterconvention sponsored by the porno movie industry, where awards were given to the best skin flicks of the year and the most tireless and well-equipped performers, many of whom stood around in the nude signing autographs.

These attractions account for packed hotels and teeming streets where you almost always seem to be walking against a human tide. The mobs of international tourists, grasping their Japanese cameras, navigate with difficulty the crowded avenues of the Strip, vainly trying to cross the broad avenues separating humans from automobiles. But they are blocked by those "giant finned cars [that] nose forward like fish," if I may borrow a phrase from Robert Lowell. He was

writing, in "For the Union Dead," about my own clogged American city of Boston, but he had captured exactly the intrinsic quality of the new Las Vegas. "A savage servility slides by on grease."

[1998]

· *Stephen Sondheim's Progress* ·

STEPHEN SONDHEIM has long been an idol of sophisticated musical comedy enthusiasts. If the adulatory books written about him over the past fifteen years are any criterion, however, the man is something far more important than a Broadway cult figure. Barely sixty-eight and still turning out musicals every two or three years, he has now become a creature of legend, perhaps one of the most significant figures in the history of Western music and literature.

This, at least, is what is implied by the nature and reach of recent Sondheim scholarship. The bibliography of Stephen Banfield's painstaking analysis of the composer's music and lyrics, *Sondheim's Broadway Musicals* (1993), identifies over 230 items of academic Sondheim material ("The Metaphor of Paradox in Sondheim's *Company*" is a typical title). This suggests that Sondheim research has become a cottage industry for scores of tenure-track scholars. Feminist, gay, and gender theoreticians applaud his ambiguous sexual themes. A brand-new field of "melopoetics" has been contrived to analyze his musical innovations. And Banfield, in the midst of such labors as examining the "phrygian matrix" of *Pacific Overtures*, has identified Sondheim as an archetypal postmodernist because of "his playful ambiguities, self-referential structures" and his "redrafting of the contract between writer and reader."

Wait, there's even better stuff. Listen to a few bars from a long scholarly riff in which Banfield descants on "Sondheim's philosophy and its instinctive relationship to the modernist apprehension of Hegel and Kierkegaard . . . (committing oneself neither wholly to the notion of 'both/and' nor wholly to the notion of 'either/or' but as it were to both)." Where is Alexander Pope when we need a new *Dunciad*? Artists like Sondheim, of course, are hardly responsible for

the pomposities written in their names. But academic refrains like this one say a whole lot about what's happening in university class-rooms these days. It says even more about what's been happening to our culture when the fourteen works of a highly talented composer for the New York musical theatre—hardly a temple of high art to anyone other than voters for the Antoinette Perry Awards—are treated with the same kind of exegetical reverence as Beethoven's *Eroica*.

Now comes a new Sondheim biography to swell the growing list of tributes—Meryle Secrest's *Stephen Sondheim: A Life*. The author of books on Frank Lloyd Wright and Leonard Bernstein, Secrest is well prepared for her task and has rigorously researched her subject. Her work adds some interesting facts about Sondheim's develop-ment both as a man and as an artist. It is also useful in the way it de-scribes the Herculean task of putting together a collective piece of musical theatre. Much of this territory has already been explored in Craig Zadan's *Sondheim & Co.* (1986), a collection of juicy anec-dotes and gossipy testimonials by Sondheim's various collaborators. But Secrest is particularly provocative in the way she strews hints about the tensions between Sondheim's ambitions and his achieve-ments.

The son of a dress manufacturer and a dress designer, Sondheim began life as a fairly typical Central Park West kid from a prosperous Jewish family. When his parents split he moved to the East Side to di-vide his time between the Hotel Pierre (his mother) and 1010 Fifth Avenue (his father). He spent five summers in camp. He was sent to Fieldston and thence to military school. He soon became painfully aware that his mother, Foxy, was trying to seduce him ("She would sit across from me with her legs spread. She would lower her blouse and that sort of thing"). In one of her occasional descents into psy-chobabble, Secrest suggests that this experience may have been re-sponsible for his lifelong suspicion of female sexuality. Whatever the case, he loathed his mother—a friend called her "the most preten-tious self-centered, narcissistic woman I have ever known in my life"—and didn't even show up at her funeral. He matriculated at Williams where his energies went into writing musicals. He was one of those smart, precocious college kids who, had he graduated today, might be doing scripts for *The Simpsons* or *South Park*.

Sondheim's musical career was deeply influenced by Oscar Hammerstein II who was also his surrogate father. And while some see Sondheim's experimentation as a revolt against traditional Rodgers and Hammerstein musicals, it is also possible to regard it as an extension of that approach—darker in style and tone, pessimistic where they are optimistic, but similar in its deployment (and debasement) of relatively weighty literary sources. When he met his future collaborator Hal Prince in Walgreen's in 1949, they instantly knew they would be "part of the future of musical theatre." But Sondheim soon found himself disabused of his "idealistic notion" that he was entering a serious enterprise: "I was going into show business and I was a fool to think otherwise."

Sondheim was hardly a classically trained musician, and, though he studied with Milton Babbitt, he wasn't much interested in becoming a serious composer. But he appreciated classical music, particularly Ravel, Tchaikovsky, Rachmaninoff, Stravinsky, and Prokofiev, and it was his innovative idea to import some of their techniques into musical comedy. His first big break came when he met Arthur Laurents, then writing the book for *West Side Story*. Laurents introduced him to Leonard Bernstein, who was slated to write the music and lyrics. Neither Laurents nor Bernstein much admired Sondheim's compositional gifts (some people still don't), but they recognized that he was a lyric writer of real consequence. And as a matter of fact, Sondheim's lyrics for *West Side Story*—along with some of Bernstein's songs and Jerome Robbins's choreography—are the elements that now save what today seems a dated and impoverished book.

Sondheim himself recognized that *West Side Story* wasn't very good (though when Harold Clurman wrote that this crude modernization of *Romeo and Juliet* was "pandering to the masses," Sondheim, who often bristled at criticism, canceled his subscription to *The Nation*). Unlike many in the theatre, Sondheim always preferred the "art" of musical composition to the "craft" of writing lyrics. Nevertheless, when he failed to persuade Ethel Merman to let him compose the score for *Gypsy*, he agreed to write words for Jules Styne's songs. Those lyrics reinforced his growing reputation as the most urbane and sophisticated figure in the American theatre—the true heir

of Cole Porter and Ira Gershwin. (With songs like "I'm Still Here" he began to earn a name as "a poet of the theatre.")

Sondheim took one more assignment purely as a lyricist, collaborating with Richard Rodgers on the catastrophic *Do I Hear a Waltz*. Rodgers didn't like him, calling him "a cold man with a deep sense of cynicism," probably because Sondheim once said, correctly, that Oscar Hammerstein was a man of limited talent and infinite soul while Rodgers was the opposite. Whatever the case, Sondheim was henceforth to assume responsibility for both music and words in all his successive work. His first major hit in that capacity was the Burt Shevelove–Larry Gelbart compendium of Plautine farces, *A Funny Thing Happened on the Way to the Forum*, though the songs for this low comedy, written in a witty salon style, could have easily been detached. Following this success he had a surprising number of box office failures, largely because of mixed reactions from the *Times* (Clive Barnes and Walter Kerr were often among his most scathing critics). These flops included *Anyone Can Whistle, Follies, Pacific Overtures*, and *Merrily We Roll Along*, most of which won a number of Tonys anyway and were later rehabilitated in subsequent productions.

These momentary disappointments, however, were alleviated by such critical and box office successes as *Company, A Little Night Music* and, preeminently, *Sweeney Todd. Sweeney Todd* was a work of high musical ambition, which began to approach the condition of opera. *A Little Night Music*, based on Ingmar Bergman's *Smiles of a Summer Night*, on the other hand, was relatively lighthearted, and even featured a tune you could hum, namely "Send in the Clowns."

Sondheim reportedly wrote this song for Glynis Johns because it allowed her limited voice lots of pauses for breath—but he never greatly liked it. For him it sounded too much "like a piano bar song," the very reason it appealed to Frank Sinatra (who said that Sondheim "could make me a lot happier if he'd write more songs for salon singers like me"). Nevertheless "Send in the Clowns" hit the charts in recordings by Sinatra and Streisand among others, and still remains Sondheim's best-loved song.

Most of these musicals, both the hits and the flops, were directed by Hal Prince in pseudo-Brechtian style and designed by that great scenic artist Boris Aronson. They also attracted a variety of

book writers, including Arthur Laurents, Hugh Wheeler, John Weidman, and George Furth. For some reason Sondheim never wrote his own libretti, though he had considerable literary abilities, and the book was usually the weakest aspect of the collaboration. In the nineties, however, two things changed the direction of his career: his collaboration with James Lapine and then, if Secrest is to be believed, his first sustained love affair with a young composer named Peter Jones.

With Lapine, Sondheim began to experiment with much more ambitious material. Whatever their intrinsic value, these works were efforts to create a new musical form. *Sunday in the Park with George* had a brilliant first act, tracing the evolution of Seurat's masterpiece *La Grand Jatte* through stories of its various subjects before it fell off precipitously into self-conscious maunderings about chromolumes and the nature of art. Their next collaboration, *Into the Woods*, also had second-act trouble, though even the first act struck some people (me included) like a view of the Grimm Brothers through the jaded eyes of New York analysands. Anyhow, it deteriorated from a Broadway fairy tale into melodramatic posturing ("all of a sudden everybody was getting killed," as its producer Rocco Landesman remarked, "and it became very dark"). With their third piece, *Assassins*, a musical account of presidents getting murdered through the decades, Sondheim and Lapine seemed to have demonstrated that some subjects were too dark and outre for Broadway musicals.

Sondheim and Lapine's latest contribution, *Passion*, was based on a nineteenth-century Italian novel by Tarchetti called *Fosca*, about a mismatched love between a young military officer and an ugly invalid who adores him with an unrestrained passion he is forced to return. Here too the composer had exceeded the possibilities of musical comedy, but in this case he seemed to have abandoned the form altogether. With *Passion* Sondheim broke out of the commercial conventions of his time to create a tremulous musical experience in the style of Puccini.

Secrest speculates that the source of this new emotional element was his love for Peter Jones, with whom he exchanged wedding rings (though they were later to part). Whatever the case, *Passion* baffled audiences and critics alike, some of whom laughed in disbelief. Ad-

mittedly the piece was barely recognizable as Sondheim. It was not smart or brittle or arch but rather pulsing with uncontrollable feeling, which meant that it was aimed at the wrong audience. The Sondheim crowd was expecting an entertainment, and what it got was bel canto opera. As Sondheim later said, with considerable accuracy, nobody would have laughed had *Passion* been performed at the Met.

Secrest notes that, like Copeland, Gershwin, and Bernstein, Sondheim never fitted comfortably into pop or classical categories. And there is no question that, as Harold Clurman once observed of Clifford Odets, he liked to run with the hares and hunt with the hounds. In *Company*, for example, he wanted his audience "to laugh uproariously and then go home and not be able to sleep." When they failed to respond the way he wanted, he groaned that he was a serious artist in a compromised world. Yet this world of compromise was the one he chose for himself, whose rewards he cherished. As Milton Babbitt once remarked about his pupil, Sondheim "had this insatiable desire to make it big." Having grown up with celebrities, it was their company he wanted to join.

Some critics have praised Sondheim for blurring the boundaries between entertainment and art. Others suggest that this was an example of what I have elsewhere called "middle seriousness," neither fish nor fowl (nor hare nor hound) but a hodgepodge of both. Rodgers and Hammerstein were initially responsible for this zoological hybrid, having transformed the robust energies of early musical comedy—borrowed from low vaudeville routines and baggy-pants burlesque—into upper-middlebrow operettas featuring great music and debased or second-rate books. With *A Funny Thing Happened on the Way to the Forum*, and to a lesser degree with Burt Shevelove's adaptation of Aristophanes' *The Frogs* (which was written for my own theatre), Sondheim opened himself up to the original energies of the genre. Although he always claimed that "melodrama and farce are my favorite forms of theatre," most of his other book musicals were inhibited by the limitations of the operetta form. (The same thing happened to Kurt Weill after he fled Nazi Germany, abandoned Brecht, and made his livelihood composing with Broadway writers like Maxwell Anderson). With *Sweeney Todd* and especially *Passion*,

Sondheim at last began to work with forms commensurate with his experimental vision.

For a Broadway composer Sondheim has enjoyed an incredibly high reputation. Bernard Jacobs of the Shubert Organization called him "one of the great poets in the history of the English language." Alan Rich, the music critic, wrote that "Sondheim has raised this art to a new plateau of greatness." Frank Rich called him "the last major artist in American theatre who believes in Broadway." And in England, where his reputation is if anything even more exalted than in his own country (he even taught a year as visiting professor of contemporary theatre at St. Catherine's, Oxford), the Sunday *Times* dubbed him "that rare thing in the musical theatre world: an intellectual heavyweight." These, like the numerous academic studies of him to be found through the Dewey decimal system, testify more to a great creative potential than to a great artistic achievement. Few would think of comparing Gershwin's musical *Girl Crazy* with his opera *Porgy and Bess*, any more than we would measure Bernstein purely by *West Side Story*. Liberated from the constraints of the commercial musical form, Sondheim may at last be in a position to explore the manifold possibilities of his prodigious talents. More *Passions*, please.

[1998]

Samuel Beckett and Alan Schneider

THE AMERICAN DIRECTOR Alan Schneider first met the Irish playwright Samuel Beckett in 1955, after being hired to direct the United States premiere of *Waiting for Godot* in Miami. Schneider had come to Beckett's Paris apartment bursting with preproduction questions, especially regarding the identity of the title character. To Schneider's initial query, "Who is Godot?" the laconic playwright famously replied, "If I knew, I would have said so in the play."

Henceforth Schneider was to devote most of his career to realizing Beckett's stated intentions in his plays. But despite his fidelity to every letter of Beckett's text, and despite the casting of such popular clowns as Bert Lahr and Tom Ewell, the Miami production of *Godot* was a resounding flop. Baffled by the metaphysical reverberations of a work that had been billed as "the laugh riot of two continents," one third of the audience left at intermission and others lined up at the box office not to purchase tickets but to ask for refunds from the management.

Beckett assumed complete responsibility for the fiasco, consoling Schneider with a blend of modesty and stoicism that was to inspire the director's lifelong admiration: "Success and failure on the public level never mattered to me much," Beckett wrote, "in fact, I feel much more at home with the latter, having breathed deep of its vivifying air all my writing life." From this moment on Schneider developed an intense infatuation with Beckett, amounting to hero worship, and Beckett responded with almost paternal affection. They soon became faithful pen pals, exchanging a total of more than four hundred letters.

Although Beckett was extremely protective of his private correspondence ("I do not want any of my letters to anyone to be published anywhere," he warned Schneider), most of these letters have now been collected in a volume called *No Author Better Served* (Harvard University Press). It has been edited with a useful introduction and great textual care (if occasionally incomplete and slipshod footnotes) by the Irish scholar Maurice Harmon, who respects Beckett's demand for privacy by deleting any material about his personal life. Harmon's title encapsulates Beckett's reaction to the punctilious way the American director had directed *Happy Days* (once again ignoring sour notices, Beckett wrote: "I've a feeling no author was ever better served"). It was Schneider's reverence for Beckett and his promotion of the plays in the United States that earned him the playwright's enduring gratitude and trust ("Thank you, again, dear Alan," he writes repeatedly, "for all you do for my work"). In return for his devotion, Schneider was rewarded with five Beckett premieres in this country and went on to stage a total of six productions of *Godot*, six of *Krapp's Last Tape*, five of *Rockaby*, and two of *Endgame*. (Although

Schneider also directed plays by Albee, Pinter, Orton, and Bond, he always seemed to be preoccupied with Beckett—that is, when he wasn't staging one of his innumerable revivals of *Our Town*).

Beckett saw none of Schneider's work on the American stage. He came to this country only once to watch his protegé direct Buster Keaton in *Film*, Beckett's short movie. Nevertheless, at least in the early days of their relationship, he tried to control production from a distance. In his very first letter to the director, Beckett warns that, although he is not averse to "changing the odd word here and there or making an odd cut," he demands the opportunity of "protesting or approving." With the passage of time, however, Beckett begins to grant Schneider more latitude in interpreting his plays. Within a few years he is replying to Schneider's questions with "Do it the way you like, Alan, do it any way you like."

Rather than take advantage of this freedom, Schneider sought Beckett's advice on every detail of his productions, even regarding the exact curve of a painted drop for *Happy Days* ("because you are so far away and this will be the premiere and we all want what you want"). He asked the playwright's permission before putting sequins on Billie Whitelaw's dress in *Rockaby*, before letting his actors close their eyes for a moment in *Play*. Schneider even submitted all his articles and publicity material in advance of publication for Beckett's approval. He betrayed Beckett's trust only once (and despised himself for it), when in order to placate his producers he dropped the stipulated da capo stage direction in the New York production of *Play* without informing the playwright. Having been told of Beckett's hurt feelings, Schneider lamented (in his autobiographical work, *Entrances*): "Why Sam continued to have faith in me after that I will never know."

Beckett's letters often reveal not only his uninterrupted faith in Schneider but a charming modesty, an engaging self-deprecation. "I was still half-asleep," he writes, "i.e., about a quarter more than usual," adding, "I'll take what's left of my head in my shaking hands and have another go." Sometimes Beckett's self-effacement almost becomes that of a Japanese diplomat, as when he thanks Schneider for his "great warmth of attachment to my dismal person and devotion to my grisly work." As time goes by this humility begins to ac-

cumulate layers of impatience with himself and his "muckheap of a mind." Worrying over Schneider's use of some of his nontheatrical material for the stage, he writes: "For me they are abortions. But I suppose what is not? More or less." Elsewhere: "Forgive this scrawl. Nothing in my head but wordless confusion." And elsewhere: "Struggling with impossible prose. English. With loathing. To think writing was once pleasure."

In return Schneider, often using gloomy phrases from Beckett's plays, sends his friend his despairing reflections on the state of the American theatre, American culture, and American politics (their letters cover the period of the Vietnam War). Resolutely apolitical, Beckett remains sympathetic to, if somewhat remote from, Schneider's concerns. He is nevertheless capable of expressing considerable outrage and contempt, especially regarding the press and its uncomprehending attitude toward his plays—"good bad or indifferent," he complains about his notices, "they get me down—and wondering what possesses these people to be writing about the theatre."

He is continually exchanging anecdotes with Schneider about "those jackals," the critics, who are "stupid and needlessly malevolent," "these bastards of journalists" who perpetually misunderstand his work. (The worst insult traded between Didi and Gogo in *Godot* is . . . "*critic!*"). He also indicts such birdbrains as "the Lord Chamberpot" who are always trying to censor his plays. Confessing to "mental weariness," he allows a tone of morbid despair, a longing for withdrawal, to enter his correspondence. He also begins to grow increasing cranky and crotchety. What this hitherto unfailingly courteous man construes as "an offensive letter" from the gentle Hume Cronyn (performing alongside his wife Jessica Tandy in a Beckett evening) "discourages me from writing to his wife, to compliment her on her *Not I*." As time goes by, even his letters to Schneider became somewhat clipped and perfunctory. "Forgive my long silence," he writes. "No excuse. Just going silent."

These are also the years when Beckett begins to grow considerably less flexible regarding revisionist interpretations of his work, and when Schneider starts to function as something of a secret agent and unofficial tattletale. Schneider is perfectly aware that creative collaborators have an impact on the intentions of a playwright. In *En-*

trances he writes that even Beckett was "gradually discovering that all actors have imaginations and get ideas that might seriously affect or even distort the intentions of an author." Nevertheless he now feels compelled to alert Beckett about an upcoming production of *Endgame* by the Andre Gregory troupe which is "inclined to use text for its own purposes," later reporting, in a long letter, on how "the production takes such liberties with your text . . . and with your directions," calling it a "self-indulgent travesty, determined to be 'different' for the sake of being 'different.' . . ."

Saying that he would have liked to spare Beckett's feelings in the matter, Schneider insists that "The main thing is to protect the play and you. But how, except to keep it from going on in the first place?" But by this time he has gotten Beckett incensed enough to threaten suit ("My work is not holy writ but this production sounds truly revolting & damaging to the play"), though he finally allows the show to go on, providing it doesn't tour. (Actually it was the very first production I invited to Yale in 1966, as well as one of the most memorable.)

Schneider also feels compelled to caution Beckett about giving Gordon Davidson of the Mark Taper rights to all the plays. He calls another off-Broadway Beckett producer "an operator," not to be trusted. He worries aloud to his correspondent about "people climbing on the Beckett bandwagon." Later, after telling Beckett about Andrei Serban's celebrated *Cherry Orchard* at Lincoln Center ("strikes me a bit like the mustache Dali painted onto Mona Lisa"), he goes to the Public Theatre to spy on Serban's staging of *Happy Days* with Irene Worth, which he grudgingly concedes to be "more or less scrupulous."

Schneider rightly feels a bit vulnerable about making adverse judgments on other directors and productions "because there is an entire cabal of avant-garde critics who feel I have mesmerized you into some sort of permanent possession of your works . . . [who are] determined to wrest you away from me." One of these critics has been speaking of the need to "break Alan Schneider's hammerjack on staging Beckett," and it is possible that Schneider may have sometimes represented himself as the only American painstaking enough to stage Beckett's plays. For all of his considerable qualities,

Schneider was not above the petty jealousies and competitive back-biting of the theatre, and for all of his growing reputation, he was curiously vulnerable to feelings of persecution. As his friend Edward Albee wrote in an otherwise friendly preface to *Entrances*, "Even in so horrid a place as the American theatre, the number of people who betrayed Alan is staggering."

Surely Schneider has to bear some of the responsibility for Beckett's growing rigidity about preserving every comma and parenthesis of his prose. "I must confess," he writes with typical flattery, "you are practically the only author whose stage directions seem so right and so much a part of what you are writing." It is not long before Beckett is refusing permission for an all-female *Endgame* and steaming over a "scandalous parody of *Godot* at Young Vic. Try to persuade myself I'm past caring." He even refuses Ingmar Bergman permission to film *Godot* because he doesn't want the play "Bergmanized." Soon after Schneider's death, my own company (the American Repertory Theatre) got into hot water with Beckett when the director JoAnne Akalaitis set a production of *Endgame* in an abandoned subway station and commissioned a brief overture for it from Philip Glass. Although he never saw the production, Beckett protested that his play had been "musicalized," objected to the casting of two black actors as Hamm and Nagg, and, citing his set descriptions, wrote in a program note that "Any production of *Endgame* which ignores my stage directions is completely unacceptable to me." The furor unleashed by this controversial event, and the unsuccesful efforts of Beckett and his agents to close it down, eventually made him put a codicil in his will insisting on control of future productions beyond the grave on pain of legal action. Just a few weeks ago a theatre in Washington, D.C., was threatened with court action by the Beckett estate after reports that its black cast members had introduced some hip-hop interpolations into a production of *Godot*. Only through the intercession of Beckett's nephew, Edward, was the production permitted to proceed.

There is much debate about the degree of freedom that playwrights should grant directors in subsequent performances of their plays. There is no debate, however, that early performances of a play deserve the most exacting and faithful attention available. That is

why Alan Schneider was such an ideal director for Beckett premieres and why he truly deserved the playwright's gratitude. *No Author Better Served* not only chronicles the almost symbiotic relationship between a great writer and a faithful disciple but adds invaluable epistolary material to the Beckett canon. Schneider's premature death in 1984 ended the relationship, but even his last moment was spent in homage to Beckett. The director was struck down by a motorcycle in London, having crossed the street to mail another letter to his friend.

[1999]

· Poker Face ·

The living room of Buster Keaton's shabby, genteel mansion in East Los Angeles. Memorabilia of his silent-film days strewn about this unusually sloppy room. Stills of Buster in his various film triumphs, including The Navigator, The General, *and* Limelight *with Charlie Chaplin. At rise, Buster, now over seventy, is alone sitting at a poker table, drinking a beer, examining his cards. He then rises to examine, one by one, the other hands on the table.*

BUSTER: Don't raise with two pair, dummy. Wait for the full house. (*the next hand*) Draw for the flush. (*and the next*) Fold. You got to know when to fold. When will you guys learn how to play five-card stud?

(*A bell rings. And rings. Buster looks up, puzzled, then calls:*)

BUSTER: Lionel! Lionel! (*no answer*) LIONEL!! (*pause, as he tries to remember*) I guess it must be Sunday, goddammit.

(*Buster leaves the stage. The sound of a door opening. He then enters with a man in his early forties, wearing a baseball cap.*)

BUSTER: Sorry. (*very English*) My man is off today. What did you say your name was?

ALAN: Schneider. Alan Schneider.

BUSTER: Well, take a seat, why don't you. (*Buster fixes himself another beer without offering one to Alan*)

ALAN: (*after a strained pause*) I'm really thrilled to meet you, Mr. Keaton. I've been a fan of yours since I was a kid.

BUSTER: That's nice. Not many people remember Buster Keaton anymore.

ALAN: Everybody remembers Buster Keaton. You were the funniest man in silents.

BUSTER: (*looking at the poker hands*) You must be thinking about the tramp. Me they called the saddest man in silents. (*another pause*)

ALAN: (*looking at the table*) You're in the middle of a poker game?

BUSTER: I've been in the middle of this poker game since 1927.

ALAN: (*looking around*) Where are the other players?

BUSTER: Dead.

ALAN: Dead?

BUSTER: This is Irving Thalberg's hand. This is Nicholas Schenck's. And this one here belongs to Eric Campbell. He was the heavy at Essenay. The tramp's company.

ALAN: The tramp?

BUSTER: You know. Chaplin. The little guy.

ALAN: (*gravely*) Oh.

BUSTER: They're all dead. (*pause*) Excepting me. The real sucker of the group is Thalberg. Always raises on two pair, the dummy. Owes me more than two million. (*looks at Thalberg's hand again*)

ALAN: Do you always win?

BUSTER: Yeah.

ALAN: What's your secret?

BUSTER: My poker face.

ALAN: I see.

BUSTER: What's your game?

ALAN: Bridge.

BUSTER: No, I mean what's your game? What you do for a living.

ALAN: I'm a theatre director.

BUSTER: Oh, you're that New York guy. I thought you were some sort of baseball player with that cap you're wearing.

ALAN: I always wear a baseball cap. It's my trademark. Like your poker face. (*pause*) Did you get a chance to read the script I sent you?

BUSTER: (*going to a table to pick it up*) You mean this piece of crap? Yeah.

ALAN: You didn't like it?

BUSTER: Couldn't understand a word. What is this thing? Doesn't even have a title.

ALAN: There's the title. *Film.*

BUSTER: Yeah, I know. Film. The fancy word they give the movies nowadays. But what's the name of this so-called film?

ALAN: There's the name. *Film.* Sam likes simple titles. He once wrote a play called *Play.*

BUSTER: Who's Sam?

ALAN: Sam Beckett. You never heard of him? (*Keaton nods No*) I sent you a comedy of his once. *Waiting for Godot?* About those two tramps in the middle of nowhere? Bert Lahr ended up playing your part. The one you turned down.

BUSTER: Oh yeah, *Godot.* (*he pronounces it "Godette"*) I remember something now. I didn't understand a word of that one either.

ALAN: I'm sorry. (*pause*) What about this . . . uh . . . movie? I hope you're not saying that part doesn't interest you, too.

BUSTER: Of course I'm interested. I'm no dummy. I don't turn down five thousand dollars for a three-day shoot. That's the fee, right? Five thousand?

ALAN: That's right.

BUSTER: Then I'm in.

ALAN: Great!

BUSTER: But the script needs fixing.

ALAN: Fixing?

BUSTER: It don't make no sense. And I wouldn't say it's a whole bunch of laughs either. The show needs some goosing up. Maybe, my walk. (*he demonstrates*)

ALAN: (*doubtful*) Sam . . . uh, I mean Mr. Beckett likes his actors to stick pretty close to the script.

BUSTER: (*not hearing*) One thing. You're going to have to cut out that bit with the cat. Dogs I can work with, especially chihuahuas. Chihuahuas are good actors. But not cats. Never get on stage with kids or cats.

ALAN: I'll mention it to Mr. Beckett.

BUSTER: I could do that bit where I sharpen my pencil and it gets smaller and smaller. Surefire.

ALAN: We don't normally pad Samuel Beckett material.

BUSTER: Because you can tell your Mr. Beckett that his movie is too short. It won't last four minutes. Even if we stretched out the cat and dog business. (*confidentially*) For a percentage of the gross I could give him some ideas about how to make it longer.

ALAN: Mr. Beckett doesn't usually accept co-authors.

BUSTER: (*not hearing*) And tell him I've got to wear one of my hats. What do you think of this Stetson? (*puts it on*)

ALAN: I can't imagine you doing a film without one of your hats.

BUSTER: Right. I got twelve of them, all different colors.

ALAN: I'll check it out with Mr. Beckett.

BUSTER: Check out one more thing. The lighting. I don't want any of those newfangled lighting effects. People got to see my face.

ALAN: Of course.

BUSTER: It's been my livelihood all these years.

ALAN: Of course.

BUSTER: (*relaxing a little*) We never used a script in the old days. In the Keaton studios. Just started with a character in a fix, then improvised and lollygagged until we figured out how to get him out of his trouble.

ALAN: I'm sure Mr. Beckett would be very interested in any stage business you can bring to his film.

BUSTER: Okay, it's a deal. I guess. Tell your Mr. Beckett I'll do this Shakespeare stuff of his. Tell him Buster Keaton is in.

ALAN: He'll be very happy. (*he stands up to shake Buster's hand*) I am, too. (*he takes his coat*) We start shooting in New York in six weeks. (*holds out his hand. Keaton ignores it*) It's been a real pleasure, Mr. Keaton. (*he exits*)

BUSTER: (*uncaps another beer and goes back to the poker table, hovering in turn over each player's hand*) (*to Thalberg's*) You missed the full boat again, Irving. (*to Schenck's*) I wouldn't bluff on that load of crap, you dummy. (*to Campbell's*) You were right to fold. (*triumphantly, revealing his own hand*) Four ladies.

(*Buster rakes in the chips as the lights fade.*)

[1999]

· Edward Albee's Identity ·

THE PLAYWRITING CAREER of Edward Albee describes a trajectory similar to that of Eugene O'Neill, Arthur Miller, and Tennesseee Williams. Each experienced an extraordinary youthful success. Each was hailed for a while as the savior of the American theatre. And each was then subjected in middle age to so much critical hostility and public disregard that his plays could no longer reach Broadway. After finally having achieved some venerable age or expired, each was rewarded with such a resurgence of passionate interest in his work as to become a hallowed figure in the cultural pantheon.

It would seem that our fickle American theatre has only two stories to tell—skyrocketing success and plummeting failure—and it spins out these narratives in a dizzying spiral of enthusiasm and neglect. Until recently one of the most neglected if not disrespected dramatists in the country, Edward Albee now finds his star again in the ascendant. This change is largely due to the off-Broadway triumph of *Three Tall Women* (which won him his third Pulitzer), closely followed by the successful Broadway revival of *A Delicate Balance*. Productions of his plays are now being staged or readied for production all over this country and in Europe. He currently holds a chair in playwriting at the University of Houston. Awarded innumerable honorary degrees, he has also become the recipient of the coveted Kennedy Center Honors. During that 1994 ceremony, in fact, President Clinton characterized the playwright's maiden one-act sensation, *The Zoo Story*, as "a play that took American theater by storm and changed it forever." The president went on to say, "In your rebellion, the American theater was reborn," thus unwittingly echoing the kind of hyperbole that set Albee up for the kill in the first place.

On the crest of the current wave of enthusiasm, Mel Gussow has written a closely detailed biography of the playwright entitled *Edward Albee: A Singular Journey.* Gussow, now a feature columnist and obituary writer for the *New York Times* after a long period as its off-Broadway critic, has known Albee for more than thirty years—at one time he lived across the street from him in Greenwich Village.

Having conducted in-depth interviews with Albee's relatives, collaborators, and friends, not to mention the playwright himself over a five-year period, Gussow has composed a long and reverential tribute to the dramatist that treats his plays largely as a form of disguised autobiography.

Written in a readable if somewhat bleached prose style, the book is therefore less useful for its critical insights than for filling in the more shadowy details of Albee's life. The plays themselves are examined not so much for their thematic purpose or structural power as for what they reveal or reflect about the playwright's past. Gussow thus disregards his subject's warnings about looking for "connective tissue" between his life and his work ("Any attempt to link his art and his life causes Albee to wince," this biographer concedes), convinced that Albee's "identity is his art, more than anyone might realize. Writing his plays he has intuitively explored and plundered his past." Out of this conviction Gussow constructs the formula of his book, which is to discover the biographical key that unlocks each play, to the point of identifying all of the self-appointed real-life models for the characters of George and Martha in *Virginia Woolf.*

Although some of Albee's past is familiar in outline, Gussow fills in a number of valuable details, partly to account for the recurring appearance in his plays of lost or silent sons, masculine hunks, benevolent grandmothers, powerful mothers, and weak fathers. He concentrates on Albee's adoption by wealthy suburban parents (Frances, the mother, a haughty dowager, Reed, the father, the scion of the Keith Albee chain of vaudeville theatres) who offered him little support and less affection; his unhappy childhood warmed only by his love for Grandma Cotter and his Nanny Church; his uneven career in private schools and Valley Forge Military Academy until some sympathetic teachers at Choate encouraged his writing; his ejection from Trinity College for cutting classes and chapel; his early homosexual stirrings preceding a long liaison with his longtime musical collaborator William Flanagan; his growing addiction to drink that invariably turned this shy retiring young man into someone capable of lacerating insults; his departure from home and his move to Greenwich Village in protest against his parents' bigotry; his stint as a Western Union messenger, delivering telegrams when not loung-

ing in gay bars; and then, climactically, the remarkable impact of *The Zoo Story*—first in Germany and then off-Broadway on a double bill with Beckett's *Krapp's Last Tape*—when the playwright was barely thirty. A two-character play about a fatal park-bench encounter between a village hippie and an uptight square, it has been compared to everything from Genet's *Deathwatch* to the Gospel According to St. Luke.

Albee's career, following this highly successful premiere, was an almost unbroken string of one-act triumphs, which made him the toast of the town. The subject of countless interviews, panels, and talk shows, he could nevertheless be extremely reticent and cryptic. He could also be very mischievous. I recall an evening when, serving as moderator on some playwright's panel, I inquired of Albee what kind of question he might feel most comfortable with. "Ask me why I don't write full-length plays," he replied. When I posed that question to him before the public, he answered with more than a touch of self-satisfaction, "All my plays are full length." As Peter Hall was later to write: "He wishes to remain an enigma at all times. Edward is a very daunting personality. He makes a religion of putting people off. He loves destabilizing people."

Three years after *The Zoo Story* and after four other short works, Albee did write a full-length play, namely *Who's Afraid of Virginia Woolf?*, which constituted his greatest success. It could have been a great success too for the Actors Studio Theatre, which was looking for a significant play with which to begin its first season. But Geraldine Page refused the part of Martha because "I want to play something where I can look beautiful"; Roger Stevens refused to "subsidize the speaking of dirty words on the stage"; and Lee Strasberg turned it down without an explanation. The only new play in the first Actors Studio season was a nitwit piece called *Baby Want a Kiss* starring Paul Newman and Joanne Woodward.

Nevertheless, with Uta Hagen and Arthur Hill in the leading roles, *Who's Afraid of Virginia Woolf?* became one of the biggest successes of the 1962–1963 season. It was also the high point of Albee's career, after which his fortunes began to spiral downward. Virtually all of his stage adaptations—*The Ballad of the Sad Cafe, Malcolm, Everything in the Garden*, and *Lolita*—were critical and box office fail-

ures. So was the initial production of *A Delicate Balance*. His most controversial work, *Tiny Alice*, became the source of considerable dismay and confusion despite Albee's continual efforts to explain it (later he was to become more critical about the play than many of his detractors). And the rapid-fire disasters of *All Over, The Lady from Dubuque*, and *The Man Who Had Three Arms* virtually buried his reputation. After that, people in New York were afraid to go near Edward Albee. The Manhattan Theatre Club, Lincoln Center, and the New York Public Theatre (under JoAnne Akalaitis) all rejected *Three Tall Women*—as if, Gussow indignantly adds, he "was not a world famous playwright, a two-time Pulitzer Prize winner who had helped to change the face of the American theatre."

Whatever the high points or dips in his career, Albee always remained fiercely loyal to his early collaborators—the director Alan Schneider (about whose cruelty to actors Gussow has much to say); the actors Sudie Bond, George Grizzard, Maggie Smith, and Elaine Stritch; the producers Richard Barr and Clinton Wilder (with whom he founded the invaluable Playwrights Unit, dedicated to encouraging young writers); and, of course, the composer William Flanagan, Albee's collaborator on a number of musical works, including *Bartleby*. But although Flanagan always remained his chief composer, Albee eventually took other lovers—first the playwright Terrence McNally, then the interior decorator William Pennington, and finally the sculptor Jonathan Thomas with whom he continues to maintain a close relationship.

Albee's homosexuality led a number of critics at the time, myself included, to assume that his sexual disposition was influencing his work in an unacknowledged way. In the McCarthyite fifties Eric Bentley speculated that the disguised character in many liberal Broadway plays was a Communist. In the late sixties and seventies, when homosexuality was still proscribed on stage, some critics assumed the disguised character to be a gay man. *Virginia Woolf*, in particular, was generally believed (not by me) to be a homosexual anecdote about two gay couples. Albee consistently denied this interpretation and blocked all attempts to stage the play in this manner. And despite Philip Roth's scorching *New York Review of Books* characterization of *Tiny Alice* as "the play that dare not speak its

name . . . a homosexual daydream," and Stanley Kauffman's Sunday *Times* piece charging that Albee, along with Williams and Inge, had invented "a two-sex version of the one-sex experience," Albee was deeply hurt by the inference that gays cannot write about women. He always insisted that he was not a gay playwright but rather "a playwright who is also gay."

Although such a distinction may sound a little disingenuous (plays like *The Zoo Story* and *Tiny Alice* do send off strong homosexual vibrations), I now believe that Albee was right to insist on it. Our own age has clearly dramatized the difference between writers who have an ideology (gay, feminist, black, or macho) and those who have no desire to advance an agenda—which is to say, between those stuck in their own *personae* and those capable of imagining other people's lives. Albee has written a few openly homosexual plays and others that could only have been written by a gay man. But the major body of his writing represents a genuine attempt to dramatize the complexity of experience through a wide assortment of characters.

Albee unquestionably suffered from what today's uncloseted age might consider homophobia, but which at the time was really a demand for a more frank, straightforward admission of homosexual leanings. Gussow tells an anecdote of a chilling evening at his own house when a drunken Albee stung Joe Papp into demanding that Albee declare his sexual disposition. Albee already had a reputation as "a bad drunk who in the name of truth-telling . . . would say the most savage things, even to friends." By his own admission he was by nature "a gentle, responsible useful person," but "with liquor, I am insane." Anyway, at this particular dinner a drunken Albee began baiting Papp for his past political associations, asking, "How long were you a member of the Party," to which an irate Papp responded, "How long have you been doing what you do?" These fruitless exchanges continued until Papp left in a huff and Albee passed out. ("It was a long time," Gussow wanly remarks, "before my wife and I had another dinner party.")

Gussow, who seems to be an uncritical enthusiast of all of Albee's work except for a few later plays, has a lot of fun identifying the critics who missed the boat on the works he considers inarguable

masterpieces. I am one of these miscreants, along with the late Walter Kerr, perhaps the only time that Kerr and I were ever in agreement. It is true that, while admiring the verbal dexterity, imaginative thrust, and technical dazzle of most of Albee's work, I almost always noticed something ersatz, even in *The Zoo Story* and *Virginia Woolf.* At the time I attributed that to what I perceived to be Albee's lack of identity, which led him to impersonate the style of other writers (e.g., Ginsberg and Genet in *The Zoo Story*; Ionesco in *The American Dream*; Strindberg in *Who's Afraid of Virginia Woolf?*; T. S. Eliot in *A Delicate Balance,* and so on). I was also disturbed by the way Albee, who began his career as a redskin, was coming on more and more like a paleface. Apart from *Virginia Woolf,* which displayed the vigor of his off-Broadway experiments, most of his Broadway plays seemed dessicated. It was as if his work were growing more precious and well bred as his fame and wealth increased. Certainly the savage if brittle energy animating his early dialogue was dissipated into what, reviewing *A Delicate Balance,* I rather cruelly called "cocktail party chit chat . . . with brandy being decanted over supernatural conversations in a *House and Garden* setting."

Trying to defend Albee against these criticisms, Gussow inadvertently provides some certification of them. His account of Albee's love affair with the interior designer William Pennington, during which he developed a passionate interest in redoing his homes, helped me understand why, for a while, I detected in Albee's plays the hand of a decorator rather than a dramatist, furnished with reproductions and pieces bought at auction. And the details Gussow uncovers about Albee's private life—particularly his sense of being a lost and lonely human on an isolated planet, an adopted child with no idea of his real parents—may account for his lack of a consistent temperament and unified style.

Gussow uses a passage from James Agee's *A Death in the Family* to begin and end his book. It is about a child whose parents "will not, oh, will not, not now, not ever, but will not ever tell me who I am," and it invariably makes Albee cry. The lines confirm Albee's uncertain sense of his own condition and may explain why he was always borrowing the skins of other artists. But since those same uncommunicative parents represent the wealthy, suburban middle

classes that also frequent the theatre, the passage may also help to explain his love-hate relationship with the Broadway audience. Although at heart he always remained an experimental writer who never stopped testing the limits of dramatic form, Albee seemed to seek the approval of the mainstream as much as he sought the approval of his adoptive parents. And although he wanted Broadway's patronage and support, he never ceased to satirize the very people who attended his plays. This ambivalence led to profound feelings of rage and hurt when that audience rejected him. "You owe me something," screams the eponymous hero of *The Man with Three Arms*. "You loved me in the good times and you're fucking well going to love me now."

What ultimately saved Albee—and these qualities remain the major ingredients for success in American theatre—was his obstinate persistence in the face of the most awful disappointments. In *Three Tall Women*, which may be Albee's finest play, he finally comes to terms with his sense of rejection, with his sense of disappointment, and with the person primarily responsible for his sense of alienation, his adopted mother, Frances Albee. He manages this not by excusing her monstrosities but simply by accepting her for what she is. The young man of the play—like Albee a prodigal child banned from the house because he likes to sleep with men—sits by the bedside of his dying mother, silent and forlorn, and at one moment kisses her face ("His dry lips on my dry cheeks"). In that tender act of acceptance, Albee's true identity is on the way to being explored, his ambivalence on the way to being resolved. That may be why, in this late play, he at last seems to have found himself.

[1999]

· *The Fête des Vignerons at Vevey* ·

OVER ELEVEN DAYS in August 1999 the village of Vevey in French-speaking Switzerland staged the Fête des Vignerons, attracting seventeen thousand spectators to each of its thirteen perfor-

mances. An ancient gala dating from just after the French Revolution, the Fête is devoted to commemorating the artistry and dedication of the local winegrowers. Indeed it traditionally begins with the coronation of the most productive of their number as king of the festival, elected to preside over the theatrical events with all the authority of a heriditary royal.

This was the fifth time the festival had been produced in this century (it is staged every twenty-two years or so), and the performance was by far the most ambitious undertaking of its kind. It featured (dressed in a dazzling array of costumes by Catherine Zuber) more than 4,500 actors, singers, dancers, and musicians, almost all of them amateurs recruited from among the local villagers. Featured also were 350 village children, 500 head of cattle, 6 muscular oxen (bred especially for the event), 100 sheep (their fleece dyed deep blue), numberless goats, ducks, and geese, and 5 helicopters that soared over the stage during a mock battle scene to the accompaniment of dazzling pyrotechnics.

In addition to sponsoring this epic event, Vevey is notable for having been the home of Charlie Chaplin and his family during the last decades of his life. You can understand why he chose to live in exile there after his troubles with a red-baiting Congress. It is a serenely lovely town situated on Lac Leman (Lake Geneva) and surrounded by the Swiss Alps on the north and the French Alps on the south. The combination of shimmering water and majestic mountains, not to mention the surrounding village architecture, served as an enchanting scenic background for the theatrical proceedings, helping to create a kind of spatial homogeneity and cultural timelessness. Watching the event, one felt embraced by nature, history, and tradition. Even a foreigner like myself could be caught up in a powerful sense of community.

The festival cost over 50 million francs to produce (roughly $37 million), most of it raised through private subscription. Expressly for the event, the noted scenographer, Jean-Claude Maret, constructed an immense stage in the town square. About a quarter of a mile long and five hundred feet wide, it sloped up toward the lake and mountains like a scoop, at the back of which panels descended from time to time to mark the passage of the four seasons. To begin the perfor-

mance, enacting a scenario written by the poet François Deblue, fifty halberded soldiers on horseback trotted onto this vast empty space followed by a hundred Swiss Guards dressed in red and carrying pikes, then a chorus of young girls on bicycles wearing pink wigs and tutus, and eventually almost every inhabitant of the surrounding neighborhood—all to the accompaniment of a rousing brass band.

This parade was followed by a *tableau vivant* representing the village of Vevey through the ages—as personified by clusters of people buying goods at a market, dressed in the costumes of three centuries. Before long appeared the clownish master of ceremonies—a variation on Harlequin renamed (with a nod to the winegrowers) *Arlevin*. He in turn introduced a variety of legendary figures traditionally featured in the festival.

These included characters both from Christian and classical legend: St. Martin giving half his cloak to a beggar; Orpheus appearing atop a mammoth turtle; Ceres expressing outrage over the marriage of her daughter Proserpine to Hades (and dooming humankind to three months of winter in revenge); Dionysus cavorting with his companion Silenus before marshaling a group of Maenads in green wigs and grey armored bathing suits, followed by an army of Bacchantes, who turned the tables on the men (to the delight of the women in the audience) by taking the sexual initiative.

The blending of Greek and Roman mythology with Christian allusions was probably a cultural memory of the French Revolution and its endorsement of classical traditions. But it was also the trademark style of the festival's head, the notable opera and stage director François Rochaix (who, I should add, is also my friend and colleague at the ART Institute for Advanced Theatre Training where he serves as director). Rochaix has always preferred to span the centuries in his productions using a mixture of acting and costume styles. For the same purpose he appointed three different composers—namely Jean-François Bovard, Michel Hostetter, and Jost Meier—to create both traditional and modern music (exquisitely played by members of the Orchestre de la Suisse Romande). The first two composed charming brass melodies and tone poems for female voices resembling that of Berlioz in his haunting *La Demoiselle Elue*. These musical contributions were received without significant controversy. But Jost Meir's

dissonant rendering of the popular anthem of the region, the "Ranz de Vache," though performed to the accompaniment of the usual alp horns, was the source of great contention in the press and among the public.

The "Ranz de Vache" is to Swiss winegrowers and cowherds what the Star Spangled Banner is to patriotic Americans. Napoleon banned it because it made his Swiss militia homesick for the mountains and tempted them to desert. The atonal treatment of the song by Meier, though he is among the most respected of modern European composers, turned into the festival's major scandal, demonstrating how wide remains the gulf between the traditional and the modern.

Nevertheless this Fête des Vignerons was a huge popular success, making Rochaix temporarily the most admired figure in Switzerland. Street names were changed in his honor, and a life-size statue of the man, a bird on his shoulders and his arm extended as if giving a stage direction, presided over the lobby of the Hotel de Trois Couronnes for weeks. At the final curtain call it was obvious what an immense feat of artistry and administration had been achieved with this event, how it gave new meaning to the word "spectacular." Carrying the flags of all the wine regions, the colossal cast of adults, children, animals, and machines filled the cavernous stage to overflowing as Arlevin brought a child forward to proclaim the festival's theme: "*amour et joie.*"

The Fête des Vignerons was a striking demonstration of the contrast between popular and mass culture in the sense that the former is defined by active participation and the latter by passive consumption. The capacity of so many people to direct their energies for so long toward a single common goal was the achievement of an extremely healthy civilization. I couldn't help comparing the orderly behavior of the army of participants, celebrants, and audiences at Vevey with the reported conduct of the drug-soaked mobs at the most recent Woodstock concert. In one place rape and looting, in the other "amour et joie." The Fête des Vignerons was an encouraging demonstration of how huge crowds of people are perfectly capable of banding together for purposes other than stampede, pandemonium, or riot.

Clearly there is a significant difference between a people determined to affirm a proud heritage and those seeking transport through musical and pharmaceutical opiates. I returned from Switzerland to find the front page of the *Times* Arts and Leisure section dominated by two long encomiums to what was proudly called our "Hip-Hop Nation." Apparently our national identity is now being redefined by the weekly record charts. But reading these articles left me profoundly demoralized. There are no doubt some fine examples of rap being created these days, but much of it strikes the ear of an old jazz musician like me as tuneless, misogynistic, homophobic, and occasionally racist. Those decrying "Eurocentric" culture as imperialist and class-conscious could find much useful instruction in the way the village of Vevey succeeded in creating a mass communal event celebrating the dignity and skill of an ancient breed of worker, still toiling in the vineyards.

[1999]

· *An Oscar for Clinton* ·

NOW THAT the whole impeachment mess has been scraped off the Senate floor, we may once again have the opportunity to behold our president in some other role than as the comic butt of Comedy Central or the chief performer in Kenneth Starr's $40 million exercise in authorized pornography. I propose to induct him into Actors Equity and nominate him for a special Academy Award for his recent State of the Union address. Instead of blinking under the blinding glare of the media lights, he emphatically demonstrated that he is a superb showman, deserving of the highest honors of the profession.

Clinton's theatrical prowess has improved exponentially since that seemingly fatal day at the Dukakis convention when, stumbling over a nominating speech as long as one of Castro's harangues, he had Democratic delegates frantically signaling him to get the hell off the stage. In the days of vaudeville they had to use a hook on the dumb clucks who didn't know when they were bombing with the

circuit audience. On the basis of his 1988 convention performance alone, Clinton's theatrical future would seem to have been limited to wiping the soprano's sink and sobering up the top banana.

But lately it's the House managers who have been doing all the bad acting, gloating over their victim like the renegade lynch posse in *The Oxbow Incident*—or, in the case of Lindsey Graham, impersonating Reverend Davidson, in *Rain*, in the act of thumping Sadie Thompson with a Bible. It's amazing how these self-confessed sinners can still manage to blame Clinton for the very vices they have been indulging in themselves. It took the unrepentant reprobate Larry Flynt to expose them for the small-town Tartuffes they are.

Meanwhile Clinton has undoubtedly emerged as the most popular actor in America, even if Republican legislators keep walking out on his act. Commentators have been comparing his reception across the country to that of Mick Jagger and Michael Jackson on a concert tour. By my lights, with his flowing mane, bulbous nose, and Fearless Fosdick chin, he looks more like an old-fashioned matinee idol on the circuit—say, James O'Neill wowing theatregoers across the nation in *The Count of Monte Cristo*.

Most actors are satisfied to receive a hand on their entrances, exits, and curtain calls. In his State of the Union address Clinton managed to provoke thunderous applause on every other sentence. He not only got the Democratic side of the house clapping wildly every time he opened his mouth, he received more than a few standing ovations. True, those Republicans who decided to show up that evening preferred to stare glumly at their hands whenever the Democrats jumped to their feet. But even this behavior became grist for Clinton's improvisatory talents. There was no question that this was a man who knew how to work a crowd.

What accounts for the extraordinary improvement in Clinton's histrionic techniques? For one thing he seems to have been taking voice lessons. (So by the way did Jimmy Carter.) Certainly something has improved his speech placement, his regional accent, and his vocal projection. He has always known how to poke a finger in the air and apply a little *ritardendo* when trying to underline a particular turn of phrase ("I did not . . . have sex . . . with . . . that woman . . . Miss Lewinsky!"). Having now admitted to an "improper" relation-

ship with "that woman," he has been freed to develop more embracing arm gestures and a whole new set of vocal intonations.

Consider how expertly he handles the teleprompter. Instead of scanning a screen he always seems to be stroking the audience. If most people are unaware that he's reading his part, it's because, like all good actors who inhabit their characters, he seems to be making up his lines as he goes along. That's impressive enough in relatively short Shakespeare soliloquies. It's absolutely dazzling in an eighty-seven-minute monologue. To achieve this effect, of course, you have to believe completely in everything you're saying at the moment you're saying it—even if your part demands that you say (and believe) the exact opposite a moment later.

The last White House actor with this kind of gift was John F. Kennedy, the most glamorous president since Thomas Jefferson. But for all of Kennedy's appealing good looks and cold steely eyes, he was undermined by a pronounced regional accent. Even when declaring, "*Ich bin ein Berliner*," he never managed to get out of Scollay Square. Lyndon Johnson, with the craggy features of a benevolent John Wayne, possessed a Texan charm that seemed virtually irresistible. It all evaporated when he found himself acting the bad guy in a war movie about battles he couldn't win. Richard Nixon reminded me of Elisha Cook, Jr., the sniveling hood that Humphrey Bogart loved to bait in *The Maltese Falcon*; there was always a character behind the character waiting to jump out and razz his performance. Jimmy Carter had genuine sincerity but also a voice that oozed peanut oil, and so his acting career never got off the ground enough to earn him a sequel.

As for Ronald Reagan, the first American president who actually *was* a movie star, he surely had much more experience in front of a camera than Clinton. But the current president almost makes the Great Communicator look like he's acting in silents. Being more an announcer than an actor, Reagan was accustomed to sell his political programs in the same manner as he used to peddle General Electric refrigerators, with a smile and a shoeshine. Clinton, by contrast, has the patented sincerity of a Method actor, the kind of vibrant intensity you associate with such movie presidents as Harrison Ford or Kevin Kline. He has even begun to look like them a little.

He is also acquiring the *Inside Edition* look: the animal mag-

netism and bright luster you see on stars at movie premieres. True, he clenches his jaw muscles a little too often when he wants to look resolute. And he overdoes that trick of pursing his lips, shaking his head, and letting his voice rise sanctimoniously when he wishes to pay homage to some sports figure or war hero or dead national leader. But let him have his moments of counterfeit piety. Considering how overexposed the man is, it is a wonder how he manages to invest each moment with even a hint of freshness.

Clinton's secret may be that he truly loves his audience and can't understand why everyone doesn't love him in return. Anyone who has spent more than three minutes with the man knows how much he loves to talk, how reluctant he is to release your hand (or your wife's arm) until he's won approval for his agenda. He is passionately and volubly devoted to demonstrating how much he loves his job.

Perhaps Clinton's greatest theatrical triumph has been his capacity to perform his role while being pilloried daily by an army of pundits. Imagine a star walking confidently on stage, as Clinton did before his State of the Union address, right after being told that he might be fired from the play and replaced by his understudy. Does he show any strain over the bad reviews he's been getting every day from the media? Not that I can see. Aside from a little puffiness under the eyes, he displays the rubicund good looks of a well-exercised health club member. His body language gives no hint of how he's been flagellated by the Judiciary Committee, harassed by the press, ridiculed by comedians. The role he plays best is that of a vigorous can-do guy, eager to return to business and to reorder the priorities of the nation, and blah blah blah.

Perhaps Clinton will support his new initiatives with more steadfastness than he has displayed with some of his political policies (and appointments) in the past. When he weds style to substance, there is no one to match him. But Al Gore's political strategists must have had a few bad moments watching Clinton's recent performances. No doubt it was cheering to see the president blowing away the opposition and increasing his standing in the polls with each new scandalous revelation. But it couldn't have been pleasant to watch the next Democratic candidate, Clinton's faithful understudy, sitting

like some frozen replicant behind his leading man during the State of the Union address. That spectacle reinforced a growing fear that our media-saturated nation would most likely never follow a mesmerizing headliner with a man who, no matter how articulate he may be before an audience, has trouble articulating his facial muscles.

Still, if Clinton could manage to overcome his early awkwardness in public, I suppose Gore can too. But isn't it a little scary that we are losing our capacity to distinguish public charisma from personal authenticity? Isn't it a little depressing that political candidates have a hard time getting elected these days unless they can display the same physical appeal and spiritual vapidity as Hollywood stars?

[1999]

· A Berlin Diary ·

THE AMERICAN ACADEMY in Berlin invited me to that transformed city last week to talk to a group of journalists and intellectuals about what passes for federal arts funding in our country. As is commonly known, the German government provides the largest cultural subsidies of any nation in the world—as much as 100 percent for some performing arts groups. Indeed more public money goes to the opera in a single German city than to all the arts combined in our own parsimonious nation. But while American artists look longingly toward the superior generosity (and cultural awareness) of German legislators as compared with America's benighted politicians, my auditors were eager to learn more about what appeared to be our more "enviable" mix of private and public funding.

I tried my best to understand what there was about our system to envy—not an easy task while giving my boilerplate exhortation about the progressive disintegration of American culture in the wake of federal neglect and private foundation agendas (the Martha Graham company being only the latest casualty of these stupid policies). In a Germany where government funding had never been an issue before, it seemed odd to hear people complaining about how exces-

sive subsidies were creating an atmosphere of dependency and waste among their artistic institutions.

One had only to use Berlin transportation to see the advantages of a well-organized and well-funded public support system. The U Bahn (the subway) and the S Bahn (the elevated) are not only extremely clean and efficient modes of transportation, they are also based on an honor system of payment. Try to imagine the freedom of that! How does one convey the sense of exhilaration that comes from being able to travel anywhere in a city without passing turnstiles or being stopped by cashiers.

Still, I was not insensitive to the notion that too much subsidy obtained too easily could have an adverse effect on the arts. My last visit to Germany (it was also my first) was in 1964, when it was already becoming obvious that West Berlin was pouring generous theatre money into extremely lavish productions. I remember a *Marat/Sade* at the Schiller Theatre that was conducted more like a Radio City spectacular than a serious philosophical play. By contrast, in Communist-dominated East Berlin—less a city than a perpetuated heap of rubble intended to remind Germans of their defeat—the relatively undersubsidized Berliner Ensemble was staging well-attended plays of relative simplicity and power, even though you could only get to the theatre through that endurance test called Checkpoint Charlie.

Returning to East Berlin after thirty-six years, I was struck by how much had changed since the dismantling of the Wall. On the site of Checkpoint Charlie was now a museum dedicated both to those who had escaped and to those shot by East German border police in an attempt to escape. Where there once was desolation, there now was luxury or at least the promise of luxury. The Hotel Adlon—a center of *luxe, calme, et volupté* before the war when it was called the Kempinski—had suffered greatly as a result of the war, the Wall, and its proximity to the Brandenburg Gate. Now it is again resuming its place as perhaps the swankiest hotel in all Europe. Architects from all over the world—including Sir Richard Rogers, Raphael Moneo, Iso Zaki, and others—are putting up huge cultural, commercial, and residential complexes in the once bombed-out Potsdamer Platz, according to a master plan designed by Renzo

Piano. An enormous glass dome designed by Sir Norman Foster atop the Reichstag allows you to survey the entire city, including the construction of a brand-new Bundestag. A striking Jewish Museum in Kreuzberg, designed by Daniel Libeskind, tries to recreate the monstrous oppression of the camps by means of a skewed series of metallic corridors resembling those in *The Cabinet of Doctor Caligari*.

If the streets of East Berlin still seem underpopulated with tourists or residents, the building sites are overpopulated with construction equipment. Everywhere you look there is a new building going up or an old one being renovated. Boat trips along the River Spee offer you vistas of cranes and derricks towering over the land like prehistoric monsters. One could imagine Disney or Spielberg making a movie in Berlin using backhoes as T-rexes engaged in mortal combat with brontosauri bulldozers.

Not far from the river, in the Berlin Mitte, is the house of Brecht and his wife, Helene Weigel, right next door to the cemetery in which they, along with some of their collaborators, are buried side by side (their marriage was not always as conjugal). The museum suggests that Weigel, as well as being a great actress (she was the original Mutter Courage), was also a great cook and not a bad gardener. It also suggests how interested Brecht was in American literature—books by Faulkner, Hemingway, Thomas Wolfe, Whitman, Robert Penn Warren, and Saul Bellow dominate his library. Apparently he continued to be very interested in America despite his flight to Communist Germany right after appearing before the House Un-American Activities Committee. The only papers in his monkish room, neatly arranged by his bed, are copies of the *International Herald Tribune*.

As for Brecht's Berliner Ensemble, it is no longer situated in what once seemed a no-man's-land, marked with warnings against *Fascismus und Militarismus*. The neighborhood of the theatre—today called Bertolt Brecht Platz—is now a very fashionable one, presided over by a statue of the playwright smoking a cigar. That familiar image is one of the few remaining reminders that Brecht was the guiding spirit behind the Berliner Ensemble as well as its principal playwright and director.

Following the recent death of Heiner Müller, Brecht's theatrical heir and a fine dramatist in his own right, the theatre, under its new Austrian artistic director, has developed a policy where very few of the founder's plays will be performed (only one—*Arturo Ui*—was in the repertory during my visit). Henceforth the theatre will be devoted to new plays by emerging talents and such middle-generation German writers as Kroetz and Handke.

Still, East Berlin culture continues to be considerably more interesting than that of West Berlin, despite its comparatively depressed economy. During my visit West Berlin was offering mostly operas, and, judging from *The Marriage of Figaro* at the Deutsche Oper, the productions are thoroughly conventional and conspicuously extravagant: brocaded period gowns, coiffured wigs, expensive props. If this is typical of German opera production (and I'm told that Daniel Barenboim's Deustche Staats Oper in East Berlin is not a whole lot more adventurous), then such American companies as the Houston Opera and the Chicago Lyric shine by comparison.

On the other hand most of the stimulating stage work during my admittedly brief visit was being performed in East Berlin, at such places at the Deutsche Theater, which has a permanent company, and at the Hebbel Theater, which is essentially a booking house. Interestingly the Deutsche Theater on Schumannstrasse (one of many Berlin streets named after artists), was the first place the Berliner Ensemble performed before it settled into its own theatre. Unlike the current Berliner Ensemble, it still retains traces of its Brechtian origins.

Those traces were particularly evident in a production of *A Midsummer Night's Dream* (*Ein Sommernachtstraum*), a play by the author the Germans like to call *unsurer Shakespeare* ("our Shakespeare"). In a new translation in rhymed couplets by the play's director, Juergen Gosch (in collaboration with Angela Schanelec and Wolfgang Wiens), this *Midsummer* seemed more like a trauma than dream—gross and earthy, carnal and animalistic. Performed on a bare stage defined by a black box, an orange floor, and a revolve that circulates a simple white and black geometrical figure, Shakespeare's most lyrical play begins with the appearance of a stocky, middle-aged

burgher tootling on a pennywhistle. This is Philostrate, played by a splendid actor named Juergen Holtz, who is later to remove his wig and clothes and transform into a bald, half-naked Puck (Theseus and Hippolyta, following the modern fashion, also double as Oberon and Titania).

The lovers soon stumble on before Theseus. They are dressed in black trousers and white shirts, and appear with slatternly posture and protruding bellies. That this is not going to be a romantic interpretation of the play (a la Max Reinhardt) is an impression soon confirmed by the entrance of the rustics, dressed in black fedoras and black suits and behaving like demented versions of the Blues Brothers. These clowns have all been renamed: Peter Quince, for example, is now Peter Squenz, and Bottom is now called Klaus Zettel. And the performances, particularly Christian Grashof's cabaret take on Bottom (Grashof is actually a dead ringer for Joel Grey), are so intimate in their downstage action that you can almost smell the actors.

Markus Moysen's Oberon is a fierce and hot-blooded demon in a long black wig and trailing black dress, and so is Katharina Linder as Titania, kissing and kicking her mate and biting his hand with the passion of an animal in heat. (Oberon himself is not above penetrating the sleeping Titania while squeezing the magic flower in her eye.) But it is Holtz's Puck that dominates the stage on every entrance. An aging elf in short pants, a bald gnome with flabby breasts, he has a relationship with Oberon that is by turns filial and fleshly, pressing his shiny dome against Oberon's naked belly for comfort, his arms around his waist, like some Breughel creature wallowing in Walpurgisnacht. And when he turns to the audience to exclaim "*Wie dumm diese Menschen bei*," he brings down the house.

Still, apart from Holtz's clowning, the humor of this production can get very heavy at times, and the lovers don't always succeed in lifting their scenes out of their customary tedium (Holtz's Puck seems to confirm this when he vainly tries to prevent Hermia from finishing one of her longer speeches). But it is a production in which I always felt the presence of a genuine imagination and a well-trained company, and a theatre spending its subsidies on artistry rather than

show. If the German public is looking for reasons to maintain their current cultural policies, it doesn't have to look any farther than the Deutsche Theater and its *Ein Sommernachtstraum*.

[2000]

· *Stella Adler at the Lectern* ·

FOR DECADES the highly respected actress and teacher Stella Adler taught a "script breakdown" class at her studio (also for a year and a half at the Yale School of Drama) designed to introduce her acting students to the great modern plays. Although she had always promised to publish her notes for this course—it had developed a reputation well beyond her classroom—the project was still unrealized when she died in 1992 at the age of ninety-one. Now her lectures, collated and edited by Barry Parris, have been released under the title *Stella Adler on Ibsen, Strindberg, and Chekhov*. It is a welcome publishing event.

Books about acting can be among the most boring forms of literature. Like most commercial training programs, they are essentially mercenary endeavors, designed with the hope of making the teacher rich and the student a star. But the thing that distinguishes Stella's work from the typical treatise on how to advance in the profession is her unusual passion for literature. "What is important to your work—and what saved me," she says in a typical exhortation, "is that through Chekhov and Strindberg and O'Neill and Tennessee Williams you can understand the world." Not only the world but yourself. Using "the truths of modern life as given to you by certain genius authors," Stella Adler believed you could also develop the gift of interpreting character through fuller self-understanding. Stella uses the great contemporary playwrights as her mentors and guides. Together they constitute almost a secular religion, with their plays as forms of modern scripture.

Despite the unusual literary focus, Stella's notes are not intended to substitute for a course in dramatic literature. They break

no fresh critical or scholarly ground. While her insights into dramatic character are always penetrating and intuitive, her control of general ideas is far from original. I was flattered to note how some of her thoughts about Ibsen and Strindberg came straight out of my book *The Theatre of Revolt*. She has not been hesitant either about looting Shaw's *Quintessence of Ibsenism* or borrowing from other critics, including her ex-husband Harold Clurman. Admiring of Ibsen for inventing realism, respectful of Strindberg for exploring marriage, she reserves her warmest feelings for Chekhov on whose tender characters she spends half the book and lavishes her most charming *aperçus*. But it's no surprise that, like Chekhov, she is more comfortable with behavior and circumstances, which is to say specific insights, than with large intellectual formulations.

I'm not even sure that *On Ibsen, Strindberg, and Chekhov* can accurately be called a book, since it is largely made of recorded lectures, complete with interruptions for questions (not lengthy ones— she is pretty short with students) and time-out for acting exercises. It's easy enough to make fun of a production like this. Stella quotes a lot from memory and thereby paraphrases or misquotes a lot as well. It is not precisely true, as she says, that "There were no railroads in Norway in Ibsen's day" (a railroad had been built by the time Ibsen reached manhood), and she's wrong in charging that "the Captain in *The Father* is without a first name" (his first name is Adolph). On the other hand it may be sloppy editing that has her misquote Ibsen as saying "I will torpedo the arts" (instead of the "ark"), thus making him sound a lot like Jesse Helms. Clearly these notes are not intended to sustain close critical scrutiny. They are meant rather to be heard and absorbed by students. What the reader hears and absorbs is the droll, sometimes hectoring voice of a self-confessed autodidact who never had the opportunity to finish her schooling.

Still, for all my caveats I consider *Stella Adler on Ibsen, Strindberg, and Chekhov* to be more helpful to an actor, and infinitely more revealing to a layman, than most recent academic scholarship on modern drama. Just compare those swollen theoretical tomes about "performativity," which, even when they use such practical acting terms as "spines" and "superobjectives," keep the reader remote from the plays as stage works. *On Ibsen, Strindberg, and Chekhov*

plunges you into the world of theatre as into a cold bracing stream in the Catskills. Like the movie *Shakespeare in Love*, it is an ecstatic paean to the theatre and to the potential nobility of the acting profession.

On Ibsen, Strindberg, and Chekhov reveals Stella Adler as a literary and social analyst, Stella Adler as an acting teacher, and Stella Adler as a great personality. She has value in all three roles, but she is nonpareil in the last. As a social analyst she tends to expend too much energy railing against the "middle class," no doubt a hangover from her fervent years with the Group Theatre. But Stella's distaste for the bourgeoisie is also a consequence of her lofty aristocratic temperament, what Clurman once called her "taste for the first-class." (One story, possibly apocryphal, has it that she joined a revolutionary protest march wearing a mink coat and carrying a poodle.)

"The middle class makes statements and knows nothing," she fumes. "The middle class does not think for itself, it is too busy. Mr. Ibsen is after this class, Mr. Ibsen and me." It was the purpose of Ibsen, who well understood the small-mindedness of the suburbs, sometimes to ennoble this class, more often to annihilate it. True, she reluctantly concedes that she is middle class herself. So are her students. But that is the worst thing about them, the source of all their confusions: "You are part of the middle class—neurotic, half-baked, half-genius, half-idiot."

Despite her weakness for social generalizations, however, what really engages her is telling her students how to play characters such as Nora in *A Doll's House* (build the character from how she tiptoes) and Hovstad the journalist in *An Enemy of the Peoole* (do research on newspapermen). Seeing the plays against their historical background helps actors remember that they are not the same as the characters they play. If you can't tell the difference, "you are a *pischer*." The confusion of self with role is the source of her continuing argument with Lee Strasberg and the Method. Strasberg says, "Take everything you know about yourself and use it to make Oslo." Stella says, learn about Oslo and you'll know more about yourself. "Unless you look up Oslo and find out, you will live in some dream world that you cannot use. If you play a Russian during the Napoleonic revolu-

tion [*sic!*] it is a good thing to read Tolstoy. . . . Your whole thing is *words* and I say leave them alone—for Christ's sake, leave them alone! Find something out about Oslo!"

Stella wants an educated actor ("I cannot be an idiot if I'm an actor"), not a self-infatuated dummy or a stupid literalist who believes "that you have to gain sixty-two pounds in order to feel the character." Compared to the musician, who knows the literature of his field, the actor is virtually illiterate. Performing in great plays requires patience, learning, and a very good technique. "That is something we don't have here—not Strasberg, nobody. I do it best. At least I will admit to you that it is all Stanislavsky, whereas Strasberg said it was all Strasberg. The ego was so great." Elsewhere she gives a fair example of her own healthy ego, retorting to an actor who complains that she didn't treat him like a professional, "I am a pretty important teacher. There is nobody giving this class better that I know in America. You are stuck with me. So you better take what is good about me and shut up about the rest."

Tough as she is on her charges, she is also the greatest champion of the acting profession. That is what she loves most about Chekhov, that for the first time in history he created plays that belonged to actors. Shakespeare didn't trust the actor, so the words have to carry you: "What a schmuck you will be if you only play the lines." A modern play needs a supplement to the words, what Stanislavsky called the subtext. "For God's sake, stop selling dialogue. After Chekhov, don't sell anything!"

Stella's hatred of selling is allied to her fervent interest in class. Both passions are expressions of nostalgia for a time when people dressed properly in the street, the porter tipped his hat, and life had form ("Now the only form is a wedding"). In the past, aristocrats used money to cultivate themselves. "But in a materialistic society, you don't use money for culture, you use it for more *things*, more money. We are bankrupt in America because it is not used for culture." This, she correctly believes, is the great theme of modern drama—"the destruction of beauty in the world, which is always sad"—and that destruction is usually caused by the confusion of classes and the marriage of vulgarity and aristocracy: Chekhov's

Natasha and Andrei, Strindberg's Jean and Julie, Williams's Stella and Stanley Kowalski. "If I married a rock singer you would say, 'Jesus, that's not quite right for Stella.'"

Her constant references to herself as "Stella" suggest how she uses her lectures to create her own mythology: "I do not care what you know about Stella. You do not know me. You only know one side of me. You do not know the side my daughters know when they say, 'Oh, don't be so stupid.' You don't know how stupid I can be." Nevertheless the most precious nuggets in the book are her digressions about her family, her life, and her own career in the theatre. Discussing Ibsen's attitude toward love, she touches on her own marital disappointments. She tells how her father, the famous actor Jacob Adler, thought the only reason to act was to give people something "bigger and better." Indeed he harangued his audience for their bad taste: "I try to bring you plays that help you to understand your life. I cannot do that if you don't want it, but if I follow you, you'll take me to the whorehouse." The most soul-ravaging whorehouse for Stella is Hollywood, which decimated the Group Theatre when first Franchot Tone and then many other members succumbed to the lure of money, stardom, and swimming pools. Stella herself went to Hollywood for a while as an actress, then many years later as an acting teacher to escape the winter months in New York. "When I go to California, I am a great celebrity—big star. Why? Because Stella is the only one who talks about Chekhov. . . . They talk about *Star Wars* and I talk about Ibsen."

Teaching at a time when theatre idealism was fading fast and most of her students were fixed on Hollywood too, Stella cajoled and scolded and warned about the easy safe suburban choices that would leave the actor sad and dead, worn down by life. "Listen to that voice inside that helps you. Be very careful. Don't let the source get dried up. It happens all the time in Hollywood, because the source of talent is not nourished by the way the product is made."

Indeed the book ends with an anecdote about Orson Welles doing a commercial—"this brilliant man—doing a commercial"— and how he was forced to bow before the ignorance of the producers in putting the stress on the wrong word. "He was worn out. If you have talent, the wearing-down by life gets to you and hurts you.

Guard against it. Fight it your whole life." Whatever her own terror of acting—and she hadn't set foot on stage since the fifties when the critics savaged her performance in a Kopit play—Stella fought her whole life against the erosion of talent and the death of hope. She embodied the finest qualities of her profession. Here, by reminding us of the fading values of the theatre, she performs her best, her most exemplary role.

[1999]

· The Juvenescent Arthur Miller ·

(INTRODUCTION TO THE 1999 MASSIE LECTURE)

FOR FIFTY YEARS NOW, ever since *Death of a Salesman* first electrified Broadway audiences in 1949, the name of Arthur Miller has been synonymous with, indeed inseparable from, that of twentieth-century American drama. A public statesman as well as a private creative artist, Mr. Miller has played a pivotal role in most of the cultural and political dramas of our time, and, particularly in his role as former president of PEN, he has forcefully represented the interests of American literary people throughout the world. Now in his mid-eighties and still going strong, Arthur Miller is our theatre's elder statesman, the man who best embodies the American dramatic image both at home and abroad.

I suspect Mr. Miller would probably ask me to delete the phrase "at home" from that statement. He has had occasion to regret the way his own country has ignored or rejected his work, notwithstanding the numerous awards and tributes bestowed on his earlier plays. "When I looked back," he wrote in his sometimes plaintive memoir *Timebends*, "it was obvious that aside from *Death of a Salesman* every one of my plays had originally met with a majority of bad, indifferent, or sneering notices. . . . I exist as a playwright without a major reviewer in my corner. . . . Only abroad and in some American places outside New York has criticism embraced my plays."

Up until the powerful Broadway revival of *Salesman* by the

Goodman Theatre in the current season, that statement has been regrettably true. But while his more recent plays have taken a regular drubbing from American critics, who generally prefer playwrights they have discovered themselves, the name of Arthur Miller is a talisman in Great Britain where he is respected as one of that country's leading resident dramatists. Bernard Shaw once remarked that England and America are two nations divided by a common tongue. Today it might be more accurate to say that we are two nations separated by a common playwright.

In the interests of full disclosure I should confess that until recently I was among those ingrates who failed to stand in Arthur Miller's corner. As a minority reviewer for a small-circulation journal, I believed it my responsibility to question some of the reigning orthodoxies of the day, including the prevailing notion that there was a direct line between classical Greek tragedy and *Death of a Salesman*. The line I perceived, rather, was between *Death of a Salesman* and Yiddish family drama as drawn through the plays of Clifford Odets. As the recent revival has emphasized, the overwhelming power of Miller's masterpiece is a result of his uncanny understanding of family dynamics.

I must also confess, on the other hand, that when the majority reviewers began to turn on Mr. Miller, as well as on Tennessee Williams and Edward Albee, I was appalled and a little contrite. It was one thing for a few fringe renegades to nip at the heels of the great. But if our three leading playwrights couldn't receive the respect they deserved from mainstream American reviewers, then something was seriously out of whack, and it was now my obligation to defend them. This may sound like sheer perversity or some crazy form of territoriality. But these attacks were getting me incensed about the fickleness of the popular press. I was grasping a lesson that Arthur Miller already knew in his bones—there were only two salable stories in corporate America: success and failure. Or, to paraphrase a Greek maxim, "Whom the media would destroy, they first make famous."

Still, the whirligig of time brings in its revenges, and now that *Death of a Salesman* is repeating its 1949 success to become the most respected play of 1999, Arthur Miller is once again where he belongs—at the very height of his professional reputation. He is there

not just because of his prodigious talents and a string of powerful plays but also because of his stubborn integrity and honesty. Like his hero, John Proctor, in *The Crucible*, he has been willing to push against the tide no matter how desperate the circumstances. In virtually all the important battles of our time, from the suppression of free expression by the House Un-American Activities Committee in the fifties to the muzzling of speech by the politically correct in the nineties, Arthur Miller has always been a (not always happy) warrior. As for his writing, it continues to grow in subtlety and humor as he continues to examine new forms—characteristics we expect more of young playwrights than of those in their eighties. Has Arthur Miller stumbled on some sort of creative fountain of youth? Is it the quality of the air in Roxbury, Connecticut, where he lives with his wife Inge, a gifted photographic artist? Is it because he lives there not as a weekend squire but as a worker of the land and an artisan of the toolshed? Not too long ago I described one of Mr. Miller's recent plays, *The Ride Down Mount Morgan*, as "an exhilarating journey as well as an exciting debut for its youthful author." It is my privilege to introduce the 1999 Massie Lecturer at Harvard. Ladies and gentlemen, the youthful author Arthur Miller.

[1999]

· *Moscow Nights* ·

AUTUMN IN MOSCOW is normally a season of change, but this year it has been marked by more than glowering skies and chilling rains. The season has also hosted a major shift in the structure of Russian theatre, sparked by the passing last May of Oleg Yefremov, artistic director of the Moscow Art Theatre (MXAT). Another in a growing list of recent and irreplaceable losses, Yefremov had been leading this celebrated theatre for the past thirty years. He was able to extend the reach of the company with some of the more innovative techniques of the twentieth century while still managing to preserve the heritage of its founding director, Konstantin Stanislavsky.

Poised to bring the company into the twenty-first century is

Yefremov's successor, the actor-director Oleg Tabakov. Tabakov is a well-regarded veteran of the company. A photograph of him playing Salieri in *Amadeus* hangs on the walls of the MXAT restaurant, next to portraits of Stanislavsky (playing Vershinin in Chekhov's *Three Sisters*), Michael Chekhov (playing Khlestakov in Gogol's *Inspector General*), and Yefremov (playing Don Quixote). Besides being a leading stage actor, Tabakov is a famous Russian movie star, which makes him an extremely popular choice for his new role. He has also been running his own company, the Oleg Tabakov Theatre, for a number of years. And as if to suggest that nothing theatrical is alien (or exhausting) to him, he has meanwhile been functioning as the head of the Moscow Art Theatre training program. Tabakov retains his position as artistic director of the Tabakov Theatre (now under the control of MXAT). But he has relinquished his position as head of the school to Anatoly Smeliansky, associate director of the Moscow Art Theatre and a celebrated Bulgakov scholar with books on Russian drama after the Revolution and an exhaustive encyclopedia of MXAT from its inception.

It is too soon to say what changes will be made at MXAT by the new management, but it is fairly safe to predict that the work will be more accessible and contemporary. One of Tabakov's most celebrated productions at his own theatre was Neil Simon's *Biloxi Blues*, a choice that would have been unthinkable at Yefremov's MXAT. The affable Tabakov has a common touch that is certain to manifest itself in the future work of the Moscow Art Theatre—and while he will probably keep the old staples in repertory, it looks like Russian audiences can begin to expect many more plays from abroad.

Visiting Moscow for a few days to see one of my own plays mounted at the Pushkin Theatre, I had the opportunity to interview some of the principals (not Tabakov, who was in hospital) and to watch some rehearsals at MXAT. MXAT was dark at the moment, preparing to open its season on October 1, Yefremov's birthday, with the production he had been directing when he died, Rostand's *Cyrano de Bergerac*. The company would thereafter perform it three days a week until Tabakov had prepared a new repertory. Russian productions are rehearsed for months before they are exposed to the public, often in full costume against a completed set. This *Cyrano*

was being completed by Yefremov's assistant director, Nikolai Skorik.

Rostand's play is an old warhorse that is too arthritic to learn new paces; and as I watched the wooing scene in rehearsal I had the impression that the success of this version was going to have to depend on the acting rather than any new directorial ideas. The set of Vyacheslav Yefimov (who is also the managing director of the theatre) was a bit of a novelty: a tubular, doughnut-shaped sculpture topped by a halo of lights that served both as Roxanne's balcony and Cyrano's hiding place. It was a handsome design, but it seemed destined to cramp the actors and to limit the space for the big battle scenes. The rehearsal gave me the feeling I had been peering into the theatre's past.

It was at the Oleg Tabakov Theatre that I got my most vivid impression of what might be happening in future at MXAT. The Tabakov, which occupies the basement of an apartment house, was showing a production of Tennessee Williams's *Vieux Carré* on its 110-seat experimental stage. (As further evidence of the artistic director's affection for the United States, the Williams play is in repertory with a stage adaptation of the movie *Sex, Lies, and Videotape*.) Like Peter Brook, Tabakov does not believe in making theatregoers too comfortable, so we spectators were forced to watch the show on cramped hard benches, our elbows and our buns competing with those of our neighbors for space. Still, the auditorium was packed, as are most Russian theatres, with an engaged, lively, and attentive group of people who obviously much preferred theatregoing to movies, television, or the Internet.

Like most of Williams's later plays, *Vieux Carré* is lushly overwritten in the playwright's most succulent plantain style. But unlike such dotage pieces as *Small Craft Warnings* and *The Two-Character Play*, it has considerable energy and (this is unusual for Williams) genuine sexual honesty. The play is largely autobiographical, taking place in the Garden District of New Orleans where the playwright took refuge after his beloved grandmother had died and he was fleeing his family in St. Louis. With a central character portentously called "The Writer," the play concerns the author's evolution as an artist concurrent with his growing awareness of his homosexual dis-

position and his gradual "coming out." Instead of staying discreetly offstage (like Blanche's sensitive husband in *A Streetcar Named Desire*) or masquerading as strutting macho studs (like Chance Wayne in *Sweet Bird of Youth* and Val Xavier in *Orpheus Descending*), openly gay men are very critical to the action in *Vieux Carré*. One character, called Nightingale, is a consumptive transvestite; another, called Tye, aside from being a gigolo, occasionally functions as rough trade; and still another, a musician named Sky, persuades The Writer to become his lover at the end of the play.

Aside from being autobiographical, the play is a virtual compendium of previous Williams works. There are echoes of *Camino Real* in *Vieux Carré*'s loose episodic structure. The class contrasts and speech contrasts between the animalistic Tye and Jane, the elegant woman he services, recall the cultural chasm between Stanley and Blanche in *Streetcar*. And an account of a go-go girl who is eaten alive by wolfish dogs recalls the cannibalistic world of *Suddenly Last Summer*. One is accustomed to find Williams repeating himself in the last plays that he wrote. The difference here is that *Vieux Carré* finds its authenticity as a memory play, exploring personal experiences the playwright has not touched since *The Glass Menagerie*. By having The Writer ruminate on how he developed a carapace around his feelings and affections while recovering from a cataract operation in New Orleans, Williams manages not only to tap into previously unexplored areas of his creative storehouse but to do some serious probes into his own character.

Vieux Carré takes place in the cheap rooming house of Mrs. Wire, a ferocious and avaricious old bag who rules her domain like a Tartar. Much to her chagrin, everyone in her establishment is not only failing to pay the rent on time but also having some kind of illicit relationship. Even worse for the reputation of the place, almost everyone seems to be sick or dying. It is a house of catastrophe, and before the play is over characters will be carried out feet first, scalded with boiling water, felled by blood disease, or destroyed by disappointment and disillusionment. Yet most of the characters in the play are also softened by some redemptive quality, such as Mrs. Wire's maternal love for The Writer. (She hallucinates that he is really her son.) Williams has not lost his belief in life as a precarious and precip-

itous series of traps that people avoid only by turning into predators themselves. He is simply leavening his patented sense of feral horror with the yeast of compassion.

The production of the play at the Tabakov, under the direction of Andrey Zhitinkin, is a very bizarre affair indeed, though it features some strong acting. Zhitinkin's idea of American bohemianism, in this severely truncated version of the play, is to deck everyone out in long white scarves. And despite the fact that the atmosphere of the work is drenched in New Orleans blues, the background music is mostly played on a Jews' harp. The self-pity of these American characters, almost all of them failed artists, seems overemphasized in the hands of the Russian actors. Playing on the narrow and deep stage, they are as cramped as the spectators watching them, being forced virtually to climb over each other while passing through their adjacent "rooms." Accomplished though they are, a few of the actors (notably the aging Mrs. Wire, played by a robust blonde in her forties) are too young for their roles. Some of the others are painfully miscast, especially the black maid Nursie, played by a white Russian actress in blackface and bandanna as if she had just walked off a pancake box. (There is only one professional black actor in Moscow—a male with a white Russian mother.)

But the real question of the production is why, when sex is the leitmotif of the play, virtually all the carnal action was excised. Aside from a little white makeup under his eyes, the gay poet Nightingale gives no evidence of his transvestite inclinations; most of the more explicit homosexual scenes have been cut; and even the heterosexual heavy breathing between Jane and Tye is subdued by the censor's muffler. Up until the late 1980s homosexuality was considered a crime in Russia, but even now, when criminal restrictions have been lifted, it is not a subject that Muscovites are willing to see on the stage. (In the Russian production of my own play, the director cut a scene in which a son takes his father on his lap because it was thought to be open to homoerotic interpretation.)

Clearly the Puritanism traditionally associated with the Soviet regime is still a factor in Russian culture. (The Puritanism in American culture is more often found among the enemies of theatre than its friends). Still, I am glad to have seen the play and to have once

again had the opportunity to mingle with a passionate and devoted audience. There are almost two hundred well-attended theatres in Moscow, over sixty of them state-supported professional companies, so one never gets the feeling in this city that classical culture is vestigial or superfluous. Quite the contrary: it remains a central fact of everyday life.

Now that the cultural Iron Curtain has melted, one hopes that classical culture could once again become a central fact of ours. American theatre practice was forever changed after MXAT visited New York in the early 1920s. The Group Theater, most famously, was founded in an effort to replicate Russian stage techniques through the agency of American actors. Today the energy seems to be flowing the other way. Though we still remain in relative ignorance about contemporary Russian drama, there is a growing Russian interest in American culture—indicated by the proliferation of McDonalds and Pizza Hut restaurants, to be sure, but also by the production of serious American plays. Tabakov will undoubtedly bring that new focus to the Moscow Art Theatre. And maybe the example of a vigorous Russian stage will once again help to reinvigorate our own.

[2000]

· *Ms. Smith Goes to Washington* ·

LIKE SO MANY bruised arts administrators before her, Jane Alexander—the sixth chairman of the National Endowment for the Arts—has bandaged her wounds with a memoir. It is part autobiography, part political history, part revenge play about Alexander's role in the culture wars of the nineties. Entitled *Command Performance*—a theatrical metaphor further worked (and perhaps overworked) in such chapter headings as "Curtain Up," "On the Road," "Backstage," etc.—the book is, at its best, an honest effort to explore the unholy marriage between politics and art, a relationship that, in this author's case, ended in a rather unhappy divorce.

A well-respected actress, trained in the nonprofit theatre and re-warded (as she tells us a little too often) with multiple Tonys and Academy Award nominations, Alexander was the first arts practi-tioner to be selected as head of this troubled institution. Indeed the Clinton administration literally plucked her out of the New York run of *The Sisters Rosenzweig* despite her total lack of administrative expe-rience. Alexander was among a number of gifted women that the president had invited to the White House in official positions. But unlike Zoe Baird, Lani Guinier, and Kimba Wood before her, she ac-tually made it through the bruising confirmation process with a min-imum of scars. This she owed not only to her personable character but also to her rather appealing naiveté.

Reared in Brookline, Massachussetts, the cherished daughter of a sports doctor, Alexander was indoctrinated from birth to be "proud of what our democracy stood for, and idealistic in our politi-cal beliefs." These sentiments, combined with her "strong opinions on issues" and her "hatred of injustice" led her to join protests against the Vietnam War and stimulated her passion in defense of civil rights. Unlike many other young people of her time, she had a profound faith in the system, believing, for example, "that if our elected officials knew the truth they would act on it." In short, this was a woman virtually destined for disillusionment. Her progress in office reminds me of Jimmy Stewart's in *Mr. Smith Goes to Washing-ton*, an innocent who comes to Congress filled with high ideals—only to discover that it is one Boss (Edward Arnold) who chooses the winning candidates in both political parties.

When Claiborne Pell called Alexander to ask whether she might be interested in heading the NEA, there was little question that if of-fered she would accept the job. She was by her own admission "an NEA baby" and she was flattered that an actress could be asked to take charge of such an important agency. When President Clinton called to place her name in nomination, she wasn't home. Following that, he wasn't home. Clinton not only failed to call her back that time, he never returned any of her calls or letters. One of the run-ning themes of this book is how deeply uninterested the president was in the NEA. Alexander concludes: "The president's men thought that art was a 'soft' issue—leave it to the ladies, and he did." Indeed

he left it to the First Lady. Hillary warmed to Alexander possibly be-
cause Alexander had once played her idol Eleanor Roosevelt on tele-
vision. Probably Bill ignored her because, unlike movie stars, artists
generate few votes and fewer political contributions. I can vouch for
the president's lack of focus on the arts. Following a conversation
with Mrs. Clinton in which she showed some concern about the
NEA, I tried to talk to her husband about the crisis in culture and,
thinking I meant national cultures, he started to lecture me on China!

Unlike her predecessors under Republican administrations,
Alexander was an instinctual civil libertarian (so was John Frohn-
mayer during his last year in office, only to be fired for his new
beliefs by President Bush). She retained a genuine concern for free
expression at a time when some very powerful members of Congress
were burdening the arts with content restrictions. By her own ad-
mission the new chairman withheld her personal opinions about in-
dividual works, and she tried her best (not always successfully) to
obey Clinton's indirect order to stay out of the newspapers. But
just as it was Frohnmayer's destiny to be brought down by the
Mapplethorpe and Serrano controversies, so it was on Alexander's
watch that the battles started over Ron Athey (an HIV-positive man
who drew designs with a scalpel on the back of another performer),
Annie Sprinkle (a feminist who invited people onstage to examine
her labia), and Tim Miller (a gay performance artist who offended
Jesse Helms by appearing before audiences nude). As usual, a hand-
ful of controversial grants were threatening to upset the whole apple-
cart.

Alexander had discovered early on that the conservative animus
against the NEA was driven by a strong Puritanism and a powerful
homophobia. In her heart she wanted to defend controversial artists,
often repeating that art by its very nature was sometimes destined to
be offensive. But after concluding that "it was important for me to
tread lightly and appease our detractors," she was unable to prevent
Congress from getting rid of grants to individual artists. Nancy
Kassebaum had told her, "You can't defend controversial art, don't
even try," and she was also learning that "jumping up and down
about the First Amendment and freedom of expression only made
things worse, like waving a red flag at a bull." As a result she rarely

referred to controversial grants directly for fear of arousing the ire of people like Strom Thurmond. At the same time that she could write that "a mature democratic society accepts the full range of artistic endeavor, even when it is outrageous," she wasn't prepared to jeopardize the NEA for the sake of a handful of provocative avant-garde artists.

This meant that Alexander's defense of art would never rise much above rhetorical generalities. Exercising her considerable charm on such courtly paleocons as Jesse Helms, Orrin Hatch, and Alan Simpson, she managed to win their affections without ever changing their votes. She dressed conservatively in low heels and drab colors so as not to attract attention, making frequent appearances in the offices, antechambers, and hearing rooms of the House and the Senate to argue and define the value of the arts. A hundred versions of these arguments and definitions are quoted in the book, and they clearly come from a well-meaning arts advocate. But reading such testimonials on virtually every page has the same numbing effect as listening to a fanatic on homeopathic medicine endlessly professing the therapeutic value of zinc pills or St. John's Wort. "It was wearing," she writes, "to have to explain again and again what the Arts Endowment did for the country or for a congressional district." It is wearing to read it too. Clearly if the arts need so much justification every time the NEA comes up for reappropriation, you can understand why this troubled agency is doomed.

Perhaps in an effort to avoid the storms that plagued her predecessor Frohnmayer, Alexander began to grow more and more populist in her postures and procedures. She became more interested in the way the arts could aid the handicapped and the underprivileged, and she increased the proportion of money going to legacy and preservation. Embarking on an exhausting tour of all fifty states—partly in order to see how the NEA was affecting artists, partly to placate politicians who wanted more equal geographical distribution of agency funds—she heard many arts administrators complaining that too much money was going to outreach programs when what they needed desperately was money for operating costs. Her answer was that she could "sell" Congress better on "outreach" than on art. She was beginning to grasp a secret known by all who aspire to stay

in office—stick to practical and achievable goals. She was also learning how to flatter the electorate. Asked by local citizens why the first state she visited was Maine, she replied, "As Maine goes, so goes the nation." That raised cheers (at the expense of confidence).

It was under acting chairman Ann Imelda Radice that the NEA first began to confuse its mandate as an arts agency with that of a social agency, a conduit for fostering handicrafts and "indigenous arts." It was under the administration of Alexander, eager to defend the agency against charges of "elitism" after her cross-country trip, that this process was accelerated. Quilt-making began to share an equal place with symphonic composition, and the achievements of playwrights were considered no more worthy of subsidy than those of iron mongers and plasterers. None of these expedients managed to reduce the woes of the NEA. The Republican Congress elected in 1994, led by Newt Gingrich and prodded by the religious right, began to call for the agency's abolition or privatization (same thing), and not even Alexander's considerable charm, preternatural coolness, and tireless appeals could persuade legislators that the arts really mattered. For all the support of such stalwarts as Sidney Yates and Teddy Kennedy, the NEA suffered massive cuts that virtually ended its life as an effective cultural force.

Alexander was rapidly learning about the inevitable tension between high art and democracy, and there was nothing she could do to halt the congressional juggernaut. Wearied by the struggle, and caught between a powerful if ignorant Congress and an angry if impotent art world, she was beginning to sound like someone who had fallen from grace, her innocence irreparably lost. While Alexander maintained her composure in public, she was growing uncharacteristically acerbic behind the scenes. Anger sharpened her prose. In her book she describes Tom DeLay as a man "whose brain could fit in an egg cup," and Strom Thurmond as a "taut, leathery gnome of a man with hair of a color not found in nature." She began to see little hope for the arts until legislators became more intelligent, which meant, in other words, that she could see little hope for the arts. It would seem that this classic liberal was losing faith not only in politicians but in the political process itself.

Despite her disillusionment, there are times when Alexander is

just a bit too eager to claim large credit for small victories. Having presided over a 40 percent cut in the agency's budget and the firing of eighty-nine staff members, she hoots like a conqueror ("We had triumphed. . . . The NEA was here to stay") just because the Congress, instead of axing the agency, had decided by one vote to reappropriate its measly $99 million. And for what purpose? Alexander is forced to restructure the stricken agency so that only one-fourth of the grants go to the arts (now called "creation and presentation") while the lion's share goes to such public and community concerns as heritage, preservation, education, access, planning, and stabilization—concerns designed to serve the consumer rather than the artist.

Alexander probably could have been less of a diplomat with legislators and more of an advocate for the avant-garde and the high arts. With hindsight, she had nothing to lose by a more forthright stand since none of her charm, graciousness, and tact managed to help save that limping animal from becoming disabled by the congressional axe. But *Command Performance* is possibly more valuable as a personal *bildungsroman* than as a history of a crippled government agency—a cautionary tale of liberal American idealism at the close of the twentieth century.

In the last year of her administration Alexander finally got an audience with the president and an opportunity to explain three things—that the arts need federal support, that they are not elitist ("I mentioned the Delta Cultural Center in his own state of Arkansas as an example"), and that the NEA would no longer fund controversial art. "That sounds good," replied the president, endorsing the restrictions. "They've got to understand the public won't pay for that." The Arts chairman writes that she felt a wave of "idealism" at this point and began longing for a chief executive who would "embrace the full spectrum of tastes, one that included all kinds of art." But she realized that she was in the real world, the world of compromise—"watering things down to make them the most palatable for the most people; being manipulative when need be to get elected; and being diplomatic which meant not saying what is really on your mind." She is talking about the president. She may also be talking a little bit about herself.

Command Performance ends with the disastrous Supreme Court decision on the NEA Four, ruling that the Congress did indeed have the right to impose content restrictions on NEA grantees. It was only the most recent in a string of defeats for the cause of a subsidized and uncensored American art. Alexander, who began with such fervent hopes and such eagerness to serve her country and her constituency, returns to the professional stage, her hair grey and twenty pounds heavier, persuaded that "the system is so corrupt that it may never be fixed." It is a sad and dispiriting note on which to end four years of dedicated service, and none of her passionate testimonials to the abiding power of artistic expression can disguise or mitigate her painful loss of faith.

[2000]

· *The Cape Town Races* ·

SOUTH AFRICA is a paradise of great unspoiled beauty, but like all Edens it has a serpent in the garden. Before 1994 the snake was called apartheid. After independence it took the form of a growing crime rate and a galloping incidence of AIDS, exacerbated by President Thabo Mbeki's preposterous HIV theories. In recent years the government has made some advances in housing and education. But partly to attract foreign investment, partly to discourage white flight, the African National Congress (ANC) has not fulfilled its promise to improve the general standard of living. Instead a lot of government resources, those not being drained by corrupt government officials, have gone into encouraging black corporate capitalism. Still, South Africans of all colors are among the world's sweetest, mildest people, and the long coastal landscape of seas and mountains and farms is unmatched for beauty anywhere, so huge areas of this country remain extremely desirable, incomparable places to live.

Nevertheless, as symbolized by the shantytown shacks that are slowly edging in on the luxury houses, economic inequality remains a grinding fact in South Africa, and poverty usually breeds violent crime. As a result the white population increasingly takes refuge from

rape, theft, and murder inside heavily gated communities. Every fifth car on the road seems to be marked "Armed Reponse"—the vehicles of a private police force that may represent the one area in South Africa where employment is on the rise.

A South African province that wasn't captured by the ANC in the last elections was the Western Cape, whose capital is the glistening beach city of Cape Town. The ruling party didn't win a majority there partly because it failed to get out the black vote, partly because the "coloreds" (a community of mixed-race descent, usually white Afrikaners, Malay slaves, and brown-skinned Khoisan people) traditionally vote for white candidates. Tony Leon's Democratic Party (DP) managed to recapture that majority by forming what some consider a devil's bargain with its former enemies, the Nationalist Party (Nats), in a loose federation called the Democratic Alliance (DA). Since the Nats were once the party of apartheid, political blocs on the Cape would now seem to be forming along racial rather than ideological lines.

Racialism in fact has become the predominant issue in this country, not only in politics but in culture. The ANC has drastically reduced arts spending, which is now down from 10 percent of an institution's budget to about 4 percent. Although this may still seem munificent by American standards, the money is largely restricted to nonwhite groups—government subsidy for European cultural expressions no longer exists. Whatever the reasons for this, whether to help promote an indigenous African culture or to punish those who voted against the ANC, in Cape Town the policy has already resulted in the loss of the city's opera company, ballet company, and symphony orchestra.

The theatre still survives after a fashion, partly because it can still draw on private funding. And just as the theatre previously confronted apartheid in plays like those of Athol Fugard, so it is the theatre that today is exploring South Africa's complicated racial issues in a full and honest manner. It is also there that a genuine multiculturalism is beginning to evolve, if the productions I saw are at all typical. At the huge Nico Theatre in Cape Town, where black people were once prohibited from appearing on the stage or sitting in the audience, many presentations are European plays or operas adapted to accommodate black performers. A few years ago I saw an excellent

all-black production of *La Bohème* at the Nico, set in Soweto. This season I witnessed a performance of the 1943 Oscar Hammerstein II musical *Carmen Jones*, featuring black and colored singers along with some white dancers performing in dark makeup!

Carmen Jones is *Carmen* transferred to a black army base in the United States during World War II. Instead of making cigarettes, Carmen works in a parachute factory; her lover, Don José, has turned into a sergeant in the U.S. Army named Joe; and the torero Escamillo has experienced a sea change into Husky Miller, a heavyweight boxing champion. Hammerstein left Bizet's music pretty much intact. But he treated the Mérimée book a lot like Peter Sellars was later to treat the libretti of Handel and Mozart operas, as pretexts for modern settings and contemporary references designed to make the operas more audience-friendly.

Although this particular *Carmen Jones* imported a couple of singers from the States to play the leads, most of the cast had broad Capetonian accents that made the American setting sound inauthentic. As a kid I happened to see this show on Broadway, where I also saw a number of other European works then being adapted for black casts (*The Hot Mikado, The Swing Mikado*, and *Swinging the Dream* were three of them). It worked well then, but in Cape Town it seemed to be a period piece. One of the paradoxes of theatrical "updatings" is how quickly they date. This *Carmen Jones* required a much fresher imagination in order to keep the piece from going stale.

The Baxter Theatre Centre is one of the busiest hubs in South Africa for dramatic work. Supported by the University of Cape Town, this well-equipped complex contains three flexible stages of various sizes. All the theatres were filled during my visit with various projects, one of them Marc Lottering's *From the Cape Flats with Love*, a satire on racial attitudes recently mentioned by the *New York Times* in an article on race-based South African humorists. The other two shows in the building were *The Kat and the Kings* and *Glass Roots*, both of them also comically preoccupied with South African racial divisions.

David Kramer and Taliep Petersen's *The Kat and the Kings* is a piece that traveled well to every city (London included, where it won an Olivier Award) except New York. There it ran into a sour press,

though it still managed to eke out a six-month run. I probably would have panned the show too had I seen it on Broadway. It is highly derivative of *Grease*, both in its fifties rock-and-roll score and its Three Stooges brand of comedy. But watching it with a South African audience was a real lesson in how your environment can influence your feelings about a theatre piece.

The musical is set during the fifties in District Six, a multicultural, largely colored area of Cape Town, later bulldozed to the ground in 1966 by the apartheid regime. *The Kat and the Kings* is a nostalgic tribute to that area during a time when Elvis Presley, Little Richard, and Chuck Berry were galvanizing the youth of South Africa. It is a good-natured story, told from the perspective of an aging shoeshine man named Kat Diamond, about the decade when he and four other coloreds formed a rock-and-roll band that achieved a certain degree of celebrity, a condition signified by their changing from work clothes into brightly colored polyester jackets. Although allowed to play in white hotels, they are forced to sleep in the servant quarters and work as bellboys during the day. "The government decided where we could eat, drink, sleep," Kat ruefully remembers, "who we could marry." The white emcee who introduces their act makes jokes about their criminal propensities: "If they weren't here, they'd probably be breaking into your car, so give them your handbag . . . uh, I mean a big hand."

The various members of the group are nicely delineated, and all the performers (particularly Terry Hector as Kat, Erica Charles as Lucy, and Alistair Izobell as Magoo) have an infectious energy that reaches to the back of the house. Kramer's staging ideas are always inventive, and Petersen's musical arrangements, though hardly original, are dynamic and effective. *The Kat and the Kings* ends with the breakup of the band as District Six is turned into a whites-only area (ironically, no whites will ever live there) and apartheid drives three of the singers into exile in Toronto. Indeed the theme of homelessness, banishment, and longing for a lost Eden creates a more compelling melody in this show than all the Western rock-and-roll. And the evening ends with a rousing Zulu dance that brings the entire audience to its feet, roaring and waving. Myself included.

Fiona Coyne's *Glass Roots* is a more sophisticated variation on the same theme, which is the uneasy yet inescapable relationship

among the races in the "New" (or, as one character amends it, "Newish") South Africa. "On the surface," Coyne tells us in a program note, "we're pretending to get on with one another . . . but we know that below ground things are different." She actually manages to explore these differences through a relatively conventional mother-in-law play on the order of *Guess Who's Coming to Dinner*.

Jocelyn (Jenny Stead) is a "creative" advertising person seeking the "quintessential South African" for a beer commercial. She thinks she has found her in a middle-aged colored woman named Verity (Gail Reagon) who votes for the Nats. Since Jocelyn's business partner is a black man named Vuyo (Wiseman Sithole), who also happens to be attracted to her, the play is perfectly set up for three-way interracial tensions when Jocelyn's mother, Mona, moves from Johannesburg to live with her daughter in Cape Town.

Deliciously played by Diane Wilson in an alcoholic daze that recalls Elaine Stritch groping around the stage in *A Delicate Balance*, Mona is continuously dousing herself with belts from portable vodka bottles. She is the "previously advantaged" type of person who may vote Liberal but who is secretly grateful to the Nats for having kept the blacks in their place—in short, a combination of Auntie Mame and Archie Bunker. (The colored Verity, just as suspicious of blacks as Mona, feels none of her liberal guilt—"It's a white thing, my sister.") Like Archie Bunker, Mona can get off bigoted nonsequiturs with an innocence that almost takes away their sting, especially since her prejudices extend to just about everybody, regardless of race. For Mona the whole country has gone to the dogs. But then, so has every country. Like most South Africans, she thinks that racism is far worse overseas than in her own backyard.

When she comes upon Vuyo, fresh from a sexual encounter with her daughter ("My God but it is hot, eh?" is the way she rationalizes his nakedness), she tells him, "I was going to ask Jocelyn if I could move in with her but you beat me to it." But Vuyo is not the only habit of Jocelyn that Mona disapproves of. Another is her cocaine addiction. And in the best-written scene in the play, mother and daughter go after each other with a ferocity that leaves them both spent. Calling her "a nasty piece of work . . . not what I hoped for," Mona tells Jocelyn that no self-respecting white boy would live with

her. She also reveals that she has not retired from her job in Johannesburg, she has been fired—more accurately, "retrenched," the word used when black workers take over positions previously held by whites.

The resolution is a more understanding relationship between daughter and mother, just as the friendship between Verity and Mona symbolizes a new harmony between coloreds and Europeans, and the affair between Vuyo and Jocelyn suggests closure of the tensions between black and white. As Vuyo says, "They can't go on blaming apartheid all the time. The past is the past." All this may be wishful thinking. Despite its acerbic edge, *Glass Roots* is essentially a light comedy that doesn't aspire much above its genre. But the unusual thing about the play, indeed about so much South African theatre these days, is the way it manages to weave in, along with plot twists and character issues, candid expressions of fear and suspicion on the part of blacks, whites, and coloreds alike regarding The Other. That sometimes brutally honest examination of prejudice, which still eludes our own theatre at the present time, is the single best hope for reconciliation in a racially divided land. It sure beats the way we Americans repeatedly and quite futilely recycle black recriminations and white guilt.

[2001]

· *Chekhov on Ice* ·

A hotel room in Badenweiler, a spa in the north of Germany. A table with some wilted roses. A chair. A bed on which we find Anton Chekhov asleep when the lights come up. We can hear Chekhov's labored breathing for a few minutes before the door opens and Dr. Schworer enters. He is an elderly gentleman in a black cutaway coat with a spade beard. He moves to take Chekhov's pulse, waking him up.

ANTON: Help the sailor. Save him. He's drowning. Oh, Dr. Schworer.

SCHWORER: (*heavy German accent*) How are you feeling today, Dr. Chekhov?

ANTON: Never better. Shortness of breath, pains in my stomach, and a serious, probably incurable case of idleness.

SCHWORER: You also have an advanced case of consumption, congenital emphysema, diarrhea, and severe rheumatic pains. Your heart is doing double duty because your lungs are in shreds.

ANTON: Thank God I don't have hemorrhoids. (*he starts to laugh but his laugh turns into a rasping cough*)

SCHWORER: That cough got you thrown out of the Hotel Romersbaden. Lucky the walls in this place are thicker.

ANTON: What can you give me for these pains in my gut?

SCHWORER: Bismuth for your diarrhea. Camphor for your cough. Morphine for your rheumatic pain. When things get really bad, I can let you have some heroin.

ANTON: Well, just between the two of us, things are really bad.

SCHWORER: I'm not surprised. You look like a corpse. (*gently, as Chekhov continues to cough*) This camphor will ease your cough.

ANTON: (*while the doctor administers a shot*) I'd trade all your medicine for a good cup of coffee.

SCHWORER: Absolutely no coffee. It's bad for your breathing.

ANTON: The only way to avoid breathlessness is to stop moving. That will happen soon enough.

SCHWORER: (*taking pity*) Ach, well, I suppose one cup won't kill you. (*he goes to leave and as he does, passes Olga coming in*)

OLGA: Good evening, Doctor. How is my husband?

SCHWORER: His spirits are fine, Mrs. Chekhov.

ANTON: Back so soon, Olga?

OLGA: How have you been passing the time?

ANTON: Working on the next stage in my career.

OLGA: And that is?

ANTON: My death.

OLGA: You turn everything into a joke.

ANTON: Life is a joke. What are you doing here? I thought I told you to stay in town and enjoy yourself.

OLGA: I enjoy listening to your complaints.

ANTON: You've been listening to those for three days now without a break.

OLGA: For years you complained I was never by your side.

ANTON: My punishment for falling in love with an actress.

OLGA: Why did you have to get sick when I was opening in your new play? I should have been there for you.

ANTON: Don't castigate yourself. It suited me.

OLGA: It did?

ANTON: A wife is like the moon. You appreciate her more when you don't have to see her every night.

OLGA: Don't joke about it. I still can't forgive myself. (*starts to cry*) And then to lose little Pamphil.

ANTON: You miscarried. It happens to a lot of women.

OLGA: Stanislavsky is saying that to get pregnant by such a great man and then lose the child is a sign of extraordinary carelessness.

ANTON: Not a bad joke for such a humorless man.

OLGA: Can you ever forgive me, my darling man of gold?

ANTON: Forget it. (*laughing*) I was never certain that child was mine anyway.

OLGA: Of course he was yours. I conceived him right after my last trip to Yalta.

ANTON: Two days after.

OLGA: What are you suggesting? (*starts to cry again*)

ANTON: Darling sweetheart, you will have children again. All you need is a husband to be with you all the time. You will have a little boy, who will break dishes and pull the dog's tail.

OLGA: I want a child with you. I feel so much remorse.

ANTON: Forget it. You're here now. Everything's fine. Except the unfinished business with my sister. Please make it up with Masha.

OLGA: I wrote her while I was in town. I asked her to forgive me.

ANTON: Thank you.

OLGA: Did you get any sleep while I was gone?

ANTON: A little. I keep having the dreams about a drowning sailor.

OLGA: Put him in your next play.

ANTON: There won't be a next play.

OLGA: You have no ideas?

ANTON: I have no time.

OLGA: Tell me your ideas.

ANTON: I want to write a play set on an icebound ship carrying a group of passengers who never reach their destination.

OLGA: (*ironic*) Sounds hilarious.

ANTON: All my plays are funny. Except when Konstantin Sergeyevich Stanislavsky directs them. Why did I ever get involved with theatre? I've lost a thousand good stories and let you actors murder my words.

OLGA: You can still write stories.

ANTON: Last night in my delirium I dreamed a wonderful new story.

OLGA: Yes?

ANTON: There's this fashionable spa, see, which caters to wealthy bankers and red-faced Englishmen. They all come there for the delicious food. They return from sightseeing, starved, tired, and dreaming of a great banquet, but . . .

OLGA: You're making me hungry, Anton.

ANTON: But the cook has disappeared, and none of them is going to get a damned thing to eat.

OLGA: Sounds just like our wedding.

ANTON: Wasn't that fun? To invite the guests to such a grand reception and then have Levitan tell them we were already on our honeymoon? (*Olga laughs heartily. Anton joins in, then starts to cough.*)

OLGA: Anton?

ANTON: I had to come to Germany to croak. What was wrong with Yalta? (*he coughs more and sits up trying to catch his breath*)

OLGA: Where's the doctor?

ANTON: Getting me some coffee.

OLGA: (*opens the door and shrieks*) Doctor Schworer!!!

ANTON: Don't bother. I'll be gone before he hears you.

OLGA: (*goes to the table and chops up some ice from the bucket, puts a hunk of it in a cloth, and goes to apply it to Anton's chest*) Here, this will make you feel better.

ANTON: You don't put ice on an empty heart.

(*Dr. Schworer enters, carrying a tray with coffee and a bottle of champagne on it. When he sees Anton, he puts the tray down quickly and administers a shot.*)

SCHWORER: I think it's time for the heroin.

ANTON: *(rising up in his bed, he screams)* Ich sterbe!

OLGA: Doctor, save him!

SCHWORER: There's nothing I can do.

OLGA: You must save him!

SCHWORER: Dr. Chekhov! *(no answer)* DR. CHEKHOV!!!

ANTON: No need to shout. I'm not out of earshot yet. *(he is gasping for breath)*

SCHWORER: Would you like me to order some oxygen?

ANTON: What for? Before it arrives I'll be a corpse.

SCHWORER: Perhaps some champagne?

ANTON: *(weakly)* What are we celebrating?

SCHWORER: It's customary on these occasions. *(he uncorks the bottle and hands Anton a glass)*

ANTON: It's a long time since I've tasted champagne. *(He downs the glass, puts it carefully on the table, then turns over on his left side and becomes very quiet. Dr. Schworer takes his pulse, then looks at Olga.)*

OLGA: Is he—?

SCHWORER: He's gone. *(he brings the sheet up over Anton's head.)*

OLGA: *(lights down on the bed, up on Olga)* No human voices, no everyday sounds. Only beauty, peace, and the grandeur of death. *(turning to the audience)* Anton my dear, golden man, a month has passed since your poor, sick worn-out heart stopped beating, and now at last I am able to tell you everything I have been through. I feel you're alive out there, somewhere, waiting for a letter. Dearest one, where are you now? Let me stroke your soft, silky hair and look into your dear, shining, loving eyes. Dear God, why didn't I give up the theatre and stay with you? I neglected my husband, I lost my baby, and now I am ashamed to look your

mother or your sister in the face. But there's one thing that wrenches my heart and trivializes all my suffering. That such a great poet—a man who hated banality and fought it all his life— had to be shipped back to Moscow in a refrigerated railway car marked for the conveyance of oysters.

(pin spot on Chekhov's face, smiling)

ANTON: What a farce!

(blackout)

[2000]

Index

A NOTE ON THE AUTHOR

Robert Brustein is the founder and in his last year as the
artistic director of the American Repertory Theatre at
Harvard University, where he is also professor of English.
He is theatre critic for *The New Republic* and the author of
a number of distinguished books on theatre and drama.
Mr. Brustein is the former dean of the Yale School of Drama
and the founder and director of the Yale Repertory Theatre.
He has twice been awarded the George Jean Nathan Award
for dramatic criticism, in 1962 and 1987, and has also
received the George Polk Memorial Award for outstanding
criticism. He is a member of the American Academy of
Arts and Letters.